So Much More Than Art

Jack Davy

So Much More Than Art
Indigenous Miniatures of the Pacific Northwest

© UBC Press 2021

All rights reserved. No part of this publication may be reproduced, stored in a retrieval system, or transmitted, in any form or by any means, without prior written permission of the publisher, or, in Canada, in the case of photocopying or other reprographic copying, a licence from Access Copyright, www.accesscopyright.ca.

30 29 28 27 26 25 24 23 22 21 5 4 3 2 1

Printed in Canada on FSC-certified ancient-forest-free paper (100% post-consumer recycled) that is processed chlorine- and acid-free.

Library and Archives Canada Cataloguing in Publication

Title: So much more than art : Indigenous miniatures of the Pacific Northwest / Jack Davy.
Names: Davy, Jack, author.
Description: Includes bibliographical references and index.
Identifiers: Canadiana (print) 20210235969 | Canadiana (ebook) 20210235993 | ISBN 9780774866552 (hardcover) | ISBN 9780774866569 (softcover) | ISBN 9780774866576 (PDF) | ISBN 9780774866583 (EPUB)
Subjects: LCSH: Miniature objects – Northwest, Pacific. | LCSH: Miniature craft – Northwest, Pacific. | LCSH: Indigenous art – Northwest, Pacific.
Classification: LCC NK8473.N7 D38 2022 | DDC 745.5928089/970795—dc23

UBC Press gratefully acknowledges the financial support for our publishing program of the Government of Canada (through the Canada Book Fund) and the British Columbia Arts Council.

This book has been published with the help of a grant from the Canadian Federation for the Humanities and Social Sciences, through the Awards to Scholarly Publications Program, using funds provided by the Social Sciences and Humanities Research Council of Canada.

Printed and bound in Canada by Friesens
Set in Garamond and Myriad by Artegraphica Design Co. Ltd.
Copy editor: Camilla Blakeley
Proofreader: Helen Godolphin
Cover designer: George Kirkpatrick
Cover image: Figures in interior of a miniature house, c. 1892.
 © Field Museum, FM 17836

UBC Press
The University of British Columbia
2029 West Mall
Vancouver, BC V6T 1Z2
www.ubcpress.ca

Contents

List of Figures and Tables / vii

Acknowledgments / ix

List of Abbreviations / xi

Introduction / 3

1 Practice and Play: The Makah / 15

2 The Haida String: Northern Peoples / 40

3 Tiny Dancers and Idiot Sticks: The Kwakwa̱ka̱'wakw / 67

4 Small Foundations: Tulalip Tribes / 89

5 An Elemental Theory of Miniaturization / 111

6 Analysis of Technique and Status / 130

7 Miniature Realities / 169

Notes / 190

References / 194

Index / 205

Figures and Tables

Figures

1.1　Makah canoe miniature found at Ozette, c. 1560 / 17
1.2　Makah canoe miniature by Young Doctor, c. 1904 / 27
1.3　Alex McCarty demonstrating carving techniques, Evergreen State College, Washington, 2015 / 34
2.1　Detail of figures in interior of a miniature house, c. 1892 / 54
3.1　Miniature canoe diorama by Mungo Martin, c. 1950s / 76
3.2　Miniature canoe diorama by Mungo Martin, c. 1950s / 77
3.3　Hamat'sa dance figurines by Gordon Scow, c. 1960 / 84
3.4　Unfinished head from Hamat'sa dance figurine by Gordon Scow, c. 1960 / 86
4.1　Maquettes for carvings at the Tulalip day care centre, 2015 / 102
4.2　Saʔbaʔahd (Steven Madison) carving a figure, 2015 / 102
4.3　Maquette for welcome figure by Joe Gobin, 2014 / 104
4.4　Joe Gobin working on his miniature canoe, 2010 / 108
5.1　Billboard in Broadway Market, London, 2013 / 113
5.2　World's Largest Trophy Cup, Republican Street, Seattle, 2014 / 122
6.1　Comparison of full-sized and miniature canoe dimensions / 136

6.2 Northern canoe miniature of tight-grained yellow cedar, c. 1880s / 144

6.3 Northern canoe miniature of loose-grained yellow cedar, c. 1880s / 144

6.4 Makah canoe miniature found at Ozette, c. 1560 / 153

6.5 Felix Solomon in his workshop, 2015 / 160

7.1 Methodological model for the study of miniaturization / 183

7.2 Raymond and unidentified associate, Seattle waterfront, 2014 / 185

Tables

6.1 Miniature canoe seriations / 132

6.2 Miniature house seriations / 133

6.3 Full-sized canoe lengths / 134

6.4 Selected miniature canoe lengths / 135

6.5 Haida longhouse dimensions / 137

6.6 Selected miniature house dimensions / 137

6.7 Miniature canoes with and without attached figures / 157

Acknowledgments

A GREAT MANY PEOPLE contributed to this book, and many more than I can include here deserve thanks. Please know that I am most grateful for your contributions.

Specific thanks must go to the staff at UBC Press, including Darcy Cullen, Ann Macklem, Carmen Tiampo, and Camilla Blakeley who have shepherded this through publication during an extraordinary and difficult period.

For the research on which this book is based, thanks go to Jago Cooper and Ludovic Coupaye, who provided patient and insightful advice throughout. I also greatly appreciated additional support from the Africa, Oceania and the Americas Department, J.D. Hill, and the Research Department at the British Museum, and the Department of Anthropology under Dr. Susanne Küchler at University College London.

Special thanks are also due to the Arts and Humanities Research Council for funding the project.

Thanks to museum staff around the world, too many to name individually, who provided information and advice on their collections, and to the Indigenous artists and communities who gave up their time to participate in this project. I wish especially to thank Mike Gobin, Joe Gobin, James Madison, Sa?ba?ahd (Steven Madison), Greg Colfax, Spencer McCarty, Melissa Peterson-Renault, Alex McCarty, Steve Bruce Sr., Gary Petersen, Trevor Isaac, Wayne Alfred, Corinne Hunt, :klatle-bhi (Cloth-Bay), Gwaai

Edenshaw, Nika Collison, and Janine Ledford. Your influence suffuses every page. This is your knowledge. I just wrote it down.

Finally, thank you particularly to my wife, Nelle, and our son, Nat, without whom this book would not have been possible.

Abbreviations

Specific miniature objects are referred to in the text by an abbreviation referring to the museum that holds them, followed by their accession number.

AMNH	American Museum of Natural History, New York
BM	British Museum, London
BMNH	Burke Museum of Natural History and Culture, University of Washington, Seattle
BrookM	Brooklyn Museum, New York
CMH	Canadian Museum of History
EMK	Eesti Kunstimuuseum, Tallinn
FM	Field Museum, Chicago
MCRC	Makah Cultural and Research Center, Neah Bay, Washington
MoA	Museum of Anthropology, University of British Columbia, Vancouver
MoV	Museum of Vancouver, British Columbia
MQB	Musée du quai Branly, Paris
MVL	Museum Volkenkunde, Leiden
NMAI	National Museum of the American Indian, Smithsonian Institution, Washington, DC

NMNH	National Museum of Natural History, Smithsonian Institution, Washington, DC
PM	University of Pennsylvania Museum of Archaeology and Anthropology, Philadelphia
PMAE	Peabody Museum of Archaeology and Ethnology, Harvard University, Cambridge, Massachusetts
RBCM	Royal British Columbia Museum, Victoria, British Columbia
SFU	Simon Fraser University, Burnaby, British Columbia

So Much More Than Art

Introduction

The Northwest Coast of North America is where seas of blue meet seas of green, the Pacific Ocean giving way to land where moss grows like a thick carpet from which trees spurt in dense thousands, forming a vast canopy of dark green. To walk into these forests around Indigenous communities on Haida Gwaii, at Alert Bay, Tulalip, or Ozette, or any other place touched by the passage of settler colonialism, you swiftly find yourself trespassing among ruins. For between the thinner new-growth trees are the remains of huge trunks, rising in blurred hummocks and splintered columns. Sometimes stretching above head height before they abruptly splinter, these trunks are overgrown and crumbling, arboreal rubble buried in the detritus of the growing forest so that they are at first hard to make out, but once you notice them you see them everywhere.

These are the remains of cedar groves, stands of huge ancient trees that once covered the hillsides and islands of the region. In a few remote or protected places they can still be found, an arboreal cathedral arching far overhead, but in most places the stumps are all that's left amid the younger, slimmer growth. They offer mute testimony to an ecological disaster that overwhelmed the Northwest Coast in the nineteenth century, following and partially precipitating the deliberate near-destruction of the ceremonial and material culture of the Indigenous inhabitants.

These forests were systematically clear-cut by non-Indigenous logging companies in the nineteenth and twentieth centuries (Marchak 1995). To a casual observer, and there were many of the time, with the trees seemingly

inevitably went the Indigenous communities on the coast, or at least their traditional practices and material culture. Their canoes and their houses fell into disuse and began to dissolve back into the forest, replaced, sometimes forcibly, by non-Indigenous style and technology. With populations and expertise rapidly declining through disease, constantly officially observed and sanctioned, and increasingly lacking ready access to the raw materials needed to build traditional material culture, rich spiritual and social practices came under demographic, ecological, and political pressure to assimilate. It appeared to these casual (non-Native) observers that before long nothing would be left. And yet this impression was deceptive, often deliberately so. The communities resisted and survived such that within a few decades a generation of enterprising and dedicated artists and educators took it upon themselves to rediscover, re-create, and teach their traditions once more. Through their example, and building on their regained knowledge, communities are producing material culture once more, each generation building and rebuilding on the previous one to restore what was lost, amid the gradual rebirth of their ancestral forests.

This book considers, on a technical and emotional level, one of the few carving practices that was sustained through all the years of degradation and loss: miniaturization. Through miniatures found in museum collections and through interviews with carvers who continue to make them today, I explore how investment in the techniques of the small and seemingly insignificant contributed to the survival of the great and existential on the Northwest Coast. In doing so, I will consider the reasons for which miniatures have historically been produced in this region, how they were used in systems of communication, and their importance in the resilience, resistance, and survival of many Northwest Coast practices.

Further, I investigate the creation, distribution, and re-use of miniatures as an essential human strategy of communication on local and global scales. In doing so, I propose a new way of thinking about miniatures, examining them not as mere diminutive relics of a fading past but as deliberate, often satirical, commentary on what survived, and as a form of opposition to the colonial oppression that Indigenous communities and artists faced, and continue to face, in their daily lives. Despite dedicated government persecution, Indigenous peoples of the Northwest Coast ensured their own survival in part through a multigenerational and subversive program of artistic resistance that kept traditions alive, and miniaturization was a key technique in this campaign.

Shaking Objects

A piece of advice circulating among those who work with material culture from the Northwest Coast sums up succinctly why it can be so hard, impossible even, for non-Native researchers, students, and museum visitors to meaningfully understand the objects they see in museum stores and displays. As French anthropologist Claude Lévi-Strauss recounts,

> I would like to tell you a story about a very noble American woman anthropologist, a princess among her people, who got her PhD and became curator in a Canadian museum. One of her white colleagues who was studying those marvellous chief's rattles of the North Pacific Coast, beautifully carved and painted with elaborate designs, was puzzled by one specimen. He turned to her and asked: "How do you read this rattle?" and she answered "We don't read them, we shake them." (1985, 5)

The princess is Gloria Cranmer Webster of the Kwakwa̱ka'wakw, a prominent anthropologist and historian who many years later gave a less poetic version of the same story, in which she makes clear her impatience at such questions, working as she does as a "shaker among many readers" (2013, 165).

Cranmer Webster's story problematizes Northwest Coast objects in the museum space by graphically demonstrating that most were never intended to be static, curated objects of public fascination. It is only by interacting with them as they were designed to be used – by one trained and permitted to do so, such as Cranmer Webster – that the objects can be interpreted effectively, and then, as she notes, linguistic and cultural differences make communicating that interpretation difficult. Without this engagement, and within the alien setting of a museum using only the alien systems of analysis to which non-Indigenous curators have subjected them, Indigenous objects cannot be adequately or appropriately understood.

In common with that of other colonized peoples worldwide, Indigenous North American material culture has frequently been deployed in museums in ways that reinforce non-Indigenous ideas of cultural sophistication at the expense of Indigenous intentions. Often objects are simply fetishized as exotic examples of aesthetic delight. This has lingering and highly problematic effects on how the public views such works, with ramifications across public culture and the arts. In 2017, for example, an article in a leading British antiques magazine condescendingly remarked that "tribal material

is seen as modern art ... finely crafted material with aesthetically pleasing shapes [that] can, when mounted in one's home, become conversation pieces at least the equal of contemporary sculptural pieces" (Ryle 2017, 16). In such an environment, any attempt to understand an object via "reading" would be futile.

The rattles that Cranmer Webster addressed are not simply musical instruments but sacred components of ritual practices unique to specific times, places, and people. As a Kwakwaka'wakw ceremonialist, she was able to acknowledge and appreciate them in this specific context, while her museum colleagues could only attempt to read their aesthetic qualities. Their beauty meant that, like so much else, they had been seized and sent to museums as part of the destruction of Northwest Coast cultural networks during the late-nineteenth and early-twentieth centuries. In the museum space, such objects were disassociated from their original purpose and meaning, conspicuously stripped of their original contexts and inserted into non-Indigenous catalogues explicitly alien to those who had originally produced and used them. Thus it is that such collections were "not made according to a deliberate plan to tell a specific story. Instead the objects came from explorers, missionaries and traders, then circulated in a secondary market that deprived them of any provenance information obtained by their initial collectors" (J.C.H. King 2012, 57). This process, which defines so much of the material available to scholars, is consciously violent. As art historian Bill Holm notes, an object is rarely respected for what it actually is but rather "torn out of context and exhibited, along with its kin, as simply the trappings of an unfamiliar culture" (1986, 133).

There was an assumption among curators of the time that by pinning objects side by side like butterflies in a drawer, it might be possible not only to classify material culture, but to classify entire peoples, and in doing so somehow to preserve less tangible cultural property and traditions before they were lost to the march of assimilation. The museum thus becomes almost inadvertently a monument to, almost in some cases a commemoration of, the attempted genocide that filled it. This is the condition in which, in our own time, researchers, the public, and those descended from the original makers find the Indigenous objects museums claim to own.

The retention, interpretation, and display of Northwest Coast collections in the museum space generates an environment known as a contact zone. A concept first posited by Mary Louise Pratt, a contact zone occurs when there is a clash or collaboration between distinct cultures potentially

struggling with what she calls "asymmetrical relations of power" (1991, 34). The idea has led to an ongoing paradigmatic shift in how museums understand their collaborations with Indigenous communities. While a museum can insist that seeking, codifying, and archiving empirical knowledge adds to museum resources and effectively increases an object's value, Indigenous people generally have a different focus. James Clifford notes in his study of Tlingit museum visitors that for them, "the collected objects are not primarily 'art'" but rather "*aide-mémoires,* occasions for the telling of stories and the singing of songs" (1999, 435–37). Studies show that in encounters between Indigenous community members and museums, the former find that "consultation is often structured to provide outside support for the maintenance of institutional practices, and source community members are wary of contributing to museum-led consultation exercises which do not lead to change within museums or benefits to their people" (Peers and Brown 2003, 2). They are encouraged to "read" to others, not to use their expertise to "shake" the objects for themselves.

This distorted environment also instils a fear of being ridiculed, which creates an imbalance in expression. Haida master carver Robert Davidson once commented, "When I first came to Vancouver, I met an incredible barrage of anthropologists. I regarded them as people who held the knowledge, and so I was afraid to say anything in front of them for fear of saying the wrong thing. I was intimidated" (Harris [1966] 1992, xiii).

The overwhelming majority of miniatures surviving from the earliest periods under examination are housed in museum collections, and any object-based research is thus conducted almost exclusively within the museum space. It takes place according to each museum's rules, for example rarely permitting handling of objects in the originally intended manner, for fear of damage. Cranmer Webster's warning is that under these conditions a museum curator cannot understand the purposes for which the object was made, and even if their institutions did allow them to seize and shake a rattle, the shaking would be meaningless because the person performing it would not be inducted into the associated ceremonies.

This essential contact zone problem, this uncomfortable reality, shrouded my research and surrounds everything that follows, creating the risk of presenting what Douglas Cole called a "white history about Indians and their procurable culture" (1985, xi). To mitigate this risk, I spoke to members of the communities from which these objects came, and asked for their help in understanding miniature objects found in the museum collections. Their

words form the basis of my analysis, and I am not revealing new information so much as sharing their insight into things long known and well understood in their communities. These interviews were conducted in 2015 and 2016 and are distinguished in the text with italics. Christopher Evans (2012, 370) notes in his work on Nepalese miniatures that due to the subtle development and essential localized specificity of miniaturization, its study must inevitably be at least partly anecdotal and discursive, and these interviews were both, while remaining crucial to understanding the objects at hand.

Swinging Clubs

I had not yet heard of Cranmer Webster's story when, as a junior collections assistant at the British Museum in September 2009, I was called to work with a major delegation of Haida people who were visiting the Pitt Rivers Museum's significant historical collections of Haida art, an event extensively documented in the book *This Is Our Life* (Krmpotich and Peers 2013). A professionally trained collection manager but a neophyte in Indigenous North American history and culture in general, and in Haida culture in particular, I was startled on the first morning to see two large, bearded Haida men enter the room, snatch up a pair of 150-year-old fish clubs, and proceed to beat at one another in a playful fashion. In this, they had immediately observed the nature of these objects and reacted naturally and appropriately to "shake" them, even as the museum staff, who hastened to intercede, tried to persuade them to put them down and "read" them instead.

In 1962, Lévi-Strauss used Northwest Coast fish clubs just like those being swung to illustrate that the aesthetic properties of an object are not incorporated merely because, as contemporary Norman Feder put it, "man everywhere seems to enjoy having beautiful things around him" (1971, 8), but because for artists on the Northwest Coast they were integral to the object's function. Lévi-Strauss described a Tlingit fish club, carved to resemble a "sea monster" (actually a seal), and concluded that "everything about this implement – which is also a superb work of art – seems to be a matter of structure: its mythical symbolism as well as its practical function ... seems to be inextricably bound up with each other" (1966, 26). Thus the incorporation of the design of the sea creature into the club, although having no scientifically discernible effect on the utilitarian principles of its production, such as weight, balance, or size, was a vital element of its construction and absolutely required to make it effective. These clubs thus

reflect Alfred Gell's definition of art as "social relations in the vicinity of objects mediating social agency," such that "anything whatsoever could, conceivably, be an art object" (1998, 7–8).

As social agents, objects contain knowledge that is imparted during the process of their creation and use – for the Haida men, swinging the club requires muscle movement and knowledge of technique, as well as an understanding of the purpose of these clubs in fishing. Consequently, aesthetics, movement, and thought can be connected through a single object. Artworks such as the rattles or the clubs are thus performative artifacts in which "art is arrested force, life held in suspension, and though 'paralyzed,' it nevertheless trembles" (Bracken 2002, 343). It was this trembling that led the Haida men to pick up the clubs and swing them.

On that occasion, the men were intercepted by museum staff, the clubs returned to the table, and the party settled down to what the staff, myself included, believed to be the more serious work of the day: sketching, discussing, and explaining the myriad objects laid on tables for the benefit of the strategically positioned graduate students at the edges of the room, poised with pens in hand. Once again, the room resembled a museum space, not an Indigenous one.[1]

That cultural clash, an example of the unequal contact zone environment of heritage exchange in museum spaces, is the scene on which this book opens: the startled experience of a young British man, educated and trained in European museum practice, recoiling from two Indigenous men interacting with Indigenous objects in precisely the way they were meant to be used by their makers. I pursue this idea by considering what happens when the entire idea of shaking an object is turned on its head. I ask what can be done when an object that may *actually have been meant to be read in the first place* appears before a foreign audience, and explore the ways in which such an object, inherently impervious to simplistic analysis and with myriad messages for diverse audiences, can possibly be adequately understood so far from its origin and initial environment.

For among the many objects viewed by the Haida delegation during their time at the British Museum was a selection of canoes. Or perhaps not canoes. I wasn't sure. In the morning I carried these small canoe-shaped objects out of the stores to the viewing rooms, laid them on tables, and watched as the Haida delegates gingerly handled them in their mandatory blue gloves, as they photographed them and, with prompting, talked at length about Haida maritime culture: about fishing and hunting, about trade and war. In the

evening I returned that day's objects to the store and prepared the selection for the following morning. On one evening, as I lowered the not-canoes into their specially made cradles, I was struck with the oddity of the situation. I began to wonder why these canoes could be carried by one person alone, why these canoes – or not-canoes – were so small, for I knew that like the massive example hanging today in the American Museum of History in New York, Haida canoes were supposed to be big.

The question stayed with me far beyond the end of that project. Unlike the fish clubs I had seen so gleefully swung, the not-canoes could not be "shaken." They were far too small to carry a person, to use for hunting or fishing, or to carry out trade or warfare. The literature was dismissive, describing them as simply "toys for their children and later as curios for white traders" (Roberts and Shackleton 1983, 121) or noting that they "were originally intended as toys for children; it was only in the late 18th century that the making of model boats turned into a souvenir craft activity aimed at Europeans" (Berezkin 2007, 39).

I began to think the problem was that these not-canoes existed in an uncomfortable space, without an obvious function; scholars have guessed that they might be toys or souvenirs, or feast dishes, or apprentice pieces, or shipbuilders' models, but no one appeared to have done any research to establish which, if any, of these explanations was accurate. Ultimately all of these potential answers, for various reasons discussed further in this volume, I found unsatisfactory. Not necessarily inaccurate but unquestionably incomplete. I have termed this discomfort *miniature dissonance,* the idea that the miniature object before you is trying to tell you something your mind is reluctant to acknowledge (Davy 2018b).

There is, however, a consensus that canoes, big canoes, are important objects, as Haida master carver Bill Reid once noted: "Western art starts with the figure; West Coast Indian art starts with the canoe" (B. Reid 2011). His observation accords with the geography of the Northwest Coast; in a region where land routes are impassable, canoes enabled communication, trade, subsistence, and warfare, played a central role in religious and ceremonial life, and were both a source of income and a highly prominent status symbol among the most powerful elite families. Truly, as Kenneth Roberts and Phillip Shackleton wrote, "beyond daily utility, the canoe as an idea and a symbol pervaded their entire life" (1983, 123). Alfred Niblack, an early ethnographer of the region, considered that "the canoe is to the northwest coast what the camel is to the desert. It is to the Indian of this region what

the horse is to the Arab. It is the apple of his eye and the object of his solicitous affection" (1888, 294).

It was obvious that these ostensibly functionless not-canoes bore resemblance to objects of real significance, and so presumably must have not only purpose but, I assumed, some measure of the importance attached to the larger canoes. Franz Boas noted that "all the work of the Indian artists of the [Northwest Coast] region ... serves at the same time a useful end" (1927, 183). If this is the case, and I have seen nothing in the years since first reading those words to suggest that it is not, then these miniature canoes must have had a useful end, and I set out to understand what that end might be.

This book therefore explores the practice and contribution of miniaturization among the various Indigenous peoples of the region of North America dubbed the Pacific Northwest. It does so by presenting case studies drawn from four Indigenous societies on the Northwest Coast, each of which explores a different but intimately connected series of communicative interactions through both the miniaturized objects themselves and the processes by which they are conceived, created, and deployed. The intention is to gain a better understanding not just of the mechanics of making such objects, which is where most existing studies end, but also of the circulating networks within which they are distributed. Toward that end, I have attempted to develop a model by which miniature objects, from wherever they originate, may be better understood as communicative devices, and thus to elucidate obscured narratives from the colonial Northwest Coast.

Miniatures have been produced on the Northwest Coast since at least the sixteenth century. They were a common product of material culture during the nineteenth and twentieth centuries in the post-contact period, and artists continue to carve miniatures today. Yet as a type, these ubiquitous objects have never previously been subject to serious analysis, and have often been overlooked in anthropological literature, or worse, dismissed as inauthentic or unrepresentative. By re-examining these objects through a research program that wove together a museum-based study, observational fieldwork, and targeted interviews, I have considered the ways in which miniature objects can reflect and inform intangible human interactions and ideologies.

The People of the Coast

Although my interest in this subject was first piqued by a serendipitous professional encounter, I did not randomly select the Pacific Northwest as

my area of study. The Indigenous communities of this region make a particularly effective environment in which to examine miniaturization as a communicative tool of ideology for four principal reasons.

First, the peoples of the Northwest Coast live in communities that exhibit comparable cultural practices and beliefs, along with significant localized differences, within a well-defined geographic region. This permits consideration of broad regional contiguities in the practice of miniaturization as well as detailed study of local specific practices and consideration of the differences in temporal, social and spatial context which may have caused alterations in these practices between communities and over time.

Second, the history of the region was relatively stable over several millennia but has changed drastically in the 250 years since first contact with Europeans. Study across this period can therefore consider alterations and/or continuities in miniaturization as a practice within specific communities in relation to major social, political, or environmental shifts in the societies in the region.

Third, Northwest Coast peoples have historically produced a significant body of miniaturized material culture that has survived in museum collections and is accessible for study. This body of material has never previously been considered collectively as a research resource because of its historical categorization as so-called tourist art. Typically considered a hybridized form of art production, tourist art is generally criticized as inauthentic and unrealistic, and sometimes dismissed as "ethno-kitsch," resulting in its underutilization as an academic resource (Graburn 1976, 6; see also Poulter 2011).

Paige Raibmon notes that for curators in the nineteenth and early twentieth centuries, "Aboriginal people could not be 'Aboriginal' and 'modern' at the same time. These were mutually exclusive categories" (2005, 201), and tourist art straddled this uncomfortable divide in ways that curatorial and academic scholarship has sometimes found difficult to comprehend. Thus, as Shelly Errington has written, due to this perceived inauthenticity or lack of quality, tourist art has too often been "invisible to normal art-historical scholarship. Or for that matter, anthropological scholarship" (1998, 62). Ruth Phillips also identified this phenomenon, noting that tourist art objects are "walled off, untouchable according to orthodox curatorial and discursive practices. Rarely exhibited or published, excluded from the canon, they have been shrouded in silence" (1995, 100). This erasure and decontextualization of Northwest Coast souvenir art allowed it to be re-dedicated to non-Indigenous purposes, and by extension did the same to Indigenous identity,

which in modern American or European societies has often been incorporated into the mainstream milieu without attribution, acknowledgment, or permission (Townsend-Gault 2004).

Finally, the contemporary inhabitants of these communities exhibit strong contiguities with their forebears in terms of material culture, in particular among those, such as artists, whose role is to maintain traditional practices. As miniaturization continues in the present day as a modified traditional material culture practice, contemporary anthropological fieldwork is a productive avenue of investigation.

It's important to be clear from the start that I will not attempt to uncritically present a picture of miniature use on the Northwest Coast as a unified whole; to do so would risk treating the diverse cultures of the region as homogeneous. Even a cursory examination of the evidence suggests that no single answer could hope to achieve such a result in any case. Neither is this book intended to reveal a theory of miniaturization for which there are no exceptions. Given the inevitable reliance on localized context for understanding, there are bound to be considerable differences in the ways miniatures are conceived in different parts of the world.

Within this framework, I use the phrase *Northwest Coast peoples* to refer to Indigenous communities of the Pacific Coast region with strong, established traditions of wood carving, particularly those with large-scale, highly technical cedar-carving practices such as canoe building. This distinction is not arbitrary, being rooted in the requirement of such peoples to have had sophisticated and coordinated systems of adaptive design, practical technique, and transference of technical knowledge in order to facilitate this profession. In short, it is based on the understanding that among these people, a carver of cedar was a distinct and significant role, invested with skill, training, and intangible specialist knowledge.

With these stipulations in mind, I explore how the peoples of the Northwest Coast have made use of miniaturization as a communicative tool through creative material culture practices rooted in long-standing traditional environments but modified through temporal shocks, and particularly adapted to the circumstances of their colonial situation. I examine the historical and contemporary miniaturization practices of four different Northwest Coast communities: the Makah of the Olympic Peninsula; the Northern peoples, in particular the Haida, who live on the Alaska–British Columbia border; the Kwakwa̱ka̱'wakw of the central coast region; and the Tulalip of northern Puget Sound. Each of these communities has pursued

linked but distinct miniaturization traditions and each continues to do so as a traditional and effective means of education, communication, and cultural expression. This research forms the basis of a consideration of the extent to which miniaturization practices are based in culturally informed, individually determined decision making in relation to specific audiences, and the effects that deployment of this strategy can achieve.

Throughout the volume I use object analysis and selections from interviews with contemporary carvers working in the field to demonstrate clearly, and often in their own words, how Indigenous artists of the region use and have used miniaturization as not only an artistic practice but as a hitherto unexamined program of material communication, resistance, and survival in the face of colonialism, colonization, and revitalization.

1
Practice and Play
The Makah

THE MAKAH PEOPLE CALL themselves qʷidičča?a·tx̌, or People Who Live by the Rocks and Seagulls (Erikson 2002, 9). They live on the forested coastline around Cape Flattery, which juts into the Pacific from the Olympic Peninsula. They are a people forged at the coming together of an important junction of Indigenous trade routes – between the western coast of Washington State, the southwestern shore of Vancouver Island, and the interior waterways of the Salish Sea – and archaeological findings from their lands present the earliest known use of miniatures on the Northwest Coast.

By considering the long heritage of miniature making among the Makah through archaeological evidence, ethnographic histories, and contemporary fieldwork in Neah Bay, Makah miniaturization can be understood within historical trajectories as part of a deliberate process of reinforcing cultural traditions that are essential to an understanding of what it means to be Makah, even when those traditions are themselves in abeyance.

The Ozette Miniatures

Around 1560, more than two hundred years before the arrival of Europeans in Makah waters, a landslide consumed the village of Ozette, burying at least six large longhouses. Lying undisturbed for centuries in anoxic conditions beneath a thick layer of mud were more than 50,000 artifacts in stone, bone, wood, and textile, until a storm exposed part of the site in 1970.

Through decades of dedicated archaeological investigation, Ozette now provides the most complete picture of pre-contact Northwest Coast life ever

discovered. Perhaps most significant was the realization that although the site reveals "approximately 2,000 years of occupation, relatively little change in either artifacts or faunal remains is evident" (Wessen 1990, 420), which is to say that the archaeological evidence suggests the material culture of Makah society at Ozette, and presumably the intangible culture to which it points, had not significantly altered over that time. The Makah of Ozette ate the same foods as their ancestors two millennia distant; they lived, fished, and traded on the same waters; and, with some adjustments, they made the same objects in wood, bone, and stone.

Among the objects collected at Ozette, now housed at the Makah Culture and Research Center at Neah Bay, is a body of material demonstrating that Northwest Coast miniatures are not a modern phenomenon. A wide corpus of miniature objects, including tiny woven hats, diminutive wooden looms, and minuscule whalebone clubs, reveals an active and highly diverse miniaturization culture at work in the Ozette community prior to the White tourist trade (Renker and Gunther 1990, 426).

Among the miniatures of Ozette, the typology that occurs most frequently and is most useful for comparative purposes is the canoe (Figure 1.1). The fifteen miniature canoes or pieces thereof have been so damaged that surface decoration and precise measurements can be hard to discern, but their collective aesthetic characteristics point to a consistency of design and presumably of function.

To study these miniature canoes requires an examination of their physical properties, sometimes termed *affordances* (Gibson 1986, 133–35). They are depictions of the Westcoast style of canoe, often called Nootkan, a vessel type popular throughout the post-contact period among the Salishan, Nuu-chah-nulth, and neighbouring groups of the southern Northwest Coast, and still in use in these regions today. This discovery demonstrated that both this watercraft design and its miniaturization were firmly established by the mid-sixteenth century, and probably much earlier.

Westcoast canoes have their origins among the Nuu-chah-nulth, whose territory stretched along the western coast of Vancouver Island. The design has many variants but maintains certain consistent features. A high, square sternpost and protruding bow, rising above the canoe and over the water ahead, are both carved separately from the hull and attached during a late phase of construction. The bow narrows into three points, in what is frequently interpreted as being carved in the shape of a bird's head. It is

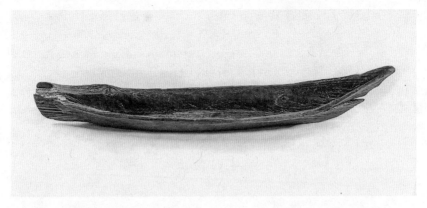

Figure 1.1 Makah canoe miniature found at Ozette, c. 1560. | Reproduced by permission of the Makah Cultural and Resource Center, 93.IV.39

engineered to split the water surface without shipping any water, and has been demonstrated to be effective even in very rough seas (Waterman and Coffin 1920, 15). The length of the vessels varied depending on purpose, with six standard sizes, the smallest at 4.9 metres and the largest at 22.9 to 24.4 metres, although the latter has been demonstrated to be unmanageable in any wind. The Makah were credited historically with being the most accomplished makers of this type of canoe; their vessels were "heavier, roomier, stronger, less cranky and more durable" than other canoe designs on the coast, though not as manoeuvrable or as fast as the Northern-style canoes of the Haida (Niblack 1888, 295).

All the Ozette miniatures are finely made, probably from locally sourced yellow cedar, and have dimensions roughly proportional to those of the full-sized canoes they resemble. Their length ranges from just 10 centimetres to more than 42 centimetres. Perhaps most important, with a single exception, they have each been made in two pieces, with the large hull (including the bow) a separate component from the detachable stern. This construction is similar to both historical and modern full-sized Westcoast canoes but completely unlike any other Indigenous-made miniature canoe from the Northwest Coast observed from the post-contact period in the course of this study, which are all carved entirely from a single piece of wood.

These similarities indicate that the miniatures of Ozette are a material culture phenomenon recognized and understood in that community as holding a defined function requiring certain features of full-sized canoes to

be retained while others were omitted. The lack of contextual information makes it impossible to be certain what this function was, but informed suggestions based on the similarities between miniature and full-sized canoes point perhaps to a practical role as training models used to demonstrate the structure and process of canoe construction to aspiring apprentices, as well as to replicate the hydrodynamics of a full-sized canoe. My interviews with contemporary Makah carvers raise the possibility that miniatures may also have held a ceremonial role:

I don't know what you can say about miniatures besides that there is a lot more to it than just being small. Because when you make a toy bow for your son, because you want him to be a warrior, they'd hold that bow and sing their war songs and power chants and they'd pray. When they make that bow they'd be praying for their son to be safe and to be strong and to be skilled in battle. So even though it's small, he'd put way more spiritual effort into it. | SPENCER MCCARTY

The Ozette miniatures point to a well-developed modelling practice with a clear technical purpose, one that relied on consistency in both construction techniques and distribution of the objects to defined audiences from within the Makah community, in whose ruined houses they were discovered. The collection is unique on the Northwest Coast; not only are there no other so well preserved archaeological finds of the pre-contact period from which to develop comparative analysis, but there are no other miniatures definitely known to pre-date European contact in 1774. Ethnographic examples from the post-contact period demonstrate, however, that miniaturization as a practice among the Makah later changed substantially to focus almost exclusively on much more stylized depictions of canoes, and canoes alone.

By the time Makah miniaturization again appeared in the object record, several decades after European contact, it had altered in significant ways. To understand why this occurred and what these new mimetic practices might indicate, it is necessary to consider how life changed for Makah society during this period.

Makah Society

Central to Makah society is a strong group identity and pride, along with a deep desire to perpetuate the culture as much as possible. Contemporary

Makah people take inspiration from a history of intratribal unity, in which the five distinct Makah communities existing at first contact acted in accordance with one another and refrained from conflict or slave taking within the group. This understanding is known to the Makah as "five villages, one heartbeart" (Goodman and Swan 2003, 41; Tweedie 2003, 27). Solidarity and continuity, and threats to these values brought by contact, provide the context within which post-contact miniaturization has occurred in Makah society.

Makah are also closely connected to neighbouring groups; their language is related to the Ditidaht Nuu-chah-nulth language of southern Vancouver Island (Renker and Gunther 1990, 422), and so similar are many aspects of these cultures that numerous surveys conflate the two. Eugene Arima writes that "only the [US–Canada] international boundary divides them into the separate entities," and many of their cultural and material practices are similarly linked (Arima 1983, 82; Black 1999; Coté 2010; Durham 1960).

First contact between Makah and Europeans came with the 1788 expedition of Irish navigator John Meares. Neah Bay, already a focal point of Indigenous trade, rapidly fulfilled the same role for the Europeans who followed, such that Makah people early became intermediaries between Indigenous and European traders (Taylor 1974, 68). Already known for high-quality canoe building, the Makah economy adapted quickly to European contact, but Makah communities suffered severely from disease, particularly smallpox. Epidemics were regular and increasingly devastating; historian Charlotte Coté writes that after an outbreak in 1852, "the beach ... was literally strewn with the dead bodies" (2010, 49). Of the five communities, only Neah Bay survived this population collapse, and Coté goes on to note that the loss almost broke the chains of oral history on which the Makah relied for generational transmission of knowledge:

> Many of these [now dead] people were the bearers of the knowledge, the people whose position in the society was to pass down names, songs, and dances their families held and owned, as well as knowledge of ceremonies, rituals and traditions. Because many of these knowledge-bearers died during the early contact period, the chain of transmission was broken. If many people within one familial line died, then this family-owned knowledge was lost.

To compound the disaster, the epidemics were followed by official sanction: in 1855 a treaty formalized the Makah Reservation, establishing US

government control over Makah affairs, and in 1863 a residential school was established to forcibly acculturate Makah children (Renker and Gunther 1990, 422). Many were later sent to boarding schools farther afield, including Tulalip and Tacoma, a program designed to accelerate the reduction in speakers of the Makah language, as Mary Lou Denney described in 1995:

> We used to ask our parents, how come we never got to learn Makah? Their reply was that when they were growing up, they were not allowed to speak their own language ... My father ... he was speaking Makah to another one of the boys that were in the same barracks ... and when he was caught, they took him outside and it was raining. The weather was very bad and they put him in a harness and they had to walk around just like animals ... So him and my mom decided they wouldn't allow us to go through that kind of treatment and that we would learn the English. (In Erikson 2002, 78)

During this period, the most lucrative trade on the reservation was seal hunting; by the 1880s Makah hunters had become so successful that many owned their own vessels (Collins 1996; Erikson 2002, 83). The increased volume of hunting reduced seal numbers to critical levels, and after a treaty in 1894 outlawed the trade the sealing industry collapsed (Renker and Gunther 1990, 428). Numerous other laws restricting Makah cultural practices were brought in at this time, enforced by reservation agents and police but regularly flouted (Coté 2010, 52–57). Resistance was inventive; Makah disguised forbidden giveaway celebrations as Christmas parties, or moved their activities away from Neah Bay to Tatoosh Island, off Cape Flattery, where government inspectors were unlikely to catch them (Colson 1953, 17; Erikson 2002, 89). Historian Joshua Reid summarizes this time by remarking that "basically, Makahs had a good life until Euro-Americans ruined everything" (2015, 276).

The Centrality of Whaling

No loss during this period was more significant to Makah society than the collapse of whale hunting. Makah communities and near neighbours were unique on the Northwest Coast in the extent to which whaling occupied a prominent position. Although scavenging whale carcasses is a common historical practice throughout the region, only these ocean-going tribes,

with access to seasonal migration routes, actively hunted whales from their canoes. Archaeological evidence demonstrates that whale hunting dates as far back as 4000 BP, and that whale accounted for as much as 75 percent of the meat intake of the inhabitants of Ozette (Aradanas 1998; Huelsbeck 1988; Losey and Yang 2007; Monks, McMillan, and St. Claire 2001).

The captaincy of a whaling canoe was the preserve of Makah elite. Taking place between the spring and early autumn to match the migratory patterns of the California grey whale, whaling required physical and mental purification. The whaler prepared by practising abstinence, constructing whaling shrines, and performing tests of endurance designed to demonstrate his fitness to lead the hunt. As Martha Black notes, "a person was closest to the Creator when he was whaling. Whalers did serious preparation, months of preparation, in their personal, sacred places before they went out to hunt" (1999, 32; see also Arima 1983, 40–41; Arima and Dewhirst 1990, 395; Waterman and Coffin 1920, 39). At giveaways and feasts the whole community engaged in ceremonies designed to attract whales to Makah waters, and while a hunt was in progress the entire village would talk in whispers to avoid scaring the whales off (Renker and Gunther 1990, 423). Spiritual preparedness was compounded by the physical requirements of hunting such a huge and dangerous creature, as Makah carver Greg Colfax recounts about his whaling great-uncle:

William Bennett was a powerful man; his strength was unbelievable. Those big 50 pound anvils, with the bull nose on the back, the pointed nose? He could take that pointed nose, tip it up, and grip it so hard he could lift it straight up off the ground. But if you look at that picture, there's the whale, there's the rope, and there's his hand. And then his hand is holding on and he's bracing the canoe. So all the weight of that canoe, all those men, what's that 1,800 pounds? 2,000 pounds? A ton? It's going through his hand, you know.

Northwest Coast whaling technology reached its apogee among Makah communities. Canoes were specifically designed for whale hunts, built with bows that stretched forward through the waves rather than attempting to bludgeon through them. Large harpoons and lances were used, the harpooner trained to strike exactly the right spot under the whale's left fluke. Once the harpoon was attached, each member of the crew had a part to play in unspooling the line, deploying floats in order to maintain contact but keep the vessel out of danger. When the whale was finally dead, its

mouth had to be sewn up to prevent the carcass sinking before it was dragged back to shore and butchered on the beach (Arima and Dewhirst 1990, 395; Kirk 1974, 44–50). This level of coordination and skill was the product of generations of praxis and years of training and operation as a cohesive crew, but despite the massive investment whaling was a relatively low-return activity. The best whalers could take one whale a year in their prime, and that single catch might be preceded by more than fifty days at sea and many failed hunts (Drucker 1966, 23).

Whaling, as befitted such a high-status institution, became integrated into Makah and the Nuu-chah-nulth ceremonial and spiritual life. Whale products were a vital component of Makah gifts and ceremonies, and the symbolism of whaling spread to other events (Coté 2010, 67); in a metaphorical flourish, wedding ceremonies were designed to re-create the sequence of events in a whale hunt, extending to the throwing of harpoons by the gathered congregation (Koppert 1930, 50). Thunderbird, the mountain-sized whale-hunting eagle of Northwest Coast cosmology, is said to have held great influence over whalers as the originator of the practice and technology of harpooning, and whaling origin stories are central to much of Makah identity and culture (Coté 2010, 15–30), as Greg Colfax illustrates:

So there was this story about how the whale-hunting stuff came to this particular village. And it started with two chiefs battling it out with one another with food. One chief, he put together a hair seal party with fifty hair seals and he invited his contest [rival chief] over and the guy says, the chief says, "I can beat that," and he turned around and invited that chief over to him and he had a hundred hair seals. The other chief says, "I'll never be able to beat that, I can't beat that," and so in typical Nuu-chah-nulth fashion, he takes off for the woods and he goes to pray. And he found a place to pray in a cave under a lake. That's where he prayed. And he was there for a long, long, long time. And then in one of his moments a tiny little whale swam by and he knew that it was for him and he grabbed it.

And from that moment of grabbing it, he began to learn in his mind, through that action, how to hunt whales. Over the next month, the months that happened, dreams came to him, and visions, of how to put all the equipment together. And so the end of the story is: yes, he does hunt whales, he did beat the guy. But the guy was jealous, followed him to where he was praying. Saw what he was doing and as he came out, he killed him. But before he

killed him he got how he did it, then he killed him, then he took over and then he started to capture whales. The man who died had a son, who got revenge on that guy, and found out from him the magic of that place. After he learned of that, he killed him and then the son rightfully took his place. So that's how whaling got started.[1]

In the 1920s, with Makah traditional practices forced into secrecy or abeyance and the grey whale population falling alarmingly due to offshore commercial whaling, the Makah were compelled to cease hunting them, engendering considerable resentment toward Whites, who were said to have "swept the whale from the seas" (Colson 1953, 123). It is in this context of cultural dislocation and suppression that the most extensive period of Makah miniaturization took place.

Nineteenth-Century Miniaturization

From the mid-nineteenth century, Makah communities and their Nuu-chah-nulth neighbours began to produce high-quality miniature canoes with elaborate hull patterning in red, black, and unpainted areas (Black 1999, 28, 114–15). Although miniaturization had no doubt continued in some form in the intervening time, these miniature canoes are the first known in the Makah historical record since the Ozette examples were buried some three hundred years earlier. The nineteenth-century miniatures were still in the Westcoast style, but the stern was now an integral part of the hull structure rather than a separate component, as it was on the Ozette miniatures and has always been on full-sized sea-going canoes.

The decoration on the canoe miniatures of this later generation, such as the miniature canoe registered as 6600 at the Royal British Columbia Museum, perhaps reflects ceremonial or cosmological practice. It features a wavy line on the interior gunwale, which has been interpreted as a lightning serpent, a cosmological creature proficient in whale hunting. This and similar examples from the second half of the nineteenth century are distinctively of the Westcoast canoe design, but similarities to the full-sized canoe are minimized in favour of an emphasis on imaginative external design. Significantly, the proportions are no longer close to those of the full-sized canoes, and the patterning does not match any known full-sized Makah canoes recorded in drawings, photographs, or descriptions from the period.

These miniatures were, it is clear, constructed to achieve an impact on an audience. Twentieth-century evidence suggests that some miniature canoes were made for use by Makah children as part of an educational process. Training for whaling crew positions began at a young age, for example, such that journalist Robert Sullivan, reporting on a whale hunt in 1999, remarked, "Each of the Makah crewmen has been training since youth, when he raced around in a miniature canoe, and threw toy harpoons on the beach" (2001, 47). Playing imaginative games is a noted feature of traditional Makah childhoods; elder Helma Swan recalled in her memoir making fishbone horses and kelp cars and playing hide-and-seek among the small canoes made for children (Goodman and Swan 2003, 64).

Beyond the Makah communities in which they were made, however, these elaborate miniatures also seem to have had an external audience, and in consequence they were not inspired solely by Indigenous practices. Some canoe miniatures were commissioned directly from artists and carvers in Neah Bay by non-Indigenous people. One collection of miniature canoes was acquired by James G. Swan, who wrote the first ethnography of the Makah and undertook to provide a substantial body of material for the Centennial International Exposition held in Philadelphia in 1876. Swan sought to procure representative examples, and became one of the first anthropologists to commission miniature canoes from Makah carvers in the late nineteenth century (Cole 1985, 13–34).

What Swan received was not exactly what he had requested, although there is no indication that he complained about this discrepancy or even that he noticed it. It is likely that the miniature dissonance of the objects he received obfuscated his understanding of what they actually depicted. Examples from this collection, now held at the National Museum of Natural History in Washington, DC (E23305-0 and E23306-0) and at the Museum Volkenkunde in Leiden (MV 1225-6), demonstrate obviously exaggerated and extended bow and stern sections, presumably elaborated to make their painted designs more eye catching. The designs bear comparison to a Nuu-chah-nulth formline, which emphasizes simple, flowing geometric patterns rather than the more figurative formline of the northern coast, and appear to be highly stylized depictions of whale hunts in progress.

These canoes do not have the blackened hulls of everyday Makah working vessels, presumably what Swan originally attempted to acquire as representative models. They are instead artistic reinterpretations of Makah stories,

prominently featuring whale designs. By figuring or embodying an aspect of culture, they stand in for the whole culture, a concept sometimes termed *synecdoche* (Gell 1998, 161). Thus these commissioned canoe miniatures intended for a wide audience at a major public exposition can be recognized not as Swan's models depicting a quaint and dying Indigenous maritime culture but as Indigenous expressions of collective identity, deliberately supplied to represent the Makah themselves.

The designs do not resemble Makah masks and ceremonial regalia. Instead these decorations are stories, recollections of events and ideas associated with the canoes. Whales and whaling scenes recur in Makah art well into the twentieth century, such as on 2013-190/2 at the Burke Museum of Natural History, on which the hull decoration features formline depictions of the flukes of a surfacing whale. The fact that this miniature was produced in 1926, just after the Makah had ceased whaling for the first time, suggests that it acts as a poignant embodiment of loss and a preservation of fading history, rather than a simple depiction of a canoe.

The Makah preoccupation with whaling is thus imaginatively reflected in the miniature record even as the practice itself receded This interpretation is strengthened by the existence of miniatures on which depictions of whaling are expressed with a form of realism; the canoe miniature numbered E73740-0 at the National Museum of Natural History is a good example. Although it is likely its proportions were determined by eye rather than through systematic measurement, they approach those of a full-sized canoe, and the design features articulated miniature crewmen performing the actions with which a whale hunt culminates. Rather than representing a type of object or an imaginative concept, it is a diorama that depicts a particular moment; that moment was probably of scholarly interest to Swan, who collected it, but also, and more significantly, of great cultural importance to the carver responsible. It is the most important moment in a Makah man's life, the day he takes a whale. Greg Colfax notes the communal pride in this activity and the depth of significance such scenes imply:

Well, you know, I'm not sure that the man who carved [the miniature] was himself a whale hunter. The interest in hunting whales went to everybody. Everybody was interested in how these guys did it. No matter where that whaling canoe went with their equipment in it, there were always guys looking at it, wishing they could go.

The figures in the diorama are archetypes of the whaling crews, men respected and venerated in Makah society; their dramatic poses and disproportionate size in relation to everything else in the scene an indication of that respect. In many designs the figures are even larger, especially when compared to the whale figures that sometimes accompany them, which are relatively puny. These tableaux, although ostensibly naturalistic, show whalers as heroic figures, giant men in pursuit of their dangerous quarry, and as the bearers of the generations of tradition they continue.

Commercial Imperatives

During the late nineteenth and early twentieth centuries, a substantial number of Makah canoe miniatures emerged as part of a burgeoning tourist market. Particularly strong links between a cadre of Makah carvers and Seattle's Ye Olde Curiosity Shop emphasize the commercial incentive. As portable representations of a large and impressive material culture that many saw as symbolic of the region, miniatures became a souvenir staple. These objects, predominantly canoes, often featured consciously fantastical design elements, intended to make them stand out on a crowded shop floor. While some possessed the quality of the pieces commissioned by Swan, others were much cruder, with proportions more grossly exaggerated and decoration applied in non-traditional styles and designs. Though completed in haste for an indifferent audience unable to determine the difference, even these must nonetheless have required knowledge of and skill in Makah canoe carving practices.

The most spectacular miniature canoe of this type, of very high quality and at 413 centimetres from bow to stern certainly the largest from the whole Northwest Coast, was produced in Neah Bay around the turn of the twentieth century by carver and healer Young Doctor (Figure 1.2). This work is exceptional in that Young Doctor appears to have made a concerted effort to replicate accurate proportions and decoration. The bow and stern appear in proportion to the body of the vessel and to its crew, who are seated in the manner of those in a whaling crew, in three pairs of two. All the figures wear bearskin clothing, and the paddlers have woven cedar rain hats. Larger than their compatriots are the harpooner in the bow and the steersman in the stern, each holding his equipment at the ready. The naturalistic scene is to an extent an illusion – the torsos of the crew members, who have no lower half, sit on woven cedar mats laid in the bottom of the vessel – but

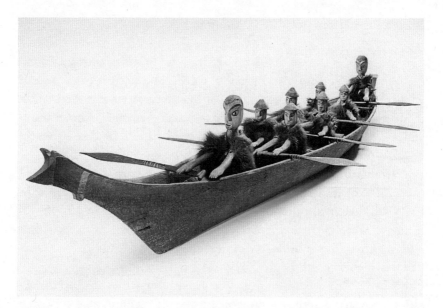

Figure 1.2 Makah canoe miniature by Young Doctor, c. 1904. | Reproduced by permission of the National Museum of the American Indian, 068874

it is one of the most significant attempts by any carver on the coast to reproduce an accurately scaled model.

Young Doctor had a reputation for quality commercial artwork and a strong relationship with Joseph E. Standley of Ye Olde Curiosity Shop, who in turn sold a number of his pieces to the collector George Heye (Duncan 2000, 90–91). This particular piece, however, was acquired by the prolific collector D.F. Tozier of the US Revenue Service at some point before 1907 and subsequently sold to Heye, who seems to have considered it of greater significance than the "tourist art" he otherwise so disdained (Lenz 2004). In either case, the canoe miniature entered Heye's New York museum and now is part of the Smithsonian's National Museum of the American Indian.

The work of Young Doctor and his contemporaries capably illustrates the competing priorities and audiences of Makah carvers at this time of great threat to traditional material culture practices and a prized way of life. Their carvings were commercial in construction, and the income they generated essential to the survival of their families, but the canoe miniatures also bore significance as self-referential representatives of Makah culture entering wider American society, especially that of important collectors and government officials.

Makah Reassertion of Cultural Autonomy

The consumers of these canoe miniatures were initially non-Indigenous, unknowledgeable customers of tourist shops and collectors who operated with similarly limited understanding of Makah history and society, but it is possible that these were also designed to reach other, more knowledgeable audiences, not yet born when the objects were made – the descendants of the carvers and whalers themselves.

After the Indian Reorganization Act of 1934, direct US government supervision of Indigenous people was gradually withdrawn and from the 1960s, language and cultural programs sought to preserve the Makah way of life by teaching it to younger generations, a movement that engaged strongly with the excavations at Ozette and led to the opening of the Makah Cultural and Research Center, or MCRC, in 1979. Although anthropologist Herbert Taylor pessimistically predicted in 1974 that the Makah language and culture would die out because of rapid acculturation, the centre remains the focal point for the study and preservation of Makah history and improved transport links have enabled the Makah to establish a successful tourist industry (Renker and Gunther 1990, 429; Taylor 1974, 78).

On the strength of this resurgence, the Makah sought to re-establish dormant forms of cultural experience. In the late twentieth century, following a recovery of the whale population, the Makah communities applied for a hunting permit to restore a traditional activity and the cultural self-determination it represented. In 1997, the tribe was granted a quota of twenty whales, to be taken over five years (Coté 2010, 135). Despite external opposition, a whale was taken in 1999, a seminal moment for Makah cultural resurgence that is commemorated by its skeleton now hanging in the MCRC (Coté 2010, 129–43; Sullivan 2001). Paige Raibmon has described this process as "producing cultural meaning, of making past and present speak to one another, of using old things that resonate with new needs" (2005, 206), or as Joshua Reid puts it, the hunt involved the Makah "articulating a traditional future instead of grasping at a long-lost, static past" (2015, 277).

Cultural expression and continuity are major factors in contemporary Makah art, but they are not the only drivers. From the response to Swan's collecting activities to Young Doctor's entrepreneurial initiative, Makah carvers have long sold their work, including miniatures, as a way to survive when traditional careers were closed off. Non-Indigenous curators such as George Heye have sometimes considered the commercial impulse to produce

art for "tourists," outsiders, to be an inauthentic development. To Makah people themselves, however, it is an endemic and uncontroversial phenomenon. Asked about the commercial aspect of historical carving, Greg Colfax was explicit: "Without a doubt, without a doubt. Some of it very commercial, you know, some of it to pay bills." Taking pride in the self-sufficiency commercial art can bring, he added, "I raised three children on my carving, was able to provide my wife and I with a way to survive. That's how I did it."

The imperatives of the commercial marketplace are also crucial to an artist's development, as Makah artist Melissa Peterson-Renault explains:

As an artist, I raised my family on what I made, so I always had to make things to sell to the museum quite a bit ... You almost have to make money on your art to get really good at it actually, to have the time to put into it in order to get good.

Nuu-chah-nulth carver Art Thompson expanded on this idea in a 2010 interview, acknowledging a principle he had been taught at an early age: "If you don't want to do anything else with your hands, do your art, because that's what is going to tell people that we haven't died, and prove that they're not going to be able to kill us. As long as you are alive and doing your arts, people will know that we're not going away" (Coté 2010, 111). For Thompson art production is not solely about making money or developing skills but about an indirectly confrontational mode of cultural resilience (Blackman and Hall 1986). In this art movement, of which miniatures are a substantial part, the objects created both reflect and develop culture (Gell 1998).

Cultural Continuity and the Makah

Although some anthropologists have inaccurately asserted, as Mark Fleischer does, that "the Makah today, do not have access to their traditional culture or language; these disappeared during their acculturation" (1984, 412), it was and remains an essential and ongoing Makah practice to transmit skills, techniques, and designs, whether mechanical or cosmological, to younger generations, a truth noted by anthropologist Elizabeth Colson seventy years ago:

> Among the Makah there exists a body of traditional knowledge held by people who lived at a time when many of the customs were still current.

> Certain skills now long since passed into disuse for all practical purposes were acquired by older men and women when they were children and youths. They no longer practice these skills or carry out the activities learned, which still form part of their culture in the sense that they at least think of themselves as capable of carrying out the customs, and they are still interested in talking about them and in describing them to all who will listen. (Colson 1953, 174)

In the 1990s, elder Helma Swan was so concerned about the risk of Makah losing their cultural traditions that she engaged in a major project to document the knowledge she had been granted for future generations, continuing the process until her death in 2002 (Goodman and Swan 2003). Much of the traditional education she describes was practical, children learning though observation and practice rather than formal education. In part this involved familiarizing children with the roles expected of them in adulthood, a system strengthened by the designation of particular roles, such as in whaling, for which positions were treated as intangible hereditary property. The right to a place in a whaling canoe was hereditary, conferred through the generations by birthright as much as by merit, as Greg Colfax notes:

Your position in the canoe was determined by your father. If your father was a harpooner, you were a harpooner; if you were behind him, you inherited your spot. It didn't change. So in any one whaling canoe, you had ten, fifteen, twenty generations of knowledge in each position, and that was the only way to accomplish it. It was that dangerous.

These "generations of knowledge" were not, however, biologically conferred. The skills and expertise required for each position had to be learned, and the bodily attributes acquired. Self-evidently, not all of this process could be undertaken at sea, in the dangerous environment of a whale hunt. Instead many skills were conferred through a combination of instruction and play, utilizing miniatures to familiarize Makah children with the shape of a whale-hunting canoe and the composition of its crew, and simultaneously binding the children together through their shared experience of culturally specific knowledge. This process did not end when whale hunting did but continued uninterrupted, preserving much of the knowledge embedded in the use of miniatures as theoretical potential.

Miniature canoes can thus be considered as educational tools, not only recognized as toys but also defined as socially useful forms of interaction (Sutton-Smith 1986, 119). Spencer McCarty explains that their significance to the development of Makah children is explicitly understood:

And in the beginning of whaling there was a story about a man that seen Thunderbird, and he went to Thunderbird's house and Thunderbird had a small canoe, maybe this big, and it had all the ropes and lines and harpoons and paddles in there that [the man] would need. And he gave it to that man and flew him home and set it on the beach in front of his house and in the morning it was big. So they would have a small little canoe to tell that story with. And then I have a canoe – it's about this long – that was my toy when I was a baby, and it has all the harpoons and stuff in there because my grandfather wanted me to be a whale hunter. Even though at the time we weren't whale hunting, he still passed the teachings down.

Miniature making and distribution within Makah society was and is, therefore, a conscious aspect of an intergenerational educational culture in which these objects acted as vehicles of communication, passing ideological information from elder to youth and encouraging play that would teach the techniques and teamwork necessary for complex operations such as whale hunting. In this capacity, each miniaturization builds on the ones before, such that a miniature becomes, as Alfred Gell described, "an object which we are able to trace as a movement of thought, a movement of memory reaching down into the past and a movement of aspiration, probing towards an unrealized and perhaps unrealizable futurity" (1998, 258). Yet as agents in a cross-generational educational program, miniatures had a role to play that was not oriented solely inward. As Young Doctor demonstrated, it could travel outward as well.

Analyzing Makah Miniatures

To understand how miniature canoes operated in Makah society, it is crucial to engage with the canoe as an icon, or representation. As an almost exclusively maritime people, Makah communities considered canoes exceptionally important and Makah and Nuu-chah-nulth whaling-canoe makers were noted for their skill; in his study of these watercraft, Bill Durham wrote, "The care and ceremony lavished on war and ceremonial canoes in the north

was matched by Nootkan attention to whaling craft ... Superb canoe craftsmanship and skill at sea could be, for the Nootkans, worthy ends in themselves" (1960, 50).

The availability of plank-built boats caused canoe production to drop off in the early twentieth century, and by the early 1950s abandoned canoes littered the beaches of the Makah Reservation. A fire at the Neah Bay fishing dock in 1955 consumed the last working canoes of the Makah, and for nearly forty years only a handful of racing canoes survived. The 1989 Paddle to Seattle, when fifteen Indigenous nations took part in a traditional tribal canoe journey as part of the hundredth anniversary of Washington statehood, re-enthused Makah canoe builders. By 1993, when the Paddle to Bella Bella launched the long-distance canoe journey as an annual event, the Makah had their own vessel and crew. Paddling the *Hummingbird* for nearly 550 kilometres was a rite of passage that led directly to the 1999 whale hunt (Sullivan 2001, 52–55).

Historical Makah canoes were not extensively decorated: surviving examples, reproductions, and historical photographs most commonly suggest a uniformly black painted exterior, often with red stripes at the bow and a red interior. Although not as dramatic as the crest designs on Northern-style canoes, these simple painted designs are part of an identifying code accessible to knowledgeable observers, as Makah carver Alex McCarty elaborates:

That makes me think about this piece I found at the Burke [Museum]. It was a model canoe and on each side of it, it said "Made by the Neah Bay Indians" inside of the canoe. And I thought for a second and I was like, how can it have been made by the Makah Indians, the Neah Bay Indians? Did they all get together and make this little model canoe? No. It's a particular canoe, it has a particular design from a particular family, and so I have studied these pieces and I know just from the model canoes that are at the Burke, there are at least two different family styles that I have been able to follow. And so I hope that when people would see this, they would say, "Oh, this is, you know, this particular style of canoe that you can trace through my Wyatch family." Me and my cousin Aaron Parker and then my grandfather Jerry McCarty and then you could tell that our canoes are the same. We paint the same designs on the side of the piece.

By considering depictions of canoes in other media as well, in particular in woven cloth, it is possible to see how they represented the Makah people.

Weaving designs have a standard pattern, equally observable among the Nuu-chah-nulth to the north. In a significant departure from carved examples, in woven pieces the crew of the canoe always takes the form of a thin silhouette with indistinguishable figures. Basketry represents the canoe as a distant and tiny object, adrift in an ocean often populated by huge and dangerous animals.[2] Animals and watercraft were pivotal in Makah understanding of their own society and identity. Whether miniature, full-sized, or depicted on baskets, canoes are powerful symbols of Makah identity, markers of the most ready form of livelihood, sustenance, and status. Alex McCarty also suggests that Makah canoe decoration indicated both communal identity and the continuity of individual familial lineages.

The greatest significance of Makah miniature canoes thus lies in what they reveal about communication practices. Consider scale: it is important that the dimensions of contemporary miniatures *look* right, but precise scaling is not a priority. McCarty acknowledges that the process in his work has "been by eye ... I hadn't thought about scaling." Thus the dimensions of even the more naturalistic Makah miniatures are out of proportion. The bow and stern are too large, the central body of the canoe truncated. McCarty observes this in a study of a miniature canoes he had produced, noting that the prow and stern are "definitely exaggerated."

These miniatures are therefore certainly not technical models in the European sense. They preserve the broad shape of large-scale Makah canoes without employing the associated boat-building techniques. They do not, in summary, represent, maintain, or illustrate the skills and knowledge of Makah boat building, but this does not imply that they are unrepresentative of Makah carving technology, or without practical application.

Miniatures as Practice

In his two decades studying and producing Makah art, carver Alex McCarty has noticed a feature of miniature canoes that may speak to an obscured priority: they are an essential component of the canoe-carving apprenticeship. It's clear that they are not blueprints for canoe construction; instead, through repetitive practice, carvers learn the act of carving itself. Northwest Coast woodcarving consists of a system of standardized cuts made using standard tools; once technically proficient, each carver is at liberty to make minor adjustments to the tools in order to create a personal style. Having spent more than a decade producing miniatures, McCarty believes that all

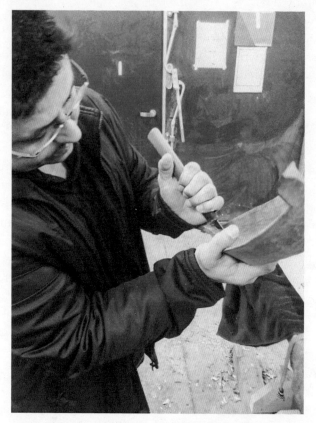

Figure 1.3 Alex McCarty demonstrating carving techniques on a miniature canoe, Evergreen State College, Washington, 2015.

the actions required in carving a full-sized canoe are represented in producing a miniature. During an interview he demonstrated the range of cuts, including straight slices to form the interior of the bow segment and curved grazes to give the hull its graceful, bird-like profile (Figure 1.3).

Miniature canoes therefore operate as learning devices not only with respect to canoe design but for all Makah carving. Their rise within the corpus of Makah material culture in the nineteenth and early twentieth century directly correlates with an abeyance in other carving outputs, as restrictions and economic deterioration blocked the construction of ceremonial or practical artifacts. Makah carving itself survived as a broad practice in significant part because of the physical presence and technical praxis of the miniature canoes of Young Doctor and his contemporaries.

Spencer McCarty acknowledged that early in his career he "made miniatures for probably four years, little masks, little canoes, little totem poles," partly to sell but also because "if I learn how to make it small then I'll have learned how to make everything." Makah miniatures therefore play an active role in artistic development and apprenticeship in creative technique, operating as educational tools that can also be sold, so that "in the meantime my name will get out there and my art will get out there and people will say, 'Hey, this guy is pretty good at carving.'" Moreover, if the carver is not skilled enough to complete the carving – "if I wreck it and have to throw it away" – the loss of the investment of time and effort on a miniature will be less severe than on a larger object.

This may imply that that shape of the miniature is irrelevant: the carver could just make practice cuts into a block rather than creating a miniature canoe, but whether a practice piece or not, Makah carvers learning their trade follow a tradition in whatever they make. Thus making a miniature is a practical training process in which the object produced is a by-product, a representation of a larger object, whose value lies in the skills development required for its production rather than in scaling. Moreover, once the miniature canoe is finished, it can, like those of Young Doctor or the carvers who worked for Swan, be distributed to audiences who know little about the Makah but will treasure and preserve it, creating an archive of Makah design and technique that will outlive the generations who made it, ready to be found intact and explored by new generations of carvers unborn when the miniatures were created.

Alex McCarty is one such explorer, and has spent years travelling the world to view, measure, and test Makah miniature canoes in museum collections. His contribution to the field illustrates that the miniatures studied in the current work operate on multiple levels for multiple audiences: the process of making them trains the carver; the objects produced provide a local Makah audience with educational support for training in traditional hunting methods; and through shape, scale, and design they contain an ideology that communicates what it means to be Makah, an understanding that can be kept safe through times of hardship.

Canoes That Float

To understand how a miniature, particularly a miniature canoe, operates within these multiple paradigms, some of their peculiar properties must be

examined. Within the design process, the carver incorporates some elements of large-scale canoes and ignores others as required for the effect they are intended to provoke. For the Makah one aspect in particular has specific importance, a feature identified by Alex McCarty – they float. In fact, they float true: "Every one of my little models that I make, I make sure that they float proud, that they have a nice presence in the water, and then when you push them they take off and they float straight." Every Makah miniature canoe is designed in this way; indeed, when McCarty was training he was taught, "If you're gonna make a model canoe, it has to float; otherwise, carve something else." He believes this is also true of the miniatures in museum collections, and has the ambition to test the idea, although he acknowledges, "I don't know if they would go for that."

The floating of Makah canoe miniatures is a form of skeuomorphism.[3] Their makers replicate design elements from other objects for aesthetic reasons to provoke a reaction from an audience, using "skilful imitation to bend reality," so that the tiny canoe both resembles its full-sized complement and simultaneously refers to intangible elements of an entire network of social relations that the larger object evokes, such as the history and resilience of Makah traditional culture, without necessarily being directly connected to either one (Knappett 2002, 108–11). Even though the function and mechanical activity of miniature canoes do not require them to float in the same way, or for the same reasons, as their full-scale counterparts, this property is incorporated into their design in order to make them reminiscent of the larger vessels.

Floating seems to be so important to Makah miniature canoes that other features become secondary. For example, in keeping with many other such objects produced as souvenirs, Makah commercial miniatures usually have flat bottoms to facilitate their display on surfaces in the home, but even these are designed to float true, with extra thickness at the base giving them ballast to remain upright. They are proudly acknowledged to have made significant journeys for their small size: Spencer McCarty recalled that his son's miniature canoe "went down the creek and to the ocean and never come back." Alex McCarty recounted a story his cousin, the carver Aaron Parker, had told him:

He sold one of his model canoes to a family on the East Coast, and he said they lived on a flood plain and so one season their house got flooded. They had to evacuate and the whole bottom floor of the two-storey house was flooded

almost all the way up to the ceiling. But not quite; you could see the water line. And so everything was destroyed in the house, except for his canoe. He said his canoe floated proud; he said all the hunting gear was still in it. It floated around the house and it landed in the centre of the kitchen. And it was completely intact. Perfect.

The constancy of canoes in Makah iconography, ritual practice, and everyday life grants them status as representatives of Makah identity. Makah artists draw on this status in order to preserve knowledge and to symbolically represent their culture to the wider world in a durable and safe format, unlikely to be targeted by police or Indian Agents. The ability of the miniatures to float – to act as a metaphor by physically performing the act for which their prototypes are famed to enable the preservation and communication of ideas – and to do so in alien environments before non-Makah audiences is a unique affordance, and one that reveals the culturally representative qualities they contain.

Miniatures as Communicative Actors

Makah miniaturization is a historical technique that is linked to contemporary production through cultural continuity, a textbook example of Alfred Gell's consideration of the single, distributed object recapitulating processes of cognition. The Ozette miniatures form the foundation of the study of this material culture tradition, revealing miniaturization to be a substantial pre-contact practice. The subsequent ethnographic record makes clear that although the process has altered significantly over time, the production of miniatures has continued, transculturally modified, but intact. In the 1880s, for example, Swan had no difficulty finding willing and skilled carvers to produce the miniatures he required for the Centennial International Exposition. Makah miniature production subsequently formed a substantial body of work in the souvenir art period of the early twentieth century, and it remains a common activity into the twenty-first century.

To place this continuing production within Makah tradition, it's necessary to trace elements of Makah society, history, and environment that have been intertwined with the process. Contact history records trading successes followed by demographic collapse, government oppression, and social dislocation, including the cessation of the socially vital practice of whaling. This period was followed by the slow reconstruction of traditional practices

in the context of modern American society. In more recent years, the discovery of Ozette, the opening of the MCRC, and the 1999 whale hunt have successively sharpened the appetite for cultural restitution (Tweedie 2003, 80) In observing specific affordances of Makah miniatures and examining alterations over time, it becomes possible to chart the roles that miniatures have played within a representative relationship concerning the "longer Makah strategy to craft a traditional future" (J.L. Reid 2015, 278). The miniatures demonstrate an ability both to work with realistic portrayals and to explore more adventurous, imaginative avenues. Their qualities also suggest a deeper association with what it means to be a Makah.

They enact, through the praxis of making, all the cuts required in traditional Makah carving. In this, the technical processes of miniaturization become as significant as the final product, if not more so, providing a subtle educational vehicle for passing on traditional knowledge with the unwitting acceptance, even the encouragement, of the oppressive authority. This interpretation is supported by the fact that miniatures are usually the first things a young carver will make, and by the explicit understanding that this is crucial in preparation for making a larger vessel.

This educational functionality exists despite the consciously exaggerated proportions of miniatures, in fact probably *because* of this feature. Consider the miniature depictions of Makah whaling vessels, once afforded the highest status of canoe design and conferred the greatest respect. Even as whaling became less and less frequently practised, carvers continued to make miniatures featuring dioramic or imaginative depictions of the whale hunt that usually exaggerated the size of the canoe crew. It is the imagery, the intangible dimension, of the vessel and the effect it provokes that is of paramount importance, alongside the maintenance of miniaturization practice.

Makah carvers thus consciously learn the techniques of their forebears by performing the same actions and simultaneously disseminating information on canoe usage and symbolism within their community and to the wider world. In this they are an example of Alfred Gell's "movement of aspiration." Even though miniature canoes are out of proportion to their larger counterparts, they are all designed to float, to make journeys. The miniatures travel, and wherever they go they act as ambassadors for a resurgent Makah identity that remained hidden, but not defeated, during the years of official repression and economic depression. Miniatures operate explicitly as physical agents of the continuity between the Makah of

Ozette and those of the present, a single, coherent type of object sustained by the practical processes of their construction and the effects they have on viewers, operating as part of an educational process and knowingly exported to diverse, sometimes alien audiences.

2
The Haida String
Northern Peoples

THE NORTHERN PEOPLES – Haida, Tlingit, and Tsimshian – live on the islands and rivers surrounding the coastal boundary between Alaska and British Columbia. The people of this region were the first on the Northwest Coast to make contact with Europeans but, with the exception of the Tlingit and the Russian fort at Sitka, remained largely remote from centres of European power in the early colonial period. Partly as a result, they suffered disproportionately from mid-nineteenth century epidemics, most lethally smallpox, which had significant and lasting demographic effects on their political, social, and material culture. This chapter seeks to understand how these effects were understood and depicted by the artists of the region, the role miniaturization played in this communication, and the continued influence of miniature objects as agents of knowledge for contemporary northern Northwest Coast artists.

To understand the manner in which the expressive visual culture of the region responded to external events, it is useful to consider the first recorded encounter between Europeans and Indigenous people, which took place off Haida Gwaii in 1774 between Spanish explorer Juan Pérez and an unknown Haida chieftain.[1] Pérez's first impressions are a particularly important reference point in demonstrating how contact-era Haida understood visual communication:

> At 3:00 in the afternoon we descried 3 canoes coming towards us ... The men were of good stature of body, well-formed and smiling expressions,

beautiful eyes, and good looking; the hair tied, and compared to fashion of a wig with a tail ... The first action they did when they approached within a gunshot of the ship was to begin to sing their motet in unison and cast feathers in the water ... Of the three canoes I referred to, the largest carried nine men, and would measure 24 codos of length [10.85 m], and 4 of width [1.8 m]. The others carried seven men; I did not note any weapons. (Quoted in translation, White 2006, 9)

In Pérez's account the Haida chieftain is not effaced by the comparatively huge vessel that has appeared off his shore but is determined to make an ostentatious display of power and wealth, projected directly toward the strange new arrivals. His reaction is not hostile, or frightened, but constitutes a cautious greeting, achieving a peaceful and approximately equal exchange. Here, as elsewhere, fruitful trading followed a dramatic and spectacular welcome that functioned as an overt non-verbal statement of authority and ownership of the waters in which the encounter took place, and which reflected the long Haida tradition of using imaginative material culture to embody intangible information.

Pérez's 1774 description of the Haida can be readily recognized. The ornate dress, the large and elaborate canoe, and the songs of greeting are all long-standing Haida practices, engaged in at any significant public event. What's more, Haida oral histories describe the meeting in much the same way as Pérez does, testimony to the efficacy of traditional Haida methods of intergenerational communication through this essential medium. Oral histories are acknowledged as the crucial bonding agents for social cohesion in the region, in which "every Haida clan also had a professional Storyteller that kept our extensive oral histories in-tact, including those that predate human occupation on earth" (Collison 2016). Haida accounts relate that Pérez's ship, *Santiago,* was interpreted as a great bird and was greeted by the chieftain with a special canoe dance (Gunther 1972, 6).

The canoe that so impressed the Spanish captain is particularly significant to the encounter, as it was no doubt the finest available and would have been deployed to make an unmistakable statement from one seafarer to another: this is my ship, this is my water, you are my guest. As Haida curator Nika Collison has noted, "Of all cedar creations, the Haida canoe was perhaps the most important. Taught by the Supernaturals, our ancestors engineered canoes up to 24 metres long" (2016).

Cosmology and Power in Early Miniatures

In the two decades following the Pérez expedition, merchant ships became regular visitors to Haida communities, and the earliest surviving physical evidence for post-contact miniaturization on the northern Northwest Coast comes from these voyagers. Trading defined Indigenous people's early understanding of their European visitors, whom they dubbed Yaats X̲aaydaG̲a, the Iron People in the Haida language, from the much-prized tools they traded for otter furs. Unlike for the Makah, there is no direct evidence of pre-contact use of miniatures within these communities, or of their use other than as trade goods, although given the ease with which miniatures took a place in commerce it would be foolish to dismiss the notion that they existed pre-contact or were applied in some role within the community. Modern Haida carvers certainly think so, as Gwaii Edenshaw explained:

Haida art is super formalized and certain aspects of it, canoe building for instance, are really formulaic. There is a geometry to it that you couldn't get to without practice and so, I think more likely, those miniatures were part of the learning process. The other thing is that up and down the coast, us included, there is a lot of pageantry and so during potlatches it's quite likely, or possible, that these miniature – and I'm talking about a wide spread of miniatures, right? canoes, but there is also the puppets and masks, miniature masks and stuff. So, especially in the case of those masks, obviously they were part of the pageantry, but possibly the canoes and stuff, too.

Consider head canoes, for example, a significant canoe design of the eighteenth century on the northern Northwest Coast, which Alessandro Malaspina collected in miniature form in 1791 at Port Mulgrave (Yakutat Bay). Surviving examples show imaginative experimentation with form, with gracefully elongated and extended sterns, affording the vessels a sinuousness they did not possess at full size. This characteristic is accentuated by the painting, in sophisticated black formline along the hull, of killer whales. The miniature is not a toy or a practice piece but a sophisticated artwork depicting a high-status watercraft decorated with images of dangerous marine predators holding cosmological significance. Precisely how Malaspina came to own this and other pieces is unknown, but whether

originally created for tribal pageantry or for sale to important trading partners, such objects are unmistakable and significant expressions of temporal and supernatural power.

The Malaspina miniature vessels reflect a design known to have been widely in use in the early contact period among the Haida, Tlingit, Tsimshian, and Kwakwaka'wakw (Boas [1909] 1975, 444; S.C. Brown 2002, 92). Head canoes are characterized by a high, square bow and a jutting, raked stern (Durham 1960, 56), and were common in the late eighteenth century but disappeared within a few decades of contact; Bill Holm estimates that they were all gone by the first decade of the nineteenth century (1987a, 153), rendered obsolete by the Northern type of canoe. Some contemporary Haida carvers, such as Guujaaw, believe head canoes were far too unwieldy in any kind of wind to have made practical ocean-going vessels, proposing that their use was consequently perhaps limited to ceremonial activity (Ramsay and Jones 2010, 13), and anthropologist Steven Brown (2002, 92) suggests that the long tail fin made them difficult to manoeuvre during maritime combat, unable to turn rapidly or to keep pace with the emerging Northern variety. He also notes that the design would have made head canoes ship considerable amounts of water in high seas, a frequent occurrence in the waters of the Dixon Entrance.

Nevertheless, head canoes were at one time recorded in large numbers on the northern Northwest Coast, as at the 1792 skirmish in Beaver Harbour, when a fleet of seventeen head canoes inconclusively battled with the American whaler *Columbia* (Howay [1941] 1990, 405). They are often found in graphic design from the period, such as on the interior of bentwood boxes (Holm 1987a, 145), and they continued to be produced in miniature throughout the nineteenth century. Such miniatures are particularly common in Russian collections, acquired from the Tlingit communities of Russian Alaska (Berezkin 2007).

It is notable that most head canoe miniatures of this time depict the crews not as humans but as masked spirits, indicating a place for these vessels within the context of cosmological oral histories more than in maritime architecture. Traditional Northern stories feature canoes heavily, and the Haida have songs telling of the Tluu XaaydaGaay, the Canoe People, spirits who travel in a supernatural vessel along the coasts of Haida Gwaii, answering the summons of shamans (Bringhurst 1999, 341; Pelton and DiGennaro 1992, 120, 151). Their description matches the little wooden crew members on these miniature vessels. Some of the best-quality examples

of this type date to the mid-nineteenth century, just as Northwest Coast Indigenous society faced potential collapse due to soaring mortality rates.

The Books of Knowledge

Epidemics had periodically swept the Northwest Coast ever since the first contact period, but the smallpox outbreak of 1862 was on an order of magnitude larger than anything that had preceded it. Originating in Victoria in March, it spread rapidly to a community of Indigenous traders, most of them Haida and Tsimshian, in nearby Small Bay. The authorities responded by expelling the traders, who retreated to their home communities along the coast (Boyd 1999; Jusquan 2009). As the traders travelled north they left a trail of abandoned canoes and dying colleagues in the communities they passed. One Haida party of sixty had lost forty members by the time it reached Nanaimo, about half-way up Vancouver Island (Boyd 1999, 187).

At each community where smallpox struck, visitors scattered to their homes, carrying the disease with them, so that by late 1863 when the epidemic finally began to subside, some 15,000 people were dead: an estimated 53 percent of all Indigenous people then living on the Northwest Coast. With the exception of the Tsimshian, whose 37 percent mortality was restrained by missionaries providing vaccines at Metlakatla, losses were exceptionally high among the most northerly tribes. The Kwakwaka'wakw lost 53 percent, the Nuxalk 58 percent, the Tlingit 59 percent, the Heiltsuk 69 percent, and the Haida a catastrophic 72 percent in less than two years (Boyd 1999, 229). Indigenous estimates put the true totals much higher. The effect of this disaster was profound, as a Haida elder explains: "Smallpox running through our people can be likened to a fire burning a library of 30,000 books. Our elders are our books of knowledge" (B. Wilson 2009).

Without the elders, the "books of knowledge," oral history was threatened with extinction. Traditional culture was at fundamental risk of collapse, a crisis accentuated by the concentration of many separate communities as their populations dropped below tenable levels. Coupled with this process was the increasingly frequent establishment of missions and government outposts among the surviving communities, with the ambition to replace traditional practices ("deviltry") with Christianity (Henderson 1974, 305). Under such circumstances, acculturation was rapid. By 1890 it was noted that among "the southern Haida ... to the satisfaction of their minister, these Indians had discarded the flashy garments and unusual

combinations. They chose quiet colours and showed good taste" (Van den Brink 1974, 59).

As the Indigenous population declined and European interference increased, Haida people moved from their familial communities into larger villages, principally Masset and Skidegate (Van den Brink 1974, 65). The 1882 *Annual Report of the Department of Indian Affairs* noted:

> The decrease of this once powerful tribe, formerly many thousand in number, now reduced to about 300. At the several deserted or partially occupied villages evidence of their former number and power is everywhere visible in the numerous old houses, crest poles and carved graves, while the population of the villages at present inhabited grows yearly less, the young men and women migrating to the towns and the older ones dying off. I was particularly struck, when visiting the several villages, by the small number of children. (Powell 1882, 142)

In this environment, the survivors of numerous powerful Haida families were thrown together suddenly, and the resulting power struggle required an extended series of potlatches. Simultaneously, the dead had to be properly honoured and memorial poles sprang up throughout the concentrated communities (Jonaitis and Glass 2010, 27, 42). The result was a brief explosion of material culture production, as surviving artists sought to keep up with the demand for potlatch regalia and for the new houses and poles of the expanded community. As settlers began to move onto Indigenous lands, a new generation of artists emerged from the catastrophe to find a worldwide art market opening up. The evidence can be found in museums all over the world, as artists produced work for sale to the increasing numbers of ships that arrived at their concentrated communities and, over time, to work regularly with dealers farther afield, such as Seattle's Ye Olde Curiosity Shop (Duncan 2000; Lee 1999).

With these commercial opportunities came the more gradual imposition of European officials on everyday life, culminating in the 1885 potlatch ban (Harris [1966] 1992, 167–71). Potlatches combined the commemoration of a particular occasion, such as a marriage or succession, with several days of feasting, dances, political negotiations, and the presentation of lavish gifts. Attended by all neighbouring families of note, a potlatch marked the power and wealth of the host and obliged attendees to match the generosity at subsequent potlatches of their own. The potlatch was the foundation

of Northern economic and legal systems, and its prohibition effectively made the Haida legal system illegal (Collison 2016).

The late nineteenth century was also the period during which the museums of Europe and North America were filled, assembling their collections from Northwest Coast peoples in an environment of cultural repression and demographic collapse (Cole 1985). In this highly unusual and turbulent context, the idea of what constituted traditional or typical practice for peoples of the Northwest Coast thus became fixed in the academic and popular imagination of European and non-Indigenous North Americans, a misconception noted by curator Jonathan King: "As a result, the most traumatic period in Native American history has provided the material basis for what is traditional and what is not" (1986, 70). It should not be assumed, however, that the Indigenous artists involved were unaware of this development. The cultures of the Northwest Coast marry rich oral histories with vibrant visual displays to generate messages through form and design. Such is the essence of formline design, for example, and this movement of objects to museums was very apparent to the artists of the region.

The northern Northwest Coast is where the complex, varied, and culturally distinctive series of related decorative practices known collectively as formline originated. This art form is based on certain key principles, the most prominent of which is that "the artist must be aware of the total space and the effect on that space of any element he introduces to it" (Holm 1965, 67). Thus formline is predicated on the spatial relationships of figures across the surface as a whole, rather than as individual compositions. Every artwork is a multifaceted story, not a static portrait, and frequently uses horizontal symmetry to emphasize the figurative significance of the design (85).

The figures that live within formline art are animals and supernatural creatures, and the interaction between them creates liminal tension between positive and negative space that allows their embedded stories to come to life through subtle transitional devices. It also allows for a form of two-dimensional skeuomorphism termed *double meaning:* the ability of one stylistic element to be a part of two or more figures, so that, for example, "the claws of a foot or the curve of a flipper, becomes the beak of a bird" (Holm 1965, 89). In this way, artists gave their works movement and trajectory, qualities all the more insistent when it is recalled that their use was social and ceremonial, intended to accentuate the movement of dances and voices in song. Indeed, the fluidity of formline and the movement of

Northwest Coast ritual dances are deliberately complementary; in these art forms "the body has its own form of knowledge and ways of learning the cultural messages encoded in the old forms" (Shadbolt 2004, 32). Though Holm restricted his definition of formline to two-dimensional art, Indigenous scholars apply it to the full range of Northwest Coast art media and emphasize its close relationship to Haida history and cosmology, noting that it "expresses and strengthens our connection to the supernatural and the spiritual. It affirms and honours our inseparable relationship to, and dependency upon, the lands and waters of Haida Gwaii" (Collison 2016). It is therefore unsurprising that when the Northern tribes represented themselves in ways that reflected their engagement with Europeans, they often did so through the medium of formline design.

Staking a Claim: The Sandeman Canoe Miniatures

In 1874 a quantity of unsolicited crates arrived at the British Museum, donated by a wine merchant named Fleetwood Sandeman. The collection includes masks, bows, figures, and other items from the West Coast of North America picked up by this Victorian gentlemen traveller, but there is one part of the Sandeman collection of particular interest, a Northwest Coast miniature canoe. Carved to exceptionally high quality from yellow cedar, it is finely painted in complex red, green, and black formline featuring a number of crest animals, of which the largest and most prominent is the killer whale on the bow. It is in excellent condition, the paint undimmed by exposure and the hull still smooth and polished, suggesting that it had only recently been made at the time of its acquisition and never subject since to any mechanical or physical process that might cause wear or damage.

An account of the purchase of this collection was published by Sandeman's friend William Copeland Borlase, an archaeologist. He describes its discovery in the City Saloon, in San Francisco:

> Altogether they formed a good collection of native manufactures, and had been brought to the saloon for sale by the original collector. In the window, in order to attract attention, they were labelled "Gods [sic] taken in the Ashantee War," but the delusion was not kept up inside the shop. It was merely an American exaggeration. (Borlase 1878)

The account unfortunately does not indicate who this original collector might have been. For that, other evidence is required. A miniature canoe at the British Museum acquired a century later (Am1976,03.3) and others at the American Museum of Natural History (16.1/2501) and the Florida State Museum (P1268) are so similar it can be stated with confidence that they were the work of the same hand, or at least from the same workshop.

The second example at the British Museum, although more faded, is painted to a similar pattern, with the same set of paddles and scalloped thwarts, the same salmon-head motifs on the midsection featuring human faces, and a killer whale formline design modified from, but directly comparable with, that of the Malaspina canoe miniatures of nearly a century earlier. It was purchased in Philadelphia in 1973, and was once in the possession of Commander Louis Sartori, who commanded the Mare Island Naval Shipyard in San Francisco until 1873 (Inverarity 1976). Sartori's command coincided not only with the period of sudden growth in material culture production on the Northwest Coast but with the most significant non-Indigenous political event in the region during the nineteenth century: the transfer of Alaska from Russia to the United States.

The ceremony for this government transformation, about which none of the Indigenous inhabitants of Alaska were consulted, took place at Sitka, a prominent Russian trading town in the Tlingit territory of southern Alaska, on 18 October 1867. Sartori was likely to have been present at this event on the USS *Ossipee,* which convoyed the commissioners to Sitka. Historian Ronald Jensen has described the scene in detail, noting how American and Russian troops paraded at Sitka, their flags hauled up and down as gun salutes from the fort and *Ossipee* rang out across the bay. There were certainly no official Indigenous participants, although Jensen notes that apparently there were "a handful of residents, including a few curious Indians" standing nearby (1975, 101). To imply, as Jensen does, that these Indigenous attendees were standing by in a state of curious, childlike innocence is to fundamentally misunderstand their position. Whoever these people were, the Tlingit, Haida, and Tsimshian clans that operated from Sitka were experienced, skilled, and sophisticated trading organizations that had cooperated with and often chafed under Russian rule for more than six decades. They would not have been unaware of the event or of its significance, and would have been aware (although perhaps unsurprised) of the snub their lack of invitation indicated.

Tellingly, Tlingit Chief Ebberts of Sitka hosted his own celebration of the event in 1869, a potlatch to recognize the transfer of sovereignty, and the concluding feast was held in honour of the visiting Secretary of State William Seward, the man who had arranged for the sale. As for the Haida chieftain Pérez had met almost a century earlier, this was Ebberts's chance to demonstrate his authority and autonomy within a changing political situation over which he had no direct control. It was reported that he "spread luxurious furs for [Seward] to walk on. A handsomely carved and painted chest covered with furs was his seat of honour, and Ebbits presented him with an ornamented hat, the furs and chest, and other gifts" (Garfield and Forrest 1948, 56). Miniature canoes might have been among these "other gifts"; it seems clear that Sartori's reassignment from Mare Island to the Philadelphia Naval Shipyard in 1873 immediately coincided with the sale of this collection at the City Saloon, suggesting circumstantial evidence of their provenance. Wherever the items were obtained, they were chiefly gifts of immense significance and technical and symbolic importance to the community from which they came, as their physical properties indicate.

An inconsistency is immediately apparent. Like the Malaspina miniatures, these later examples depict head canoes, which were common when the Malaspina miniatures were made but had long vanished entirely by 1869, when the sale at the City Saloon took place. When Canadian artist Paul Kane sought them out in 1844 he was unable to locate any, resorting to a miniature on which to base his own substantially inaccurate depictions (Harper 1971, 238; Holm 1987a, 145; Kane 1859). It is quite possible that no one living in 1869 had seen a head canoe afloat, let alone produced one. And yet here, emerging from these communities in gloriously carved and painted cedar, is a body of high-quality head canoe miniatures, placed directly in the hands of foreign dignitaries involved in the Alaskan transfer.

The question is therefore why carvers living in the 1860s – in the aftermath of a devastating epidemic and under a change of sovereignty to which they did not consent, decades after the last head canoe disappeared – decided to revive it as a carving motif. We must consider why in particular they chose to produce head canoes very similar to spirit canoe miniatures previously gifted to Russians, this time without the spirit crew but still bearing spirit figureheads and replicating much of the crest art of the earlier examples.

Moreover, these miniatures were larger, of higher quality, and with more complex formline decoration painted onto the sides than previous miniature canoes from the region. If, as I suggested in the previous chapter, imaginative, intangible ideology is the driving ambition behind the miniature, then these ones are objects of representation – not, or at least not just, of an archaic canoe design but of an entire world. A world of rich waterways, fish stocks, fur territories, and a whole maritime system of communication and livelihood that to survivors in the communities of the northern Northwest Coast must have seemed ever shrinking, ever more in danger of disappearing.

These miniatures of the 1860s recall a time before widespread European settlement, before the social dislocation of European trading interventions destabilized Indigenous political and economic systems, before the sea otters on which those trading agreements relied were driven to near-extinction, and before the worst ravages of smallpox. These canoe miniatures are nostalgia, memory made real, maybe even grief given form. But they also embody pride in ancestral designs and practices, and they are more than a wistful recollection of a lost world; they are hope, aspiration, gifts to remind the strangers who held power that the Northern tribes were not dying, were not forgotten but could still, when required, produce things that spoke of beauty, supernatural power, and significance.

Charles Edenshaw and the Modern Haida Artist

Among the Northern carvers of this time, perhaps most prominent was Charles Edenshaw (c. 1839–1920) of the Haida, known as Daxiigang or 7idansuu in his own language, to whom considerable developments in carving are attributed. In their biography of Edenshaw, Robin Wright and Daina Augaitis write that "*7idansuu* created a significant artistic legacy within a stunning story of survival that drew on Haida values, systems and beliefs, as well as the ability to adapt and innovate" (2013, 21). Curator Doris Shadbolt noted that "Edenshaw's career started when Haida culture was still intact and ended after it had come close to being destroyed" (2004, 31), a trajectory that clearly played a considerable part in his personal motivation and art production (Hoover 1995; Wright and Augaitis 2013). The art of Edenshaw and his contemporaries, and their use of miniaturization, helps us to understand its position within Northwest Coast material culture as a

means of embodying and transmitting ideology across cultural boundaries and between generations.

During his long career Edenshaw created a number of high-quality miniatures, including several houses and many totem poles, and experimented with a range of archaic canoe designs. He was also a proponent of a considerably expanded range of production in argillite, a soft shale found on Haida Gwaii, developing his repertoire from pipes into plates and figures. Edenshaw was one of the first Northwest Coast artists to create jewellery from hammered silver dollars, all made purposefully for the burgeoning souvenir trade via the regular steamboat services, which brought considerable wealth to the northern coastal communities (Bunn-Marcuse 2015; Raibmon 2005, 143; Wright and Augaitis 2013). His body of work is notable not only because it contributed high-quality goods to the tourist art market but his example allowed Haida artists to continue practising traditional activities away from the increasingly intrusive gaze of the colonial authorities.

As with the Makah, an irony lies in the fact that "Victorian travellers and museum collectors endeavoured to obtain tokens of 'authentic' aboriginality, even as missionaries and Indian Agents were concurrently trying to stamp out surviving signs of aboriginal identity" (Glass and Jonaitis 2011, 14). Vancouver-based Kwakwa̱ka'wakw artist Corinne Hunt, whose work often explicitly engages with Indigenous responses to colonial oppression, offers an example:

I heard this story about the Haida women who used to have tattoos up their arm. And after the Christians came they weren't allowed to have tattoos, so they started wearing the bracelets. And they would wear four or five large bracelets on their arm.

These bracelets, adorned with familial crests, replicated the forbidden scarification practices, operating as removable tattoos in much the same way that other tribes hid their potlatch activities as Christmas celebrations. It was a method of preserving traditional culture without incurring the enmity of the colonial officers on whose goodwill the weakened communities now depended. Marcia Crosby notes that such practices do not dilute Indigenous authenticity, since "aboriginal culture is not intrinsically held only in cultural ('art') objects. It is held in political, social and economic dimensions, in our

memories, in local knowledge, in new and evolving institutions" (2004, 116). It survives and endures with the people, not by clutching to traditions that will bring oppression and censure.

Edenshaw was not the only prominent carver in the region during this period; he was part of a network of artists producing material for both Indigenous and commercial purposes. In many ways this group established the role of the modern Northwest Coast artist, who operates freely both in commercial art contexts and within traditional tribal material culture, finding a balance between these competing (although not mutually exclusive) interests while furthering an individual style.

The Miniature Village of Skidegate

One of the most prominent and important collective works by this group appeared at the 1893 World's Columbian Exposition in Chicago. A team of carvers worked together to produce a series of miniature replicas of the traditional longhouses and poles from the Haida village of Skidegate. These examples, alongside a number from the Heiltsuk commissioned at the same time, represent 23 percent of the entire body of surviving miniature houses produced on the Northwest Coast. The Skidegate miniatures offered a highly simplified external presentation of the traditional structures of the village, displayed behind a roped enclosure and equipped with the simplest signage. In the aftermath of the Exposition a number of museums, including the British Museum, commissioned their own miniature houses from some of the carvers involved. (Edenshaw was not among the Exposition carvers, but he did later make miniature houses under commission.) Unlike the Kwakwaka'wakw displays at the exhibition, which were accompanied by a delegation instructed to "show whatever is asked of them in relation to their customs and mode of life particularly the ceremonies connected with their secret religious societies" (Cole 1985, 123), the miniature Skidegate village had no Haida interpreters on hand to explain the display to the visitors (Wright 2015).

This particular miniature community, created in one place for an alien audience in another, has a number of features which allow us to approach the underlying ideology of the carvers; the houses, which are not to scale, show only the traditional historical community of Skidegate, long-standing longhouses familiar to Haida for centuries and reminiscent of those photo-

graphed in 1878 by George Dawson (MacDonald 1983). In reality, however, the composition of Northwest Coast villages was already fundamentally changing under the influence of missionary and government activity; for example, in 1887 missionary William Duncan transplanted the entire Tsimshian community of Metlakatla (Seguin 1986, 482). During this time, longhouses gave way to dwellings that superficially resembled them but had sash windows and divided living spaces. Soon new towns were being built in which totem poles and longhouses were replaced by bland American clapboard homes for individual families, breaking up the extended family and clan structures of pre-contact life (see, for example, Bringhurst 1999, 138; Jonaitis and Glass 2010, 66).

By 1934, a government report noted that the Haida had replaced all of their old longhouses with "two-story frame houses which they built according to a new design and furnished in a modern style"; it was also apparently observed that "Haida women are model house keepers. It is gratifying to note the whiteness of their wash on the lines, fresh white curtains and the cleanness of their floors" (quoted in Van den Brink 1974, 102). The artists who created the Skidegate miniature village for the world's fair lived among these changes, and yet nothing of this encroaching hybridization appears in their work, which reflects instead a rapidly disappearing way of life in a controllable and relatable way.

Ostensibly this nostalgic design has a straightforward reason: Franz Boas, who had overall control of the exhibition, had instructed the commissioner of the miniature village, James Deans, to obtain a traditional display of material culture, which at the time was so plentiful and readily available that Deans was able to purchase "three boxcar loads of Haida material" (Cole 1985, 123; see also Wright 2015, 381). Deans (1887) had a long-standing interest in the interior construction of Haida longhouses, and this commission therefore also most likely reflects his personal fascinations and ideology, not that of the carvers.

However, just as it would be naïve to assume that the Indigenous spectators of the Alaska transfer were unaware of its significance, so it would be naïve to assume that simply because Deans had commissioned the village in a particular way, the Indigenous artists who made it had no agency in its construction. Producing artwork on commission is the traditional method of most ceremonial Northwest Coast art production, and it has never prevented Indigenous artists from adapting their works to include personal

Figure 2.1 Detail of figures in interior of a miniature house, c. 1892, observable only by using a flashlight. | Reproduced by permission of the Field Museum, FM 17836

style. In some of the Skidegate house miniatures, the proof of this individualism can be found inside.

The houses formed a static display without serious interpretation, certainly without any Indigenous interpretation; they were later installed in the Field Columbian Museum in the same configuration (Cole 1985, 124). They were not to be played with or handled but were intended by an American collector to cumulatively create a simplified, small-scale mimetic depiction of a traditional Haida community for consumption by an American public with minimal comprehension of the environment from which they came. The miniatures are solidly built, not easily disassembled or adjusted, but close examination reveals human figures inside two of them (FM 17822 and FM 17836).[2] In FM 17822, the surviving figures constitute a family scene with two figures, possibly a woman and child, dressed in button blankets, while a shaman in regalia stands between them. In FM 17836, the scene features a series of small figures around a larger central figure, while in the corner (out of the shot) a large ceremonial box drum hangs from the ceiling (Figure 2.1).

The figures cannot be seen from the exterior of the houses, and certainly would not have been visible to the visitors to the World's Columbian Exposition. There is no evidence to suggest they were a deliberate part of the commission; Deans makes no mention of them in his published discussion of the display (1893), although some of his manuscript notes indicate that he was at least aware that the figures were there. That only a few of these houses feature this detail suggests a curious selectivity, probably not at Deans's request but marking an individual decision by some of the carvers involved.

The exteriors of the houses are out of proportion with full-sized Haida houses but look sufficiently similar to convey their appearance. The interior scenes are not carved on a realistic scale, the sizes of the figures instead indicating their relative importance to the occasion being depicted – the shaman and the chieftains are much larger than their comparatively tiny blanket-wearing audiences. Indeed, the inside of the houses is an Indigenous-controlled space that forsakes realism for the dimensions of Indigenous messaging in miniature. As a student of Haida architecture, Deans cannot have been unaware that the interior configuration of the miniatures only slightly resembled those of the full-sized houses, lacking the pits and benches that characterized a Haida longhouse and substituting a plainer canvas on which these miniature figures danced. Other miniature Haida houses made in other contexts, such as Am1898,1020.1 at the British Museum, have removable fronts that expose the interiors for interactive display to the audience. The structural solidity of the Columbian Exposition houses, by contrast, necessitates a flashlight and a craned neck to view the dancers, suggesting that this was not part of their commissioned functionality for audiences to view, but private commentary from the artists.

The scenes are not of the everyday. They do not show weaving or cooking or carving but important ceremonial moments in the Haida calendar and in the life cycle of these houses: dances and potlatches; families and hierarchies, painstakingly rendered with a specific system of scale interpretable only by a knowledgeable Haida observer; details of clothing and facial features. They show traditional Haida life at its most energetic and emotive, and they do so within non-proportional miniatures of traditional architecture. All the elements of this lifestyle were under continual threat in Haida Gwaii: the houses were disappearing, the dances forbidden, and the clothing replaced by drab European garb. Yet here, invisible before the eyes of the world, at the heart of a celebratory expression of how America desired itself to be seen, little Haidas danced in the dark.

Satire and the Expression of Ideology through Art

The case studies highlighted thus far are tied to the expression of pathos, memory, and nostalgia in material culture, the representation in miniature of a world slipping away. Yet these efforts should not be mistaken for token gestures against an inevitable fate. Northwest Coast material culture is explicitly expressive and communicative, and these objects were part of multigenerational trajectories of resistance. As part of an overtly communicative visual culture, artists of the region have always been well versed in the nuances of visual political communication, and satire was a particularly important form of that resistance.

Intercultural satire in Northwest Coast art has been described as a "public means with which to express resentment and challenge," the most famous example being a Tlingit totem pole erected at Tongass around 1885, mocking William Seward (Jonaitis and Glass 2010, 68). As mentioned earlier, Seward was hosted at a potlatch at Sitka by Chief Ebberts in 1869, but he is reported to have behaved ungraciously and worse, never reciprocated the honour (Garfield and Forrest 1948, 55–56). In disgust, Ebberts had a pole carved portraying Seward with a white face and red nose, a calculated insult that diminished his status before the Tlingit. A reproduction of this pole stands in Alaska to this day, Seward's infamy transmitted down the generations.

In another case, during the 1870s a man from Skidegate was prosecuted for drunkenness while visiting Victoria and on his return home raised effigies of the Victorian officials who had convicted him, which were then routinely subjected to public ridicule (MacDonald 1983, 45). Satire also operated on smaller scales, with many examples to be found among the argillite souvenir art of the Haida from the 1850s onward. These speak both inward to a Haida audience and outward to a non-Indigenous one (Warrior 1999). Haida argillite artists particularly delighted in portraying Europeans, especially sailors, in nonsensical or absurd positions (Sheehan 1980, 83). Am1837,0408.1 in the British Museum, for example, is a panel pipe on which a sailor, tangled in rigging, is chased by three formline bears. Am1954,05.1000, also at the British Museum, is an argillite tableau in which a European man trains a gun on a woman, often interpreted as his Indigenous common-law wife.

Charlotte Townsend-Gault has identified this duality, in which different messages reach different observers, as continuing into the modern era. In her conversation with Robert Duncan of the Wei Wai Kum, he commented about souvenir art, "We want the visitor to see something of our culture,

that's how they will know that we are here. But they don't need to know everything" (2004, 186). Part of the display is for internal consumption, a statement of ownership for tribal members, and part is external, a statement of identity for non-Indigenous audiences.

The key point to be drawn from these examples is that carvers from the northern Northwest coast have always been sufficiently well versed in the principles of visual communication to produce material culture, often explicitly for consumption by European customers, that observes and even satirically mocks European sensibilities and behaviour. This has humorous implications but is not a solely comedic exercise. Satire could be used to critique authority in terms only understood or explicable to an Indigenous person raised in that visual milieu, without presenting a direct challenge to colonial authority that would force reprisal.

The Haida have never stopped being satirical; in 2011 the British Museum commissioned artist Michael Nicoll Yahgulanaas to produce a work in his *Copper from the Hood* series, a sculpture using copper leaf on an actual car hood to depict the traditional Haida story of a ravenous woodworm, driven to consume all it encounters. Yahgulanaas deliberately intended this Haida representation of destruction to be prominently placed within a European museum collection that includes "thousands of wooden objects, 'hidden' treasures to be consumed." Although described in a humorous way, the satirical "imagery can therefore be understood as an ongoing critique of museums as keepers and containers of cultural heritage" (Levell 2021, 114).

This evidence of satire establishes a presumption of subversive meaning in the miniature art of the late-nineteenth-century northern Northwest Coast. Satire is often absurd and humorous, but it has serious and calculated intent. Miniaturization is an intimate technique that employs simple reduced-scale tactility and exploits our fascination with familiar similarity to transmit information subtly, through intangible means. The Makah have used miniatures to project their identity far out into American society; the Northern tribes have used miniaturization to project their identity across time.

The assumed audience for the miniatures described above was the American souvenir hunters who bought them or the crowds at the Chicago fair who saw them on display, but another audience, a less obvious one, may have been in mind:

JACK DAVY: *This may seem a little out there, but it's something I am considering. Do you think that artists like Charles Edenshaw, who were*

> *working after the epidemics, do you think that this was part of their thinking in what they were doing? That they were preserving techniques and things for the future?*
>
> GWAAI EDENSHAW: *Yeah. Charles Edenshaw was a real artist, so I don't think that he is the best example of this. I think that he would have been compelled to do that work just by the fire burning inside of him. There were other artists, in that time period and later, who weren't natural artists, but for whatever reason carried forwards that huge body of slate work that kind of has that naïve aspect to it when you consider the formality of the art. I actually love it; there's all this stuff from that time period that is a bit weak on the rules of the art but which just has a nice feeling to it, but I believe that those people felt a pressure to maintain that art and I'm really grateful that they sort of kept that unbroken line of work from the height of our art to the new renaissance that we are in now.*[3]

Edenshaw is here drawing direct links between the work of artists in the late nineteenth century and his own oeuvre. Moreover, in doing so he suggests that many of the artists in this period, particularly lesser-known and lesser-skilled practitioners, undertook the work not from natural inclination or solely out of financial or social necessity, but because they saw the encroaching decline in traditional Haida material culture practices and took it upon themselves to preserve what they could. It is not a radical leap to suggest, therefore, that such people employed multiple imaginative methods of persuasion in seeking to achieve their goal, of which miniaturization was a common and effective component.

Like the floating canoes of the Makah, these miniatures travelled. The carvers of the era made them as containers and transmitters of information, often satirical, into non-Indigenous society. They knew that these objects, these souvenirs, would be prominently displayed before audiences incapable of grasping their true significance. They were, in short, intended to belong in the museum, and for a very specific political reason. They were there to survive.

Louis Shotridge: Miniaturization and the Museum

While Charles Edenshaw and others created souvenir art for broad distribution, other artists of this period acted on their concerns about the future of Northwest Coast art with efforts preserve it. Louis Shotridge (1882–1937) was a Tlingit pioneer in the relationship between Indigenous Northwest

Coast peoples and American museums, and his use of miniatures was significant. Educated at the Haines mission school, Shotridge exhibited traditional material culture practices at the 1905 Lewis and Clark Centennial Exposition in Portland, Oregon, and was invited in 1912 to join the Penn Museum in Philadelphia as a curatorial assistant, a position he retained for twenty years. Shotridge took on a wide variety of roles within the museum, one of the most consequential of which was the preparation of the new Indigenous North American displays following the withdrawal of the Heye collection in 1915 (Berman 2013; Preucel 2015).

In this role, and again and more ambitiously when the gallery was refurbished in 1928, Shotridge sought to preserve clan distinctions, invisible to uninitiated non-Indigenous curators, within the displays. This was an innovative approach to curation far ahead of its era. Part of his display methodology included the construction of elaborate miniature dioramas of Indigenous villages, including the Tlingit community of Klukwan and the Haida settlement of Haina. These scenes, complete with tiny canoes, houses, and totem poles, were among the first Indigenous-made dioramas of their kind created specifically for a museum setting, and they represented a real effort not just to present to the Philadelphia public an ideal of how Indigenous communities were laid out but also to preserve the information they contained: by the time these dioramas were constructed, the villages depicted had either been left uninhabited to return to the earth or completely replaced with European-style housing (Preucel 2015).

Shotridge himself wrote, "It is clear now that unless someone go to work, record our history in the English language and place these old things as evidence, the noble idea of our forefathers shall be entirely lost" (Williams 2015, 63). He therefore accompanied his collecting and curation with extensive documentation of Tlingit oral histories (Milburn 1986). Shotridge was said to feel "the onrushing tide of modernity in Alaska and he devoted his life to recording the history of his Tlingit people" (Williams 2015, 75). After his dismissal in 1932, however, his displays were dismantled and reorganized, and following his early death in a construction accident a few years later, decades would pass before another Northern artist sought to consolidate and rebuild traditional design and display practices.

Bill Reid and the Haida String

The period known among the Haida as the Silent Years, from about 1920

to 1960, saw a marked decrease in art production among Indigenous people along the coast, including among the Northern tribes (Steedman and Collison 2011). Joan Vastokas refers to a period of "colonization" in which

> traditional art forms began to disappear with the disintegration of traditional patterns of culture and the production of "arts and crafts" for tourist consumption ... By the early twentieth century, traditionally high standards of workmanship as well as traditional reasons for making art had almost entirely disappeared ... [The] decline in general quality as well as quantity may be attributed in large part to the loss of cultural meaning attached to the art works. (1977, 158).

Certainly there was a significant alteration in art production in the region from approximately 1920. This was matched by what Ronald Hawker calls a public "fight for control over the meaning of Northwest Coast objects, which were increasingly being housed in American, European and Canadian museums" (2003, 171).

Although carving never disappeared among the Haida, by the late 1950s it had changed dramatically from the art form experienced by Edenshaw and his contemporaries. There were no longhouses, no canoes, and no overt potlatches, which meant that there was no demand for regalia. Master carver Robert Davidson recounts that in "1965 or '66 I knocked on every door in the village [Masset] looking for any evidence of the classical period. And I found one box. So the people were really removed from that classical period" (Hall and Glascock 2011, 31).

Into this situation arrived Bill Reid (1920–1998), born in Victoria, the son of Sophie Gladstone, a Haida from the recently vacated village of T'aanuu, and a great-grandnephew of Charles Edenshaw. He trained in art production at what was then the Ryerson Institute of Technology (now Ryerson University) in Toronto, the first Northwest Coast artist to receive formal higher art education, and had little contact with traditional Haida culture until he was twenty-eight. Then, as a semi-fictional biographical memoir approved by Reid himself put it, he "began to experience a strange compulsion to carve" (Harris [1966] 1992, 187).

Reid voraciously consumed Haida art from books, from standing poles, and from museums. He was the first Northwest Coast artist to visit many European museums, and he used these experiences to hone his skills, initially as a jeweller and then later in other carving media, including argillite and

cedar. The tiny, detailed work his jewellery entailed was prefaced by youthful art that included a miniature tea set, carved from chalk in 1932 as a gift for his sister (M.J. Reid 2011, 56).

Reid's advances into Haida art were in a sense encouraged by its damaged continuity: although as a boy he was partially educated in Haida ways by his grandfather Charles Gladstone, he grew up away from Haida Gwaii and was not apprenticed to a living master carver who would have enforced the strict rules of social obligation inherent in traditional Haida art (McLennan 2004, 38). Reid therefore had a certain freedom to experiment with form, material, and structure, in which, in the words of his granddaughter Nika Collison, he "began to carve out a new aspirational chapter in Haida history, weaving the past into the present and designing our future, if you will" (Collison 2016). Reid was explicitly conscious of this position, accentuating the past to build for the future. Marcia Crosby writes that Reid's "return" to Haida identity, "this romantic journey home, was a return to a time and place that he and others made up: the 'golden age,' the 'classical period' of the late eighteenth and nineteenth centuries (comparable to other great civilizations), uncontaminated by modernity" (2004, 124).

In this he understood himself to be connected to Charles Edenshaw, sharing the latter's passion for experimentation and redevelopment of traditional art forms to satisfy financial necessities and simultaneously generate a body of work that would be displayed and valued beyond the Northwest Coast, intriguing and educating an audience with its form, structure, and meaning (Duffek 1986; Duffek and Townsend-Gault 2004; Herem 1998; Hoover 1993; McLennan 2004, 43). Although Reid claimed, a little disingenuously, that his art was intended "to isolate myself into a nice little world where I could merely play with the concepts of these beautiful designs and turn out finely made objects" (B. Reid 2000, 213), he was well aware of the ability his work had to convey significant messages and used it to full effect as a leading campaigner against corporate logging operations in Haida Gwaii (Dawn 2004).

Reid's relationship with miniatures operated within a circular system of prototypes, what Alfred Gell (1998) calls "agent/patient relations" in the art nexus. Adapted to miniaturization, this concept dictates that in order to be created, any miniature *must* have a thing or things to resemble or it is meaningless; it demands a prototype from which to be drawn. In turn, miniatures can act as prototypes themselves, providing an imaginative experimental format from which larger practical or artistic creations can be developed (see, for example, Küchler 2010; Schaffer 2004).

Thus, miniaturization was one artistic method through which Reid could discover his own "Haidaness" (M.J. Reid 2016, 23). He produced miniatures throughout his career but was better known for learning from them, particularly in his attempts to build a Northern-style canoe in the 1980s. Martine Reid's biography *Bill Reid and the Haida Canoe* describes the process in detail, including the artist's methodical study of miniature canoes in museum collections all over the world (2011, 74–78). When in 1985 he carved his first canoe, a 250-centimetre-long miniature lay next to him as an architectural model. Since there were no surviving Haida traditional canoe builders at that time and miniature canoes are not to scale, Reid encountered many problems in constructing this first canoe, and much trial and error and adjustment were needed before the finished canoe was ready for its maiden voyage (Ramsay and Jones 2010, 6). With Bill Reid, the Haida canoe miniatures in museums interrupted history not just in the present but for the future of Haida carving, the miniatures operating as a single object distributed though time.

From this first canoe project sprang more such projects on the coast, most notably Reid's large canoe *Loo Taas*, which has travelled the world with its crew giving demonstrations of Haida watercraft. It, and the canoe journeys it inspired, are commonly cited as the genesis of a resurgence in canoe culture among Indigenous Northwest Coast peoples (Neel 1995; M.J. Reid 2011). Miniatures have played a significant part in this process right from the beginning, used by modern carvers to practise form and shape. When Bill Reid was examining longhouse design at the Museum of Anthropology in Vancouver in 1960, he mocked up a paper miniature to experiment with design and style. When one of his younger colleagues, Robert Davidson, was photographed in his studio for a book by Peter Macnair, a smooth Northern-style canoe miniature sat on the table to his left (1977, 150).

Contemporary carvers see themselves as a continuing part of this legacy. Gwaai Edenshaw was an apprentice to Reid, and talked of this connection:

JACK DAVY: *Do you see yourself as part of the ongoing process of preserving and, I guess, developing Haida art?*
GWAAI EDENSHAW: *Yeah, absolutely. I mean I sort of see myself, on the one hand as just a working stiff that's just plugging away doing you, know, what I gotta, but especially recently, with some of the revelations that have come to us through the work at the Pitt Rivers and the master of the great*

box and subsequent studies that have been in, I felt like we've really rediscovered some important little pieces of the story. Particularly around the box, but then there's other little elements. And so yeah, I'm feeling lately more a part of it than ever.

Miniatures as Ideology and Continuity

A 1966 novelization of the history of the Haida Nation, *Raven's Cry*,[4] which Bill Reid approved and for which he supplied the illustrations, purports to recount Charles Edenshaw's thoughts in the 1890s:

> The race was dying out. The social order was dying out even faster. Charles Edenshaw, *Da·axiigang*, did what he could to let both die with dignity. He assumed the head chieftainship of the *Sdast'a·aas* Eagles with quiet ceremony. He continued to give feasts at intervals, and to distribute gifts to the people.
>
> But his whole being was caught up in a strange compulsion. His race was dying out; and he could not stop the dying. His social order was dying out; and he could only see that it died with the dignity of the Haida. But one thing was too strong to die, Haida art!
>
> It was as though this unique style of decoration, developed through thousands of years in an environment that was fabulously rich and yet chill and challenging, was too strong to die with the people and the social order that had nurtured it. Now, threatened with extinction, it worked like a compulsion through *Da·axiigang*, like a disembodied spirit using the fingers of Charles Edenshaw. It would live on! This man was the link between its past and its future. (Harris [1966] 1992, 180)

It is of course impossible to know whether these thoughts ever passed through Edenshaw's head or the heads of his contemporaries, but there is no doubt that to modern Haida carvers this artistic connection between generations is very real:

> There is a practice in our culture called "putting a string on" someone. For example, during the times of arranged marriages, a family of a very young girl might endow a great deal to the family of a young boy, effectively "putting a string" on that child, ensuring the two would one day marry, and move forward in life together.

> I like to think Charles Edenshaw and Bill [Reid] put a string on their work, binding us to something that is so much more than art. Binding us so that we'd come together in the future, when the time was right. (Collison 2016)

Understanding this string is key to understanding the role miniatures have played in the relationship between Haida artists of the late nineteenth century and Haida artists of today. The art deliberately forms a bridge of knowledge that spans generations and crosses uncertainty, as Gwaai Edenshaw explains:

JACK DAVY: *When you go to museums and look at collections, is it for inspiration?*

GWAAI EDENSHAW: *Yeah, to re-learn parts of our culture. You know they say that the upper amount of Haidas that there were before the epidemics was 40,000, the lower would be 20,000, and then the whole population dropped down to about 500, I think about 600 actually. So you think about the amount, the amount of knowledge lost there.*

Miniaturization was not an alien technique to the Haida, although there is no definitive proof, as there is among Makah communities, that the practice existed before contact. Northern artists were certainly enthusiastic practitioners in the immediate post-contact era, supplying high-quality canoe miniatures to Spanish, British, and Russian merchants and explorers. These objects display not only skilful carving techniques but also a rich and adventurous approach to imagination, as demonstrated by their disproportionality, their painted decoration, and the figurative scenes they depict. They are representations not of everyday working canoes but of the highest-status, most aspirational, and most magical of Northwest Coast watercraft, qualities that accentuate the inherent fascination provoked by miniaturization.

In the late nineteenth century, Northern cultures such as the Haida were under huge threat. Population collapse was followed by official repression that sought to eradicate the traditional practices. The forests in which Haida peoples had lived for thousands of years were being clear-cut without permission or even the most basic consideration for their way of life, leaving shattered stumps and nothing left to make poles, canoes, or houses. Even Haida language was fast disappearing, and the psychological blow was

devastating: "What our Ancestors must have experienced during this time is more than one can bear to imagine" (Steedman and Collison 2011, 18). Nika Collison (2016) contextualizes the significance of language being erased:

> Born from the lands and waters of Haida Gwaii, it is not just a language; it is a different way of thinking, a different way of seeing, a different way of knowing.
> It is Haida knowledge, history and wisdom stored.
> It defines our intrinsic relationship to the lands, waters, airways and Supernatural Beings of Haida Gwaii: that which makes us Haida.

Yet despite the suffering, or perhaps because of it, Haida people took up miniature carving as a medium safe from official persecution and developed the art form in new, expressive ways. They knew that the only way to preserve these practices was to continue them. And that is what they did, protecting it until future generations could discover it once more, so that, "Today, children grow up knowing the raising of poles and the paddling of canoes. They've slept in longhouses and they live off the land. They're adorned with fine hats and regalia as we put our chiefs forward. They begin singing and dancing in the womb" (Collison 2016).

What those carvers chose to create is key to understanding the role miniaturization has played in developing the "string" that links northern Northwest Coast art across generations, allowing modern Haida society not just to regain lost history but to build on it to redefine their future, interrupting historical trajectories through the work of carvers such as Bill Reid (Worl 2008). Miniaturization of course operated alongside numerous other techniques and processes, but its unique quality of ideological representation meant that its products functioned both as satirical resistance to colonial oppression and as a reservoir of knowledge for future generations.

Northwest Coast material culture is explicitly visually expressive, incorporating figurative design elements as fundamental components of functionality. Northern artists consciously understand the affordances required for display, and have always responded effectively when commissioned to produce artifacts for sale as souvenirs or to museums or expositions. They have created objects that provide an attractive and fascinating experience to the audience in much the same way as they would when carving a mask for a potlatch.

Smaller artworks, such as bowls, spoons, and masks, can travel to these destinations comfortably, but larger examples of material culture, such as full-sized canoes, houses, and totem poles, are not so easy to convey and lack the intimate qualities necessary for ideological transmission. In miniature, however, these colossal symbols of personal and familial identity can travel farther, in greater numbers, and with greater effect. Just as the Makah employed them, Northern miniatures can represent their makers in strange places among strange people; portability is one of their essential qualities. What differentiates the miniaturization taking place among the Northern tribes at this time is its imaginative qualities. Even when drawn from physical prototypes, almost none make any attempt at proportionality, particularly the houses. Most portray canoe or totem pole designs that disappeared generations ago or never existed at all, and they often feature painted decoration reminiscent of the crests of powerful families or of cosmological events. The prototypes of these miniatures are not usually physical objects but imagined or learned designs, intangible elements that would otherwise have been lost in the crises of the nineteenth century.

Thus they preserve the ideology they embody, forming a relationship between miniature and people. The canoe miniatures given to a foreign naval commander evoke a lost time when head canoes controlled the coast of the northeastern Pacific, decorated with the personal crests of the men who had them made. Inside the houses on display before the assembled American people, tiny figures perform dances forbidden by government edict. Louis Shotridge creates mimetic replicas of empty villages. These actions could all be interpreted as nostalgic glimmers of fading cultures; certainly that is how contemporary anthropologists saw them. And yet that is not the Haida way, not the way of the northern Northwest Coast. They form a movement of aspiration. The art endures, it adapts, and it survives, and when Bill Reid and his contemporaries returned to the art, it was waiting for them, including the miniatures with their preserved ideological messages intact, and it helped to shape them as carvers and to shape the art they continue to produce to this day.

3
Tiny Dancers and Idiot Sticks
The Kwakwa̱ka̱'wakw

OFF THE NORTHEASTERN COAST of Vancouver Island lies a small archipelago of forested islands, the trees once clear-cut and now growing once more. On one, Cormorant Island, is the village of Alert Bay, the primary settlement for the 'Namgis Kwakwa̱ka̱'wakw[1] people and a scene of Northwest Coast oppression, resistance, and survival. Within that story, miniaturization has played a crucial yet unacknowledged role in subverting colonial authority and preserving traditional practices.

Unlike in neighbouring northern and southern communities, Kwakwa̱ka̱'wakw culture exhibits little physical evidence of a long history of miniaturization. The earliest ethnographic accounts of the practice date only to the 1880s, when Franz Boas commissioned a set of miniature canoes from Quatsino, now in the American Museum of Natural History in New York. In my survey of canoe miniatures, only thirty-two could be positively identified as Kwakwa̱ka̱'wakw, with none dating from before the last decades of the nineteenth century. Like the Quatsino miniatures these examples were commissioned largely by anthropologists. It would be naïve to assume that miniaturization had played no part in Kwakwa̱ka̱'wakw material culture prior to this date, but comparison with the much larger surviving miniature corpus of neighbouring groups such as the Haida or Coast Salish indicates that the practice was not as common.

Nineteenth-century studies testify to the richness of Kwakwa̱ka̱'wakw visual culture and to the exceptionally large social, political, and economic significance afforded to the potlatch (see Boas 1966; Codere 1990). In opposition to this practice, along with other dances and ceremonies

often conflated with it, the government of British Columbia amended the 1885 Indian Act to explicitly ban the potlatch, a law that was for decades routinely disobeyed within Kwakwaka'wakw communities but which remained a constant existential threat hanging over their ceremonial and material culture. In 1921 the threat was realized, when Indian Agent William M. Halliday responded to an unauthorized potlatch with the confiscation, deliberate desecration, and ultimate sale of potlatch regalia and materials, large-scale arrests, and the establishment of a residential school at Alert Bay, thus effacing and dominating the largest Kwakwaka'wakw community. The result was the near cessation of the potlatch as a formal event and the imposition of harsh restrictions on Kwakwaka'wakw society. In combination with economic stagnation, the repression had a devasting effect: in the words of anthropologist Helen Codere, by "the forties, the potlatch system was broken" (1961, 483). Indigenous traditions were trampled all along the coast, but it was uniquely among the Kwakwaka'wakw that they were deliberately, systematically, accurately, and effectively targeted by law enforcement (Cole and Chaikin 1990, 181).

The damage was profound. Forty years after Halliday's operation, Codere lamented that "it might be possible to claim that this was the end of Kwakiutl culture and that the remainder of their history is simply that of rapid assimilation to White Canadian culture," but she was ultimately correct when she nonetheless concluded that "reports of the death of Kwakiutl culture have been greatly exaggerated" (1961, 513; Ringel 1979). Since the advent of the so-called renaissance on the Northwest Coast, Kwakwaka'wakw culture has once again been openly practised in communities such as Alert Bay, and Kwakwaka'wakw material culture forms a popular part of the regional art movement (Cranmer Webster 1990).

Miniaturization though played an important role in the survival and revival of Kwakwaka'wakw traditional culture in the twentieth century, the key lying in important aspects of miniaturization within material culture production and distribution – including commercial considerations and practical education – that have led to a coherent strategy of non-violent resistance.

The Role of Potlatching

Kwakwaka'wakw people live in communities distributed across the central coast of British Columbia, organized in bands located primarily along the

coastlines of the Queen Charlotte and Johnstone Straits that separate Vancouver Island from the mainland. Their lands are exceptionally fertile, so much so, Codere noted, that "their permanent villages, material wealth, and capacity to support an extensive ceremonial, potlatching and artistic life makes them much less comparable to the hunters and gatherers with which they are often classified than to settled agriculturalists" (1990, 364).

Although potlatching systems are common all along the Northwest Coast, they may have reached their greatest size and significance among Kwakwaka'wakw communities. Codere called the potlatch "an institution that contributed to the integration and dynamic drive of Kwakiutl society by validating social status and giving material manifestation to an expanding and changing network of social exchanges and reciprocities" (1990, 368). The Kwakwaka'wakw held them for many reasons, including small intra-village potlatches to cover the shame of falling out of a canoe, children's potlatches with toy gifts, and play potlatches in which the social order was temporarily overturned (Codere 1956; Ford 1941, 85–86). There were also much larger and more important events, known as Máxwa in the Kwak'wala language, at which chiefly names would be assumed, gifts distributed, and at the most important potlatches of all, marriages agreed, confirmed, and annulled (Codere 1990, 368). Crucially, Kwakwaka'wakw potlatches were not always serious events, often incorporating considerable humorous and satirical elements. These particularly involved jokes at the expense of Europeans and government officials, operating as satire in a similar vein to that found in the material culture of their northern neighbours (Codere 1956, 340).

The primary economic function of a potlatch was the distribution of wealth. Hosts would present their guests with large quantities of trade goods, most commonly blankets but covering all markers of value in Kwakwaka'wakw society. The most valuable of these gifts were coppers, ceremonial containers of wealth shaped into large, angular copper shields. A host might prepare for years, storing wealth and taking out loans in order to be able to afford a potlatch, and the gifts imposed an obligation on recipients to exceed them at potlatches of their own. A successful potlatch thus left the host's enemies and allies alike with substantial obligations. It is for this reason that the Kwakwaka'wakw termed potlatching "fighting with property," since the imposition of obligation demonstrated social, economic, and political supremacy without the necessity of resorting to violence (Codere 1966b).

Proliferating employment in logging, fishing, and canning industries in their territory in the mid-nineteenth century led to a profound breakdown

in traditional social structure among Kwakwa̱ka'wakw bands. Since any person, no matter their ancestry or clan, could now gain access to enough wealth to hold a potlatch, the hegemony of traditional chiefly families was disrupted (Piddocke 1965), a systemic problem exacerbated by very high mortality during the period. Possibly as much as 75 percent of the Kwakwa̱ka'wakw population died from epidemics between 1830 and 1870 (Cole and Chaikin 1990, 68).

Halliday and the Cranmer Potlatch

Alert Bay was founded in 1881, when the 'Namgis band of Kwakwa̱ka'wakw was persuaded to relocate from the mouth of the Gwa'ni River to Cormorant Island, where a fish-processing plant had been constructed. It was intended that the Indigenous arrivals would work at the plant and their children would attend the mission school, where education was focused on agriculture (Cranmer Webster 2013, 266).

In 1921, William Halliday learned that a potlatch had been held on Village Island, to the east of Cormorant Island in the Johnstone Strait. At the potlatch, which was organized to recognize the divorce of Chief Dan Cranmer and his wife, Emma, the chief received repayment of the goods presented at their wedding and then distributed potlatch goods of greater value, assessed by Codere as worth at least C$30,000, making it the largest potlatch recorded to that date (Codere 1961, 467; Codere 1966a). Delegations from many Kwakwa̱ka'wakw bands attended, although few from Alert Bay itself, as they were particularly concerned that Halliday was planning a major operation. The agent had become increasingly aggressive in his prosecutions of potlatch participants in recent years, issuing fines and prison sentences to several prominent persons (Cole 1985, 250).

Notified of events at Village Island by an Indigenous informant, Halliday made sweeping arrests of the potlatch participants. Most pleaded guilty, although Kwakwa̱ka'wakw accounts of the trial suggest that their claims were deliberately mistranslated by interpreters. Halliday authorized the remission of prison sentences for those who agreed to surrender their potlatch regalia, including masks, clothing, and coppers (Sewid-Smith 1979, 47). Although most did so, some refused and were sent to Oakalla Prison Farm, where they were forced to perform deliberately humiliating menial tasks such as feeding pigs. Others hid or destroyed their regalia rather than have it confiscated by Halliday's police agents (Cole and Chaikin 1990, 119–24).

Halliday placed much of the seized regalia on display in the parish hall at Alert Bay. Exposing reserved chiefly regalia and wealth in public was an intentional attempt to desecrate it as well as a conscious expression of his victory. The confiscated regalia was then catalogued, boxed, and sent to the National Museum in Ottawa, where it was dispersed. Small *ex gratia* payments were made to the owners of the material, although some did not receive the cheques while others refused them as insultingly low compensation for what they had given up (Cranmer Webster 2013; Sewid-Smith 1979).

The loss of the regalia and coppers and enforcement of the ban on potlatching was devastating to the Kwakwa̲ka̲'wakw; the ensuing period became known in Alert Bay as the Dark Time and was a major catalyst in the narrative of what is sometimes called the Dark Ages of Northwest Coast culture (Hawker 2003, 17–33). Despite Halliday's confidence, however, Kwakwa̲ka̲'wakw potlatching did not cease entirely but instead withdrew to the fringes of society, taking place in distant villages during the worst weather to obscure its appearance, a practice known as a "bootleg potlatch" and similar to the remote celebrations of the Makah (Cole and Chaikin 1990, 165; Cranmer Webster 2013, 267; Macnair 1986, 515). As Kwakwa̲ka̲'wakw historian Daisy Sewid-Smith (My-yah-nelth) wrote, Halliday "was sure the 'evil' Potlatch had at long last died, but the truth of the matter is that it had gone 'underground'" (1979, 1).

Despite resistance, traditional potlatching became less and less frequent in the ensuing decades, and by the time of the repeal of the ban in 1951, "a lack of community feeling and leadership" had led to an almost total cessation of organized ceremonial activity (Codere 1961, 501). Dan Cranmer himself lamented in his later years, "So I am a big man in those days. Nothing now. In the old days this was my weapon and I could call down anyone" (Codere 1966a, 117).

Halliday then obtained funds for the construction of St. Michael's Indian Residential School in Alert Bay. The largest such institution in British Columbia at the time, Halliday boasted that it was "one of the most modern and up-to-date buildings in the whole of Canada, with a capacity of 240 pupils." In 1935 he proudly wrote that "the change in the attitude of the Indians toward education can be seen, for instead of encountering a difficulty in obtaining pupils, the school is almost full and next year will have a capacity enrolment" (Halliday 1935, 235). Despite his confidence, conditions were squalid. A 1947 inspection revealed that "everywhere was found evidence of very bad housekeeping and maintenance. On the boys' wing only one toilet

was found in order, most of the others being in a filthy condition and running over into the dormitories" (TRC 2015b, 179), and another report the same year concluded that the "quality of food given to the children and staff of this institution is one of the dark pages in the history of this school" (247).

At the school, Kwakwa̱ka'wakw culture was banned and students were stripped of their Kwak̓wala names and arbitrarily assigned English ones instead (TRC 2015a, 599), or later stripped of names entirely and referred to only by number (TRC 2015c, 67). Pupils were forbidden to speak Kwak̓wala or other Indigenous languages – the goal was "to get them comfortable with English, because that was the language of the dominant society" (TRC 2015b, 542) – and they were beaten or humiliated if caught doing so (TRC 2015c , 49–50, 141). Pupils who attended throughout the school's existence report savage beatings for minor disciplinary infractions, administered arbitrarily (TRC 2015b, 375, 389; TRC 2015c, 141), and rampant sexual abuse ignored by school authorities (TRC 2015b, 424). It is unsurprising that in this brutally repressive environment traditional culture suffered among the generations who endured it. St. Michael's physically dominated Alert Bay: an ostentatiously brutalist structure imposed in the midst of the Indigenous community, a constant reminder of Halliday's authority and the desire of the Canadian government to destroy Kwakwa̱ka'wakw culture and assimilate Kwakwa̱ka'wakw people.

Although Halliday sought to eradicate traditional Kwakwa̱ka'wakw culture with his assault on the potlatch, he ultimately failed, because "Indians were not supine victims of white legislation. That the [potlatch] law went largely unenforced [after 1927] was in great measure a result of native resistance, even defiance" (Cole and Chaikin 1990, 183). Indeed, the immediate response to Halliday's operation was a sudden increase in material culture production as those whose possessions had been confiscated commissioned replacements. Through this process, a new generation of carvers, among them Mungo Martin and Charlie James, became proficient (Cranmer Webster 2013, 268). Over a longer time, however, the slow erosion of potlatching, and in particular of public performance, meant that the associated regalia was no longer in regular demand and production gradually declined. Aggressive Christianization and modernization led some to willingly renounce the potlatch, and to destroy longhouses and regalia, while the financial crash of the 1930s threw the commercial systems on which the potlatch depended into chaos (Cole and Chaikin 1990, 161–64). As a result,

little traditional carved material culture was available during the 1940s and 1950s, and much of that which had survived intact was acquired by collectors and dealers (Cole 1985, 254).

Charlie James, Ellen Neel, and Mungo Martin

A few Kwakwaka'wakw carvers refused to abandon their traditions entirely during this era, thus ensuring that their designs and techniques were not lost. Perhaps the most significant member of this group was Charlie James (Yakudłas, c. 1867–1938), who continued to carve in Alert Bay (Nuytten 1982, 8). Alert Bay had become a regular stop on the Alaskan cruise circuit, and James was able to subsidize his large-scale totem poles by carving small objects, and in particular miniature poles, for sale to the reliable influxes of tourists seeking souvenirs.

James was an enthusiastic practitioner of miniaturization, typically producing variations on standing poles at Alert Bay, with the same composition of crests, although their order and position could vary considerably. Jennifer Kramer notes that while others churned out "speedily made and cheaply priced imitations of full-scale totem poles, James showed the same care and attention to detail in his larger and smaller works" (2012, 45). He was nonetheless derided by some contemporaries for his miniature totem poles in particular, which were mockingly referred to as "idiot sticks" because it was said that "any idiot" could carve them (Cranmer Webster 2013, 268; Davy 2019; Hawker 2016, 5; Kramer 2012, 45).

Although he worked to a range of designs, James's most commonly reproduced pole was one he himself had carved, which now stands in the U'mista Cultural Centre. This was an important image for James, most likely reproduced frequently as a way of affirming the crests and lineage he was forbidden to display through potlatch, as U'mista curator Trevor Isaac explains:

A lot of times I know that for Charlie James in particular, he carved the pole repeatedly because that was their crests and the history of his own personal family. So if you look on the top it is a Qulos [Sea Eagle]. The Qulos is the first ancestor of his people and then underneath it tells of a legend, a separate story, of going into the undersea world, so that's why it's got the bear from the sea, or a sea bear, and there's a killer whale and a frog and a bullhead

and the man. So this is a story that he felt very strongly about that he always depicted, and most of his totem poles are the same crest figures but sometimes arranged differently, but still telling the same story.

James did not stick rigidly to this imagery, however. Ronald Hawker notes that his miniatures, freed from the restrictions of traditional art practice, deliberately play with reality: "They interact. They break free of their compression onto the columnar form of the pole. They come alive. Of all James's carvings, this genre is perhaps the most captivating to the outside world. At their best, James's miniature poles are playful, beautifully carved and painted, evocative, and creatively ambitious" (Hawker 2016, 153). His miniatures frequently manipulate form, theme, and structure with an eye to diverse audiences. In a miniature pole produced around 1930, for example, he replaced the central figure with the Hollywood icon Pepito the Clown, playfully dedicating the work to the celebrity (Hall and Glascock 2011, 111). Such works are sometimes described as his "oddities" (Hawker 2016, 161).

So prolific was James that his works have sometimes been credited with fundamentally changing what is expected of a totem pole: he is thought, for example, to have been the first pole carver to incorporate outstretched wings on the surmounting eagle (Glass and Jonaitis 2011, 15). It is no coincidence that Kwakwa̱ka'wakw people themselves fondly remember him as a traditional artist, while non-Indigenous writers have often classified him as a maker of curios for outsiders (Macnair, Hoover, and Neary 1980, 72–73); his work knowingly spanned this division, consciously blurring the lines between traditional art for community use and touristic art as part of a unified body of artistic commentary. His dual reputation exemplifies and to an extent critiques the separation between internal and external understanding of Indigenous authenticity in the early twentieth century. Despite sometimes being derided in his lifetime, he is now considered among the finest artists of the region and his work has subsequently informed broad contemporary understanding of Northwest Coast art (Nuytten 1982).

After his death in 1938, James's granddaughter Ellen Neel (1916–66) assumed his position as the most prominent miniature pole carver among the Kwakwa̱ka'wakw, adopting many of his designs (Nuytten 1982, 16). Neel recruited her family into the miniature totem carving industry, supplying curio stands and souvenir shops along the BC coast with large numbers of hand-carved and painted poles. As has been seen with respect to Makah and Haida production, Neel responded to commercial imperatives as she

refined James's designs, creating sharper lines and more defined imagery to cater to the higher end of the expanding and increasingly competitive souvenir market (Hall and Glascock 2011, 130; Nuytten 1982, 54; Townsend-Gault 2004, 194). Neel and her family were prodigious and highly skilled carvers and painters, often playing with the medium for commercial fascination, as exemplified by the 1954 "world's smallest totem" presented as a gift to the entertainer Bob Hope (Nuytten 1982, 58). In this way imaginative experimentation through miniaturization and distribution beyond her own community defined Neel's work; although she had produced thousands of miniature totem poles in her career, the last piece Ellen Neel ever made was a miniature canoe (Nuytten 1982, 72).

At the same time as Neel was running her pole workshop, her uncle, Chief Mungo Martin (Nakapenkem, c. 1880–1962), James's stepson and another of his protégés, was advancing Kwakwa̱ka̱'wakw material culture in a different way, described as "almost singularly responsible for the revival of Northwest Coast art" (Macnair, Hoover, and Neary 1980, 73). In 1950, Martin assumed a position at the Museum of Anthropology at the University of British Columbia, the first Indigenous Northwest Coast artist since Louis Shotridge to be heavily involved in museum collecting and curation. Like Shotridge, Martin saw his position as an opportunity to preserve and display traditional material culture, arranging the acquisition of a number of significant examples of Kwakwa̱ka̱'wakw regalia in the 1950s (Cole 1985, 254). He later moved to work at the Royal British Columbia Museum in Victoria, where he carved and built a traditional longhouse named Wawaditła, which was to function not only as a large-scale installation but also to host newly legalized potlatches (Nuytten 1982, 87). Martin carved prolifically for the Royal British Columbia Museum, producing a full-sized canoe and a substantial body of carved art, including a number of miniature canoes demonstrating Kwakwa̱ka̱'wakw hunting practices. These objects reflect Martin's engagement with miniaturization as a communicative device.

One example, now held at the U'mista Cultural Centre, is a diorama illustrating two Kwakwa̱ka̱'wakw men on a seal hunt; another diorama, of a highly fanciful killer whale hunt, is in the collection at the MoA (Figures 3.1 and 3.2). These two miniatures reveal Martin's attention to differences in the audience and environment of the museum and the Indigenous community. Both are small hunting canoes made from close-grained yellow cedar painted in Kwakwa̱ka̱'wakw block colours. As is usual in Northwest Coast miniaturization, the proportions are distorted, but the small-scale

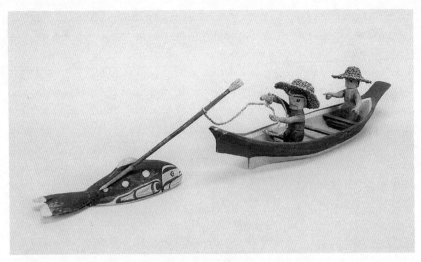

Figure 3.1 Canoe miniature diorama by Mungo Martin, c. 1950s. | Reproduced by permission of the University of British Columbia Museum of Anthropology, MOA A4259

vessels are broadly in proportion to their crew, who feature simple, naturalistic clothing, including woven hats (lost on the U'mista miniature).

The U'mista diorama was a gift from Martin to a community member and in it the canoe crew are hunting realistically sized seals that are poised to leap from a shore. It is a traditional Kwakwaka'wakw hunting scene using traditional technology in a naturalistic manner. The other example was presented by Martin himself to the Museum of Anthropology. It shows ostensibly the same Kwakwaka'wakw hunters targeting an unusually small killer whale. The whale is the only part of the diorama that is painted with formline, although Martin's other work clearly demonstrates that he was highly proficient in the art form: skilled in its application and knowledgeable about its significance. The MoA example comprises dissonant images that are at odds with the other hunting diorama: the Kwakwaka'wakw have never hunted whale of any kind, killer whale hunting is not a traditional practice anywhere on the Northwest Coast, and no one would consider it appropriate to hunt any whale in a canoe of such small size.

Thus one miniature is a naturalistic reproduction of a common Kwakwaka'wakw practice, while the other an imaginative autoethnographic representation of an event that could not have occurred. It is, as Kwakwaka'wakw artist Wayne Alfred described such carvings at interview, "a Kodak moment. You've captured that moment in time inside that legend. Do you know what

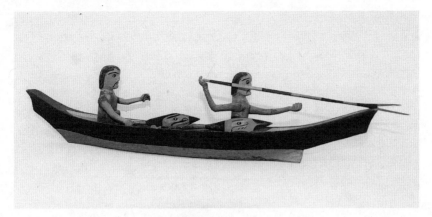

Figure 3.2 Canoe miniature diorama by Mungo Martin, c. 1950s. | U'mista Cultural Centre, Christina Cook photographer

I mean? Because every legend's got truths in it: places, times, and names and actions that happen in there." Alfred also noted the aesthetic appeal of the piece:

WAYNE ALFRED: *There's some pretty good miniatures in here. You see that seal and that in here, the seal and that? Why did they make that? What was that all about?*
JACK DAVY: *The Mungo Martin piece?*
W.A.: *Yeah, the bunch of seals diving off. Nice little miniatures, yeah. And the same thing is plaques – what are they for? Same thing, people like them because it looks good on your wall rather than a mask, you know, looks good over a fireplace if it's just stained. So people like them in the corner of their frameworks on their house, you know, put it along there, like a thunderbird or something straight up.*

The seal-hunting diorama has undeniable aesthetic qualities, as Alfred notes, and was designed to sit on a shelf as a decoration in someone's home. At the same time, it demonstrates a clear separation in Martin's work between miniatures for Kwakwa̱ka'wakw consumption and miniatures for consumption by non-Indigenous museum audiences. The potlatch ban had been repealed only in September 1951, and certain ceremonials had begun again the following year (Cole and Chaikin 1990, 168–69; Spradley 1969, 159–62). Although many Kwakwa̱ka'wakw were initially reluctant to participate, Martin was an active proponent. However, the Canadian government presence was still emphatic in Alert Bay, and Kwakwa̱ka'wakw people had only recently faced reprisals for keeping traditional ceremonial artifacts. Recalling this, it becomes possible to interpret the U'mista miniature, with its imagery of traditional hunting, as a "safe" object that would not attract attention from the authorities when displayed in the home. The whale-hunting diorama, displaying "a moment in time inside that legend," portrays a cosmological narrative that had until recently been hazardous in a Kwakwa̱ka'wakw home but was safe and preserved in the museum environment.

Martin's liminal position between competing and in some ways mutually exclusive worlds indicates his dual role at a time of great social change, using miniaturization as one tool to explore what art meant for the Kwakwa̱ka'wakw following legalization. Paige Raibmon comments that Kwakwa̱ka'wakw "survival under colonialism required compromises, but these compromises were not necessarily symptoms of decline, and could be signs of resiliency" (2005, 64). Trevor Isaac explains the complexities of this adaptation, which had to marry traditional restrictions on the use of ceremonial objects with the modern imperative to display them:

In earlier times none of the artifacts would be on display in the home of a chief or even allowed on display in a museum. So that's what I'm trying to think of. There is the traditional historic role and then there is today's terms. So there is a tricky way to balance our life in Western society and the traditional. The culture has changed so rapidly in such a short period. There is a lot that we cannot control, I guess, any longer.

Martin's two dioramas offer a contrast between art for museum display, in which imaginative material culture is protected from reprisal, and art for the Kwakwa̱ka'wakw home, where it was ostensibly not. It does not invite

value judgments over quality or meaning, but it does emphasize the message that some stories are safe and some are dangerous.

Martin took seriously his ambition to further scholarly understanding of Kwakwaka'wakw culture, improve links between museums and Kwakwaka'wakw communities, and advance his own commercial carving business. Curator Wilson Duff wrote of him that

> he has assigned himself the task of preserving all he knows about Kwakiutl culture. Whether it is by book or adze, paintbrush, on the tape recorder, or in the notebooks of his anthropologist friends, he is determined that this knowledge will be recorded for posterity. In my view, this objective appraisal of the situation and this conscious decision to preserve the culture are Martin's clearest claims to true greatness. (Quoted in Nuytten 1982, 108).

Thus James, Neel, and Martin had, with others, deliberately and systematically used miniaturization to preserve Kwakwaka'wakw practices and techniques during the years when open potlatching was in abeyance, and they left trained apprentices ready and enthusiastic to continue the process.

Commerce and Resilience

As elsewhere in the region, resilience through art could not be achieved without a commercial market, and small objects, with their fascinating tactility and relative portability, were an effective way to reach that market, as two Kwakwaka'wakw artists explain:

I started painting them on clam shells and selling them to tourists, so here's this seven- or eight-year-old boy sitting in front of the council hall in downtown waterfront Alert Bay as all these big ships would come in and hundreds of people would be walking by and I would sell all my painted clam shells to these tourists. The smaller ones were a dollar, a little bit bigger were two dollars, and the real big ones were five bucks. So after I sold the first ten, I went and grabbed twenty shells, the next day sold them, went and grabbed forty shells. I doubled it every time. Eventually I said I'm going to fill this box right up. So I filled the box up and I painted all of them and went and sold them down the beach. In one day I sold them all, 450 bucks I made in one day when I had that full box. | GARY PETERSEN

> [Russell Smith] came by and he was starting to make his miniatures and he was selling them for fifteen dollars, sometimes twenty-five. We're talking about the early '60s, late '60s, [it] was a lot of money back then – what's twenty-five dollars today? – when you are only paying ten cents a pop and fifty cents for a pack of cigarettes, thirty cents to get in the movies. See what I mean? | WAYNE ALFRED

It is not an easy career; some artists found the returns on miniature objects too small. Wayne Alfred commented, "I have a hard time with them to sell them. Unless someone orders them and wants them. People in white society like to see big for their money," while "making a miniature is no easier than making a big mask. You learn to make a big mask first, because on the little ones you have to do exactly the same cuts, it's just smaller and smaller knife cuts and if you make one mistake you have to throw it all away." Gary Petersen was likewise concerned that customers did not understand the amount of work required to produce a small object:

> There is just as much work in that miniature as there is to make one that is ten inches, a face mask. The same number of swipes comes off of it, but a smaller ratio. So if it takes 150,000, or say half a million swipes for this face mask, it's going to take half a million swipes for this small one, but smaller pieces, tiny little cuts. And on a small piece, if you make a mistake it shows. On a big piece you can be off just a little bit and you don't even notice it, but on a small one, if you make one mistake after two weeks work you've just ruined it. You've got to take that whole thing and take it down a little bit more here, do it [in] replicate on the other side, so a lot of people have to realize, those small ones, they're worth just as much as buying a big mask, some of them.

Despite the troublesome economies of small-scale carving, the ready market for portable souvenirs encouraged an increase in carvers operating in Alert Bay and other Kwakwaka'wakw communities. Those with the skills found that carving provided a sufficient income when other careers were closed; artist Steven Bruce Sr. recounts that the booming fishing industry discriminated against inexperience, and that carving staved off unemployment: "I was trying to get a job on a fishing boat and back then, in the '80s, the early '80s, the fishing industry was booming and the last thing they wanted was a greenhorn on a boat."

Carving education was not an informal process. It required an apprenticeship with an experienced carver, more often than not starting small and learning though experimentation:

If you can do lots of small ones you get your basics and then you switch them round on the piece and change the nose, change the eyes, the nose and create these different characters in your culture and you can learn a lot from doing these small ones. And it keeps you ... for me, it kept me excited and wanting to learn more. | STEVEN BRUCE SR.

Thus the physical processes of miniature production at this early stage of a carver's career facilitated a grasp of the principles of carving, an opportunity to experiment, and the income necessary to persevere with a lengthy and arduous training. In this way miniaturization, which had enabled Charlie James, Ellen Neel, Mungo Martin, and their contemporaries to preserve traditions in earlier times, continued to form an essential part of the development of young carvers in Alert Bay at the very point in which Northwest Coast material culture production began to increase once more, during the so-called renaissance.

Gordon Scow and the Tiny Hamat'sa

Beneath the acculturated surface of Kwakwaka'wakw life in the 1950s, the period that Helen Codere researched with such concern for the future of traditional practices in places like Alert Bay, miniaturization continued to operate as a subtle method of non-violent cultural resilience, preserving what was possible in miniature form and sending it to external audiences within view of colonial authorities. As observed, potlatching and ceremonial life did not cease completely after Halliday's campaign of 1921 but continued underground in more subtle and less visible ways. Gift giving, disguised and to an extent conflated with Christian holidays, retained its reciprocal, symbol-laden position in Kwakwaka'wakw society.

One of the most significant events of the Kwakwaka'wakw calendar was the Hamat'sa ceremony. Held in the winter, it was reserved for scions of the most powerful noble families, those with the right to join the Hamat'sa society, sometimes called the Cannibal society. Preparation could take several months and involved bodily suffering and deprivation, communal celebration, and restrictions on the distribution of knowledge (see Holm 1990, 381;

Macnair 1986, 511; Spradley 1969, 81–93). The dance lasted several days. Only through this ceremony could young men from noble families enter the ritual societies that marked adulthood, and some were inducted when they were as young as ten (Cranmer Webster 1990, 388). The dancers wore distinctive masks depicting Baxwbakwalanuksiwe', the Man-Eater-at-the-North-End-of-the-World, who took possession of the aspirants during the preparatory period and was tamed by the dancers during the ceremony.

Hamat'sa masks and regalia were restricted. Traditionally an initiate could dance only in a mask made by someone within the society due to the spiritual power inherent in the event, as Trevor Isaac explains:

There are certain things, like the hamsaml masks from the Hamat'sa series, like the model poles, you know the larger masks, they are so powerful. And the spirituality around those artifacts from the different dance societies, at one time only a Hamat'sa could carve – that's what I was told – only a Hamat'sa could carve one of those cannibal bird masks, hamsaml masks ... so it wasn't public knowledge how something would appear or disappear.

James Sewid describes one of the last such events, which took place in 1931, and begins with a frank admission that he was unwilling to violate the potlatch ban and place his young family at risk of his imprisonment:

My grandfather came to me and told me once again that he was going to put on a big do and it was going to be the last one. And he told me "I want you to be my top dancer" ... Well I just figured I shouldn't do it because I already had a couple children and I guess I was afraid of the law at that time. It was against the law to have potlatches and put on those dances [and] I didn't want to break the law. (Quoted in Spradley 1969, 81–82)

Sewid was nevertheless prevailed upon to participate in the Hamat'sa ceremony, which after suitable preparation gathered representatives from numerous Kwakwaka'wakw communities at the isolated community of Village Island, the place where Dan Cranmer had hosted a potlatch in 1921 and where there was no permanent government presence. The event passed successfully, the assembled Kwakwaka'wakw together performing traditional dances and songs alongside some designed specifically for the event. The celebration continued for several days, until Sewid had been inducted into the Hamat'sa society. As it concluded,

We heard that a sergeant of the mounted police was coming up to Village Island to investigate what was going on. They had heard about our dance there and that a young man had been put through it, which was against the law ... He told us "I have been sent from the government to investigate what was going on in this village and I'd like to see what it is that you were doing." He demanded to see it that night so we put on a good show for him. The dances we did were all mixed together and not in the right way we had been doing them. I was dancing with a fool's mask on ... One of our people was interpreting to him [the officer] what it was all about. And he asked him "What is that dance there?" referring to me. "Well" he said ... "We call it the fool dance because he is supposed to be a man who doesn't know anything."

The police officer clearly wasn't completely deceived, however, as he then insisted on seeing a second dance closer to the original Hamat'sa: "At the end he got up and thanked the people and said 'It was a wonderful dance. I really enjoyed it. I can't see anything wrong with it.' After that he went back to Ottawa" (James Sewid in Spradley 1969, 93).

This anecdote neatly illustrates that Kwakwaka'wakw people were well practised in continuing to pursue ceremonial and material practices despite government observation and repression, and had developed subtle mechanisms to preserve these activities should they be caught. Sewid's description is a good example of ethnodrama, an occasion when invented dances for non-Indigenous audiences helped to bypass restrictive laws against traditional ritual practices and preserve ceremony in plain sight (Hawker 2003, 120). Townsend-Gault notes that such practices were widespread on the Northwest Coast at this time, "deployed as a form of protection, offering a screen behind which cultural practices could be continued" (2004, 190).

In Sewid's account, not only did the Indigenous participants attempt to protect restricted dances from uninitiated eyes, and themselves from a repeat of the 1921 repressions, but they did so in a manner that subtly mocked the official, rendering him ignorant and foolish to the Kwakwaka'wakw in attendance. This satirical practice was not dissimilar from that among the Tlingit and Haida, and in this context, it becomes possible to see much of the oeuvre of James, Neel, and Martin as material examples of ethnodrama. Neel and Martin were once recorded laughing about non-Indigenous assessments of miniature totem poles, because "a white person wouldn't know the difference anyway" between a traditional and non-traditional totem

pole (Jonaitis and Glass 2010, 158), echoing the dual audience identified by Townsend-Gault in conversation with Robert Duncan of the Wei Wai Kum First Nation (2004).

Codere (1961) notes that even ten years after the ban on potlatching and ceremonies was repealed, these activities were still not overtly performed. The memory of reprisals, including prison, fines, and confiscation of regalia, remained, and many Kwakw<u>a</u>ka'wakw were more concerned with obtaining economic and legal rights than with restoring lost traditions (Cole and Chaikin 1990, 170). Only later in the 1960s did ceremonial life begin to become open again. When the hated residential school at Alert Bay finally closed in 1974, it had been more than forty years since the last traditional Hamat'sa ceremonies, and the correct dances and songs risked being lost if they could not be taught to younger generations.

It was during this period that a carver at Alert Bay began to make little figures and distribute them as gifts to Kwakw<u>a</u>ka'wakw boys in attendance at Christmas giveaway ceremonies and other occasions. His name was Gordon Scow, and his family had been prominent in protests against the

Figure 3.3 Hamat'sa dance figurines by Gordon Scow, c. 1960. | U'mista Cultural Centre, Christina Cook photographer

potlatch ban in the 1920s (Sewid-Smith 1979, 82). Scow's figures provide a unique look at the ways in which miniatures can be used to consciously preserve and transmit culture through the essential affordances of the medium.

Scow's small human figures were carved from a local hardwood, probably alder, stained brown and varnished. They stand approximately 24 centimetres tall, each on its own wooden block; their well-proportioned limbs are positioned in dancing poses, with adjustable arms articulated with brass pins. They wear red cotton garters, arm bands, and breechcloths, the fabric unravelled at the edges to create long tassels. Their heads are covered by articulated Hamat'sa masks with adjustable jaws and fabric fringes, painted in the traditional red, white, and black designs of the full-sized masks (Figure 3.3).

Perhaps most significantly, no two are the same. Each figure has a different style of Hamat'sa mask and performs a different stage of the complex dance, the importance of which James Sewid makes clear in his account of his preparation for the last Hamat'sa ceremony:

> It was at this time that all the retired hamatsas would come and teach me how to dance and the new songs. They kept all of this a secret and nobody else could watch except the retired hamatsas. It was awful hard for me to take because they just sat there watching me dance and if I had made any mistakes they told me to do it all over again ... It was very important to do that dance right and not trip and fall while you were doing it. (Quoted in Spradley 1969, 85)

Scow's figures are not decorative curios or autoethnographies for external audiences. None was made for sale, and they do not exemplify casual experimentation with form and structure, such as the simplifications of Martin's canoe miniatures or the playful experimentation of James's poles.[2] These are faithful, well-scaled mimetic reproductions of Hamat'sa dancers, as is even more evident when they are deconstructed. Parts from an unfinished Scow figurine, held by the U'mista Cultural Centre at Alert Bay, reveal an impulse for personification concealed behind the mask (Figure 3.4). Each figure has a mask suited particularly to that dance and that dancer; the mask is firmly attached and cannot be replaced or swapped. However, the mask is not attached to the body directly. A small piece of wood connects the two sections, and this connective piece – invisible once the figure is completed – is shaped like a human face, with human features drawn on.

Figure 3.4 Unfinished head from Hamat'sa dance figurine by Gordon Scow, c. 1960. | U'mista Cultural Centre, Christina Cook photographer

Although the unfinished face has no discernible identity, the figures evidently depict individual dance participants, not necessarily living people from the community but people performing real and particular roles, analogous to the whale hunters in Makah miniature dioramas of the late nineteenth century. That Scow, a significant member of a prominent family, gave the figurines as gifts to Kwakwa̱ka'wakw boys in the years following the repeal of the potlatch ban but before the return of regular ceremonial activity, combined with the obscured identities of the specific dancers, suggests that he was undertaking a conscious role in Kwakwa̱ka'wakw society as it underwent dramatic transcultural alteration. In this capacity, his production and distribution of the figures can be seen as a movement of aspiration.

The dancers are toys operating as direct educational tools; they can be manipulated to re-create the Hamat'sa dances in miniature over and over again, small enough to be practised away from prying official eyes and innocuous enough to appear nothing more than a doll or curio to the uninitiated. Through tactile inhabitation, the miniature permits its owner to assume the status of a dancer and practise for the day when he might be allowed to dance in the old ways and to join the Hamat'sa society as his ancestors did. Moreover, the variety, mobility, and individuality of the figurines, coupled with their distribution through the community, indicate

that they were for communal as well as individual practice. Hamat'sa dances required several participants – Sewid recalls "about twelve or fifteen boys with me that had been hired by my grandfather" (Spradley 1969, 89) – and so the boys of Alert Bay could gather in their houses or deep in the woods of Cormorant Island and practise the Hamat'sa together under instruction from Scow or another elder. Years later, anthropologist Bill Holm wrote that "this dance, called the hə'msəmala 'wearing the cannibal mask,' was one of the more dramatic of the [winter ceremonies] and, as of the 1980s, one of the least altered by the passage of time" (1990, 381). Perhaps Gordon Scow and his miniature dancers were part of the reason these traditions survived and recovered as well as they did.

Miniaturization as Cultural Resilience

As Haida carvers took up the art form as a means of cultural continuity at times of crisis, so too did the Kwakwaka'wakw: "The ongoing tradition of carving was another symbol of the determination of our people to carry on, despite increasing pressure from outside to abandon the old ways. While some of the best examples of our 'art' from the period may now be in faraway museums, our creative output never died" (Cranmer Webster 2013, 269).

It was not carving alone, however, that maintained Kwakwaka'wakw material culture; it was its use as an ethnodramatic and subversive means of non-violent resistance, embodying Gell's "movement of memory reaching into the past" (1998, 258). Just as Charlie James preserved his family crests by producing them over and over again in miniature, using his imagination to vary and experiment with the form but always from the same template; just as Mungo Martin reproduced two versions of Kwakwaka'wakw hunters, one realistic for Alert Bay and one traditional and imaginative for the Museum of Anthropology; so Gordon Scow used miniaturization to simultaneously preserve his culture, educate new generations, and protect his people from reprisal. This behaviour is recognized by contemporary carvers. Commenting on the Haida miniatures discussed earlier, Wayne Alfred remarked, "So they probably wanted to leave it for memory."

Kwakwaka'wakw of the early twentieth century had lived through epidemics and economic crisis, and in 1921 faced the potential wholesale destruction of their traditional cultural systems through Halliday's vindictive enforcement of the potlatch ban and establishment of the Alert Bay residential school, which threatened to eliminate Kwakwaka'wakw traditions

and the Kwak̓wala language for future generations. Over time, traditional practices were driven further and further from their communities and traditional material culture became less and less common. But Kwakwa̱ka'wakw artists and elders learned how to resist repression and preserve practices for a more accommodating future. It has even been suggested that the potlatch law itself not only generated but sustained resistance, as the potlatch survived most strongly among those for whom it was most strongly prohibited (Cole and Chaikin 1990, 175). Whether or not that interpretation holds up, by the middle of the 1960s the process had gone into reverse. At a potlatch in 1966, a visitor witnessed Kwakwa̱ka'wakw children from the nearby residential school being "herded into the dance house to witness events that were almost as unfamiliar to them as they were to their non-Indian teachers" (Macnair 1986, 516). Indigenous artists were subsequently invited to St. Michael's to teach classes on Kwakwa̱ka'wakw art (TRC 2015c, 194). As dances and ceremonies once again became common, the Hamat'sa was rebuilt using the knowledge, evidence, and example left by the elders (Wolcott 1967, 54).

Making miniatures was one crucial technique in Kwakwa̱ka'wakw cultural resilience, allowing practitioners to place ritual material culture into facile and mundane contexts. By turning totems of huge familial significance into "idiot sticks," miniaturization distracted government officials away from these expressions of Indigenous identity and permitted artists to experiment and develop their work, to export it and distribute it, and to pass it to their children and grandchildren. By conflating play with tradition through miniatures, children could learn the dances and symbols that defined their place in the world – safe from reprisal or arrest. When the law changed and Kwakwa̱ka'wakw regained control over their own affairs, miniaturization and other survival strategies allowed them to rebuild their ceremonial and material culture traditions.

4
Small Foundations
Tulalip Tribes

THE TULALIP RESERVATION IN northwestern Washington was so named because at its heart lies a sheltered natural harbour shaped like a clutch purse: a *tulalip* in the Lushootseed language. It is the home of the Tulalip Tribes, an artificially assembled Indigenous group comprising elements of seven Salishan tribes from the surrounding territories, those who surrendered their lands and moved to the reservation under the terms of the 1855 Treaty of Point Elliott.

In recent years, as the part of the so-called renaissance of the Northwest Coast, the Tulalip have changed dramatically, attempting to progress from historical disenfranchisement and cultural dislocation through a major political and artistic alteration in both social and material culture supported by new revenue streams. Miniaturization is an important aspect of the practical process by which this has come about.

The only ethnography of the Tulalip published to date is the 2013 posthumous semi-autobiographical *Tulalip, from My Heart*, compiled from interviews with elder and culture bearer Harriette Shelton Dover (1904–91), daughter of Chief William Shelton. This key resource underlies the following exploration of miniaturization as a crucial component of Tulalip redevelopment of their reservation and society in the twenty-first century.

The Ties of Culture and Business

The Tulalip Tribes are named for the Tulalip Reservation on which they live, situated on a small pocket of land between Puget Sound on the west and

Interstate Highway I-5 to the east.[1] The reservation lies some 56 kilometres north of Seattle city centre and approximately 112 kilometres south of the Canadian border, with the city of Everett and its naval station immediately to the south across the Snohomish River and the town of Marysville immediately to the east on the other side of the highway. In practical terms, Tulalip marks the northernmost point of the Seattle-Tacoma-Olympia conurbation that stretches along the eastern shore of Puget Sound. The reservation itself covers some 90 square kilometres of secondary-growth forest, with a few hills and small lakes to break the treeline. It was probably originally selected because it had no significant natural resources beyond limited lumber and fishing grounds that were later lost to non-Indigenous fishing operations.

The Tulalip are not a historic tribe; rather they are composed of parts of seven Salishan peoples – the Duwamish, Snohomish, Snoqualmie, Skagit, Suiattle, Samish, and Stillaguamish – who lived semi-nomadic lives of seasonal migration along the shores of northeastern Puget Sound. All are from the Coast Salish culture area and spoke dialects of the Lushootseed language, but in 1855 the Treaty of Point Elliott drew an arbitrary circle over the bays and islands of this part of northwestern Washington, sweeping Indigenous people within that circumference onto the Tulalip Reservation without regard for ancestral and familial ties. As no tribe had paramount authority on the reservation, the families formed an informal council to keep order and negotiate with the government, and when the 1934 Indian Reorganization Act handed political control back to the inhabitants, rather than installing a traditional chief or elected senate they formalized the council into the Tulalip Board of Directors to oversee reservation life. Their lack of cultural homogeneity caused them to consider themselves more a business organization than a cultural group or political government; Dover wrote that younger people came up with the idea of a board of directors, "since if we are going to handle or take care of tribal land, then we are in business; so let's call it a board of directors to take care of the business of the tribes" (2013, 202). Although, as elsewhere on the Northwest Coast, ancestral lines are minutely tracked and ancestors venerated, over generations of intermarriage and cooperation the divisions between these separate tribal groupings have largely broken down. During my fieldwork one resident confidently explained to me that she was now, explicitly, a "Tulalip woman" rather than a member of one of the original tribal groups.

For decades Tulalip was a quiet rural community, subsisting on fishing, logging, and the sale of long-term leases on beachfront properties to Seattleites. A thriving trade in homemade fireworks, illegal in Washington State but legal on the reservation, was for many the high point of the economic calendar. Referred to as Boom Town, informal fireworks workshops and markets used to line the rest stops of I-5, as families produced spectacular homemade fireworks in the run-up to the Fourth of July each year. Popular tales abound of eluding or bribing state police and detonating gigantic piles of explosives as advertising.

Today, however, Boom Town has been reduced to a vacant lot close to the Tulalip bingo hall. The Tulalip Reservation has transformed itself by effectively maximizing its natural resources: the Tulalip Board of Directors voted in the 1990s to legalize gambling within a restricted area close to exit 200 on the I-5 at a traditional village site known as Quil Ceda. The Quil Ceda Creek Casino proved successful with the through traffic between Vancouver and Seattle. Well-placed advertising and a fortuitous location meant that within a few years the tribe had made significant amounts of money from their investment. The decision was consequently taken to significantly develop the reservation's gambling infrastructure.

The Tulalip Resort Casino opened in 2008 and is perhaps the largest such institution in the Pacific Northwest. Designed to Las Vegas proportions, it sprawls along the western side of the I-5, featuring a designer outlet mall, food court, several large warehouse stores, and acres of parking, all centred on the casino and hotel itself. The hotel includes a spa, a conference centre, a swimming pool, and several gourmet restaurants, all surrounding a large gaming floor populated by ringing fruit machines and gaming tables for craps, roulette, and blackjack, with VIP lounges for high-end games.

Continually in operation and very popular, especially at weekends, the casino draws in visitors from across the Northwest. I was told that charter flights specifically catering to casino visitors run regularly between Shanghai and the Seattle-Tacoma International Airport, bringing in coachloads of free-spending Chinese gamblers; certainly I saw a significant Asian clientele on the gaming floors. The casino is not, I was informed, a popular gaming venue for reservation residents because, I was told, it is seen as a space for *Porucs,* apparently a lightly derogatory term among the Coast Salish for white people.[2] Though largely absent from the slot machines, Tulalip tribal members are much in evidence among the visible casino and hotel staff: pit

bosses, croupiers, cashiers, receptionists, and concierges were overwhelmingly Indigenous. These employees often emphasize their origins with jewellery, badges, and beaded accessories such as hairbands and bolo ties in the Tulalip colours of white, black, and red, ostentatiously demonstrating their tribal connection to the casino itself.

These visual statements of identity extend beyond personal adornment to the building itself, for what especially separates the casino from its Vegas compatriots is its deliberate Tulalip theme. Not a pan-Indian pastiche, nor even the generic totem theme common to smaller and less lucrative casinos elsewhere in the Northwest, but an explicitly Tulalip identity: huge steel drum designs featuring Tulalip crests and animals stud the external and internal walls; Tulalip canoe motifs are ever present – artfully arranged full-sized carved wooden West Coast canoes and numerous artistic interpretations in glass and metal. There are shoals of steel salmon hanging from the ceilings that shimmer in the lights, and oversized installation pieces in the shapes of traditional Tulalip paddles and combs mark hallways and lobbies. Even the carpets have been designed by tribal artists with weaving and wave patterns. Behind the main reception desk, a wide stained-glass window depicts a skeuomorphically basket-like ovoid eye staring out onto Tulalip Bay, replete with formline orcas, throwing artificial light on the guests as they arrive. Most spectacularly of all, in the main lobby stand three full-sized totem poles.

What makes this decoration consciously Tulalip, rather than Coast Salish or generically Northwest Coast, is that from start to finish it has been designed and produced by professional artist tribal members operating on the reservation itself at the nearby Tulalip Tribes Art Manufacturing Center. To ensure a steady stream of work, the Tulalip Board of Directors retains a contractual monopoly on decorating commissions for the casino and most of the surrounding outlet stores. What the board chooses to commission for this purpose, and the methods by which it does so, shines a light on how Tulalip wish to be seen by visitors to their reservation.

Tulalip Tribes Art Manufacturing Center

Casino revenue is used to provide at least six and sometimes more Tulalip carvers with reliable full-time employment. This work is facilitated via the Tulalip Tribes Art Manufacturing Center, more commonly known as the carving shed or carving workshop, an installation situated close to exit 202

on I-5, just a few metres from the outlet mall but sheltered from view by a grove of tertiary-growth Douglas fir. When I visited in 2015, the carving shed was managed by Mike Gobin, who was recruited for the position not because of his undeniably excellent carving ability but because of his experience in project management and budgeting while employed at the Quil Ceda Creek Casino. Working with Mike are the tribe's full-time carvers, such as elders Steven Madison and Joe Gobin, the younger James Madison, and various apprentices and graphic artists, some of whom are hired on a casual short-term or part-time basis.

All work in the carving shed is officially authorized by the tribe's board of directors, and the facility is run as a branch of government. Carvers receive salary and benefits, and have a working week from 6:00 a.m. to 3:00 p.m. Monday to Friday, although hours can be extended to accommodate larger projects or major deadlines. Mike is proud that despite the heavy workload the workshop has never delivered late on a project. Although visitors are common and welcome, from itinerant drop-in anthropologists to organized school parties and occasional casino guests, it is an active workshop. Its rules explicitly prohibit non-tribal members from working within the facility, in part due to the importance of preserving Tulalip authenticity and exclusivity over its products.

The building itself is a converted mid-twentieth-century white timber warehouse situated amid a collection of similar warehouses, another of which contains a collection of old totem poles awaiting conservation work. On the ground floor is a wide carving area, with stacked wood and a number of half-finished projects at various stages of development. Racks of personal traditional carving tools and shelves of more expensive electric tools are ranged along the walls along with hoists, pallet trucks, and other lifting and stability equipment. On the north side is a partition, behind which is a smaller workshop with band saws, pillar drills, and other larger and more expensive pieces of woodworking machinery, behind which is a storage room where finished or nearly finished carvings are kept for polishing and painting until they are ready for installation. The larger equipment is purchased for the collective through the board of directors by special application, while the handheld tools belong to individual carvers and many are custom-made to personal specifications. Tulalip interviewees made it clear that they did not consider the use of modern tools to detract from the authenticity of the art because, as Mike Gobin commented, "we're not stupid. If they'd had these tools back in the day they would've used them too."

Upstairs is a long attic room with a bank of high-specification computers with state-of-the-art graphics software attached to a large architectural printer. The workshop is thus among the best appointed of any Northwest Coast carving facility; although carving collectives are relatively common, nowhere else on the coast do they operate on such a large, organized scale, with salaried employees. Instead, individual carvers or carving families usually establish their own workshops, tailored to their particular tastes and requirements and reliant on sales for income.

Although the carving workshop does not run educational programs – the workload is too heavy for outreach or large apprenticeship schemes – the initiative attempts to generate an organized and systematic future for Tulalip carving by example and practice, operating alongside and to an extent replacing the ad hoc familial carving lineages of the past with a unifying Tulalip artistic identity. Within this program individual artists are given considerable scope to express themselves, while ensuring a regular supply of high-quality commercial Tulalip art. This is placed strategically throughout the reservation to make expressive and overt statements of ownership of the land and the revenue it generates.

Coast Salish Contact History

To understand the significance of the Tulalip art program and its engagement with a site of conflict, it is necessary to consider the colonial history of the Coast Salish people and the role art has played in that exchange. The Coast Salish were among the last of the peoples of the Northwest Coast to have regular contact with Europeans, as settlers began to move inland in the early nineteenth century. Thus, they experienced first contact more gradually and often via other Indigenous intermediaries. It wasn't until the division of the region, and consequently the Coast Salish peoples, between Canada and the United States in 1846 that an extensive period of settlement began to seriously encroach on Coast Salish territory. The US response to these growing tensions was to establish reservations across western Washington State over the next half century, and to force Coast Salish groups living there to move under threat of violence. Little thought was given to making the reservations conform to existing linguistic, kinship, or settlement patterns.

Administration of the Tulalip Reservation was at first handed to the Catholic Church, which established a school, and for the following eighty years the Tulalip Tribes, like the rest of the Puget Sound Salishan communities,

came under the control of American political and religious authorities. The first mission school was opened in 1857, and in 1902 a new government boarding school was established on the reservation under the control of Dr. Charles Buchanan, superintendent of the Puget Sound Indian Agency. Like other residential schools along the Northwest Coast the school had a brutal environment, but the community's relationship to Buchanan seems more mixed. In some non-Indigenous texts he is portrayed as a vaguely benevolent figure, described in the University of Washington Libraries collection, for example, as "a sympathetic defender of the Indians in his charge."[3] Probably influenced by her father, William Shelton, who as a chief had a working relationship with Buchanan during his tenure, Harriette Shelton Dover remarks, "In some ways, he was too mean. But, in other ways, he was a nice man to know" (2013, 145). When it came to children at the residential school though, Buchanan was savage. Dover recalls his behaviour:

> When some boys couldn't take the strict regimentation anymore, and the hunger that we lived through, they ran away from school and tried to go home ... Dr. Buchanan shaved their heads and made them wear girls' dresses ... They were fed bread and water for two weeks, in an isolation room ... Dr. Buchanan took the runaways to another room. They took off all their clothes and were made to lie over a stool, and then he would strap them. He was a big strong man. You could hear them calling and crying because they would roll off the stool. The strap burns – it hurts. He strapped them all over their bodies, and he followed them all over the floor because they rolled over, and he hit them on their heads or wherever he could hit them ... They were almost dead, really. That's a long, long road to being civilized. (Dover 2013, 121)

Buchanan died in 1920, and the school closed shortly before the 1934 passage of the Indian Reorganization Act, which passed control of the reservation to its Indigenous inhabitants. This long history of violent cultural and linguistic suppression left an indelible mark on the Salishan people who experienced it and their descendants, instilling deep opposition to white power structures. In her memoir, the normally equable Dover commented, "I hated the white people with an undying hatred" (2013, 133) and Lamalchi elder Rocky Wilson, whose parents were sent to the Tulalip school, called white governance "the iron fist," writing that since contact "the whites have deemed us to be savages and murderers" (2007, 134).

In the 1960s and 1970s Tulalip and other Puget Sound Indigenous peoples campaigned to restore legal rights to their traditional fishing grounds, access to which had been eroded by piecemeal environmental legislation, overfishing by American trawlers, and a suspiciously zealous US Coast Guard operation targeting Indigenous fishing vessels over minor infringements (Dover 2013, 174). In 1974, the Boldt Decision, heard in a US district court and upheld on appeal the following year, awarded Indigenous fishing concerns 50 percent of the Washington salmon catch and returned a measure of autonomy and self-sufficiency to reservation residents (Boxberger 2007; J.J. Brown 1994). After the state refused to enforce the ruling, the case went before the Supreme Court and was largely reaffirmed in 1979. This legal struggle, in combination with other challenges to legal and political restrictions on Indigenous movement and enterprise, took place against the backdrop of the so-called Northwest Coast renaissance. In particular, pioneering Haida artist Bill Reid provided expert advice to Tulalip carvers in the 1980s as they sought to emulate his role in the resurgence of traditional carving practices. The push for recognition of historical legal rights continues, forming an essential part of modern Salish identity through their demand to be recognized as independent, Indigenous authorities (R. Wilson 2007).

Tulalip Totem Poles

Around the start of the twentieth century totem poles began to appear in Salish communities for the first time. Not native to the Puget Sound region, the design was adopted when master Salish carvers became concerned that their work was not being taken seriously in comparison with the more dramatic constructs of the Northern tribes and started to produce their own poles in response. The pioneer of this work was William Shelton of the Tulalip Reservation, many of whose works are still standing. Shelton and his contemporaries did not simply copy Northern styles but adapted the traditional Salish housepost style for the new medium. As a result, Salish poles do not depict family lineages but traditional stories, with figures running vertically up the pole in a style markedly distinct from the intertwined beings of Northern formline. There was another key difference. Although Salish peoples generally considered intangible intellectual property to be owned by families and passed down as inheritance, this idea was less likely to be applied to material culture, and Salishan artists did not work within the more onerous

restrictions imposed on imagery to the north. As a result, they were freer to express individuality in their art production (Barnett 1955, 57).

Under William Shelton's influence, the totem pole art form soon spread to other Salish carvers, and poles sprang up all along the Washington coastline. They were regularly maintained and protected from the weather with thick coats of paint, giving them a distinctive, blocky appearance that accentuated the separate figures on the poles. The poles were placed in positions of prominent political or legal conflict; a Lummi pole erected in 1952 by Joseph Hillaire, a schoolmate of Harriette Shelton Dover, stands outside the Whatcom County Courthouse in Bellingham, depicting the arrival of European settlers to the region in 1852. Shelton himself erected a 21-metre pole outside the Washington State Legislature in Olympia in 1940, depicting *skelalitut,* spirit figures demonstrating to the uncomprehending legislators how to live a moral life.

In siting the poles in specific places of law and government, the artists are thus able to tell stories with conflicting messages for different audiences. To the non-Indigenous observer, they are celebrations of collaboration and peaceful co-existence, emphasizing the hybridization of Indigenous design at moments and sites of colonial contact. To the Indigenous viewer, they depict moments or stories of conflict, positioned at sites of White American authority and communicating messages whose irony is accessible to the Salish community but largely lost on non-Indigenous inhabitants. As Charlotte Townsend-Gault's encounter with the Wei Wai Kum First Nation revealed, by sending different messages to Indigenous and non-Indigenous audiences, the carvers are staking a claim for their communities to be participants in legal and governance systems rather than their victims, and refusing to accept passively the marginalized position imposed on Salish peoples of Washington State.

Nowhere is this contestation more notable than through the presence of totem poles at schools. Initially, they were dangerous symbols of Indigeneity, to be shunned and destroyed. In her testimony to the Canadian Truth and Reconciliation Commission, Sarah McLeod of the Kamloops Secwépemc recalled that her mother gave her a miniature totem pole to carry with her when she was sent to residential school, as a way to remain connected to her home and people. When the nuns who ran the school discovered the totem pole they denounced it as the work of the devil and forced McLeod to throw it away (TRC 2015d, 107).

More recently, Indigenous people have insisted on the reverse: the insertion of totem poles into the school environment. Perhaps in reaction to the attitudes prevailing in the long-gone residential school, all the schools on the Tulalip Reservation have large, prominent totem poles standing outside them, made by local carvers and maintained annually by the children. This placement purposefully reinforces the Indigenous ownership and ethos of the schools, and is a tactic employed by other Indigenous peoples in the region.

In 2014, concerned by high dropout rates among Indigenous children, Nooksack carver George Swanaset Sr. raised a pole at Nooksack Valley Middle School. The Nooksack tribe has long been noted for exceptionally severe cultural dislocation (Smith 1950, 330), and Swanaset commented on the intended impact of the pole in helping Nooksack children feel less alienated by the school environment and encouraging pride in their origins: "They're going to come to school and it's going to be able to relate to them" (Criscione 2014).

Making totem poles and other monumental art is a relatively modern convention, and Salishan peoples established these pieces as markers not explicitly of individual or familial authority, as elsewhere, but of a broad communal, tribal, or racial identity. Often sited at legal, political, or educational locations steeped in the history of conflict between Indigenous and non-Indigenous people, they have operated as a highly visible, dramatic, and yet still subtle means of pronouncing ownership. The poles have not lasted long, however, even by the standards of the region. The thick paint, intended to keep water out, instead sealed the water already in the trunk deep inside the heartwood, which began to rot, and many poles have fallen as a result, including Shelton's pole at Olympia.

When casinos became a popular means of bringing revenue to Indigenous communities in the Northwest, totem poles were rapidly placed there too. In doing so, tribes were proclaiming authority and ownership over their principal revenue stream, marking independence from the state authorities, and consciously associating themselves with the "Indian casino" brand. At some locations the poles are of poor quality, and even a cursory examination shows them to be curiously generic, lacking local or familial significance and with chainsaw toothmarks still visible, especially on the back.

Aware of the symbolic significance of the totem pole and wishing to acknowledge it while steering clear of generic implications, the directors of the Tulalip board made a deliberate decision to reinforce Tulalip art and

identity at the heart of the casino project. When the resort was in the planning stages, they made a commitment to fill it with works by Tulalip artists, valued at more than US$1 million in total (Thompson 2007). The centrepiece was a commission from the Art Manufacturing Center of two large poles and a huge welcome figure to stand in the lobby. These poles, carved to very high quality through a combination of traditional and contemporary techniques, are an unambiguous statement about who owns the casino and the land on which it was built.

The central pole is a tall welcome figure, and the poles flanking it represent the past and future of the Tulalip Tribes. To its left is a tall pole designed in traditional Salish style by Joe Gobin, depicting a shaman atop a bear figure above six drummers; although the composition owes much to Northern pole formline style, particularly the bear, the figures are recognisably Salish in design. The second pole is by the artist James Madison and features a more modern composition that combines Northern formline and Salish design, reflecting the artist's dual Tulalip-Tlingit heritage and elements of his contemporary art training. A bear, killer whale, eagle, and wolf, all Northern crest animals, are studded with traditional Salish faces and more northerly formline visages in blue and white glass, giving the pole a translucent quality that contrasts effectively with the dark red-brown of the cedar. That these three artworks stand in the hotel reception leaves a visitor in no doubt, like a guest at a potlatch, about who is the host and therefore who holds authority and power in this environment. They do so in a way that is both direct and monumental, but that is also subtle in terms of the personal relationship between the poles and two of the most successful living Tulalip artists.

Additional poles and colossal welcome figures have subsequently been commissioned for a large tribal administration centre, the Hibulb Cultural Center, and the reservation hospital, among other places. The creation of the monuments, all special commissions from the board of directors, required a lengthy planning and development process.

Creating a Tulalip Pole

I was told that Salish carvers of the past typically followed the Northwest Coast tradition of commissions, whereby a prominent chieftain ordered work from a professional carver to commemorate a particular event or ceremony. Unlike in more northerly tribes, most Salish carvers also did

mundane work for everyday subsistence, although recognized carvers could make a living from commissions alone. Although the carvings on Salish poles and posts tell stories rather than embodying a reserved iconography, they are still subject to the concept of ownership, and only those who are endowed with inherited rights to the stories may give permission for them to be carved on poles. Interviewees explained that these prohibitions remain in place when carving for internal tribal commissions, although in keeping with most contemporary practitioners of Northwest Coast art, Tulalip artists are known for their experimental designs when producing pieces for the commercial art market.

A commission for a new pole or any large-scale commercial artwork on the Tulalip Reservation comes initially from the Tulalip Board of Directors. When a new building is commissioned or major project started, large-scale art installations will be incorporated into the original plans, subject to the availability of labour and materials. An open call for design submissions will go out to tribal members, whether or not they are salaried carvers or even recognized artists. Mike Gobin told me of his surprise at some of the designs submitted, high-quality proposals coming from men and women of the community who had not previously given any indication of artistic talent or inclination.

The submissions are collated, assessed by the Art Manufacturing Center and the board of directors, and then the winning designs are purchased for the tribe. At that point, Mike Gobin will establish a work program, deadline, and budget with the board, taking into account existing commitments and availability of material to present a feasible schedule for delivery.

Availability of materials is very significant in determining the scope of the commission. Few old-growth cedar trees are left on the reservation, which like the rest of the region was clear-cut a century ago, leaving giant tree stumps to wash out into the bay. Those few trees that still stand are protected by the tribal forestry department, their location a secret. A larger selection of trees of the necessary age and size can be found in the Cascade Mountains, but they too are rarely cut. When one falls naturally it is sometimes allocated to the Tulalip, although it is up to the carvers themselves to secure the tree, which will, by its very survival, be in an inaccessible location, and retrieving the wood is therefore expensive and time consuming. The only alternative is to secure suitable wood from one of the major logging companies that operate in less-touched forests farther north, which brings

expenses and compromises of its own. A full-sized old-growth cedar trunk can nonetheless provide enough wood for several large poles; those erected in the casino are all carved from the same tree.

With a schedule arranged and wood secured, the next stage is planning. This can take as long as eighteen months, during which time the carvers will discuss options for the commission, confer on designs, prepare hand-drawn sketches and vector drawings and, in a unique innovation for the region, produce three-dimensional digital representations of the pole, using these graphic models to test proportions and possibilities with the wood available. The digital design stage is unusual; few other carvers of the coast use software to produce such a varied range of experimental designs before starting to carve. Prepared in the carving centre's graphics workshop, the digital models permit the carvers to explore the various permutations of design and structure and apply virtual physical tests on the pole to determine its endurance and strength. The process is no less than a divergent form of modern miniaturization, allowing for endless experimentation and manipulation in a safe, dimensionless space without consequence. It is not the only form of experimentation that occurs, however, for in the last part of the process before submission, a maquette or miniature of the pole or figure is physically produced.

A maquette is made from a small cedar block (Figures 4.1 and 4.2), shaped to be an approximate scale model of the larger artwork. The carving is precise but simple, with close relief details usually omitted in favour of an impression of proportion and design. The maquette is painted in the same colours as the planned work and then shown alongside sketches, digital designs, and an oral presentation to the board of directors. The directors discuss the design, and may suggest alterations before voting on whether to approve the sculpture and set a final deadline and budget for completion.

The carving process has no formal spiritual or ritual dimension, yet a spiritual and cultural aspect of the work is discernible in other ways. Joe Gobin, for example, always carves the eyes of the figures on the poles at the very last possible moment as the "eyes bring the piece to life," although this applies only to the final piece, not to the maquettes and drawings that are merely tools contributing to the work. Once the large-scale carving is complete, the tribe's spiritual doctors purify the workshop in preparation for the pole's departure and a public ceremony takes place as the pole is raised.

Figures 4.1 and 4.2 Saʔbaʔahd (Steven Madison) *(right)* carving a figure based on the maquette *(above)*, 2015.

Hibulb Welcome Figures

By constructing a maquette, the artist acquires knowledge that cannot be gleaned from blueprints or sketches, or even from digital animations. James Madison notes that miniatures work on the artist to provide "so many avenues for purpose. They are part of learning how to carve," and that the maquettes "get you to the finish line faster."

The welcome figures at the Hibulb Cultural Center offer a good example of this effect in action. The first Tulalip art that visitors to the centre encounter, these huge human figures in cedar are rooted in the Salish tradition of welcome figures, which were traditionally positioned on a beachfront to welcome arrivals by canoe to the community. Welcome figures are usually

substantially larger than life, with painted features and arms either occupied or spread wide in greeting. The pair at the entrance to Hibulb were commissioned from the carving workshop by the Tulalip directors, and responsibility for carving them given to Joe Gobin and James Madison. They were to be male and female figures, standing approximately three and a half metres high inside the entrance to the centre. The figures stand prominently and alone within the wood and stone entrance hall.

James Madison's figure is the woman, an elder executed in his recognizable contemporary Salish style. She wears a calico headscarf and a long dress reminiscent of Salish women in photographs from the early twentieth century, a basket of freshly gathered clams in her arms. Red and white paint picks out basketry designs on her dress and headscarf, and the scene appears naturalistic until you notice that her bare feet are standing on an opening clam from which a human face peers out, in a commentary on the foundation and continuation of the Tulalip, who were said to have been born from the clams of Tulalip Bay. Calling the piece "empowering and memorable," Madison is explicit that work such as this, harking back to the historical Tulalip while introducing modern components, plays a role in the ongoing development of a unified Tulalip culture:

Listen to the wood. The wood is gonna tell you what it wants to be. We are keeping our culture alive. Art is an active part of marketing our people and tribe. These monumental pieces, letting everybody know who Tulalips are, who the Coast Salish are. Creating a larger identity for the Northwest Coast. I breathe this, I bleed this.

The other figure, by Joe Gobin, addresses continuity in a different way. It depicts a young man with the smooth, rounded facial features of traditional Salish design, the wide eyes, broad nose, and open lips that feature so heavily in traditional art from this part of the coast. The figure wears a loose smock with a red-and-black sash and a cedar-bark rainhat, and carries a paddle in its hands. This is a depiction of a pre-contact canoe captain.

No miniature was made for the female figure, but Gobin's maquette had a prominent place in the workshop at the time of my visit, sitting on a table close to the door (Figure 4.3). The larger figure is much more detailed, while the maquette appears as an experiment in proportion, an attempt to play with the ideas behind the figure and explore what works best. The toolmarks, such a prominent and important part of the texture of the large carving,

Figure 4.3 Maquette for welcome figure by Joe Gobin. | Tulalip Tribes Art Manufacturing Center, 2014

are absent from the smoothed, sanded maquette, and the proportions of the sash and hat have changed noticeably from the maquette to its larger relative.

Significantly, the paddle on the maquette has snapped – it is positioned at a less acute angle than on the later, larger carving, and has broken on the shoulder and been repaired. The lesson was that the paddle was incorrectly

balanced on the maquette, the position and the weight of the blade making it too fragile, so Gobin made adjustments in the final artwork to eliminate this weakness. Gobin was thus learning and developing his technique through the process, the miniature working on him as he worked on the miniature, forming an imaginative and physical experiment within a thoroughly traditional design.

The Tulalip Canoe

With his late friend and mentor Jerry Jones, Joe Gobin was at the forefront of the Tulalip canoe renaissance in the 1980s. The Tulalip likely originally used the Coast Salish design of canoe, but by the late nineteenth century Tulalip peoples had adopted the lighter and more streamlined Westcoast style, apparently under influence of the Quileute Tribe, with whom they have long had familial and commercial links. Tulalip canoe culture was very active in the early twentieth century, as Tulalip communities participated in the Salishan tradition of canoe racing against neighbouring communities and continued to use canoes for this purpose well into the mid-century, but like many Salish communities, the Tulalip ceased the regular production and use of traditional working dug-out canoes in the early twentieth century, and there were no working canoe carvers in the community for several decades.

Canoe racing is specific to the Salishan tribes of the southern coast. Although more northerly tribes held demonstration races and feats of seamanship, these were not organized or structured in a recognizably competitive way. For the Salish tribes however, canoe racing was and remains a regular and popular pastime, each community preparing a skilled and effective crew to race at well-attended regattas. The canoes used for these events are usually highly adapted Westcoast-style vessels, with an exceptionally narrow beam to improve speed and minimize weight. As regattas are held in good weather, the sea-handling qualities of the canoes were less important than on other designs and so they became single-purpose vessels whose success and failure in the summer racing season was tied to communal pride and representation. Salish canoe racing never died out in the way other elements of canoe culture faded during the mid-twentieth century, and it continues to this day.

In the late 1980s, as traditional canoe building became more and more important as a marker of cultural identity for communities on the Northwest Coast, Joe Gobin and Jerry Jones set themselves the task of creating the

Tulalip Tribes' first large traditional dug-out canoe in fifty years, a mission to "bring our ocean-going canoes back." Haida carver Bill Reid had been at the forefront of canoe design in the contemporary period, and Gobin and Jones approached him directly, obtaining his agreement to teach them canoe-building techniques. They learned much under his guidance. Gobin recalls making many miniature canoes at this time in order to practise the steaming process before attempting it on the larger vessel. Both he and Jones came from carving families and had learned to carve as children – miniature canoes were a staple of Gobin's carving education – but neither had ever seen a full-sized canoe under construction. Their process was thus one of trial and error; steaming in particular proved particularly complex, as long cracks opened in the first canoe's hull and had to be patched with metal plates, which can still be seen under the paint.

The canoe was ultimately a success, and was used to participate in a number of Canoe Journeys in the 1990s and early 2000s. Gobin and Jones went on to make several more canoes, both working vessels and display pieces: one hangs from the ceiling in the entrance hall of the Tulalip Tribes council chambers and another stands in the midst of a water feature at the main entrance to the casino. Both of these display pieces, although made as sculptural installations rather than operational vessels, are produced with the same techniques and to the same specifications as the working canoes and coud be taken down from their positions and out onto the water at short notice.[4]

Since cedar trunks are a rare commodity in Tulalip, Gobin has also made a canoe from cedar strips, narrow planks of wood placed adjacent to one another over a canoe-shaped frame and held in place by dowelled joists. This design does not require an expensive whole cedar trunk and has apparently proven faster in the water than the solid dug-outs. Gobin's work on canoes illustrates both imagination and willingness to adapt traditional designs for practical and symbolic requirements, as well as a clear understanding of the significance of the canoe to Tulalip identity.

The Tulalip Miniature Canoe

In July 2010 at Songhees, near Victoria on Vancouver Island, Indigenous peoples including representatives of many Salish tribes from Canada and the United States came together to celebrate the official renaming of the Salish Sea. The Salish Sea campaign had been a pressure issue in Indigenous

relations in British Columbia and Washington State for some years, tied to the increasing legal and nominal reclamation of former tribal lands by Indigenous groups. The campaign sought to eliminate colonial names for the bodies of water on and around which Salishan peoples live: Puget Sound, named for Lieutenant Peter Puget of Captain George Vancouver's expedition in 1792; the Strait of Georgia, named for King George III on the same expedition; and the Strait of Juan de Fuca, named in 1787 by British ship captain and maritime fur trader Charles Barkley after a fabled Greek-Spanish sailor said to have explored this coastline in 1592 (Wagner [1933] 2002, 2–3).

After much debate a compromise was reached whereby these bodies of water would retain their colonial names but be officially known collectively as the Salish Sea in both Canada and the United States. The celebration at Songhees was planned to commemorate this renaming, with the highlight to be the dedication of a canoe named *Salish Sea,* carved by Lieutenant-Governor Steven Point of the Skowkale First Nation and Kwakwa̲ka'wakw artist Tony Hunt, and its presentation to the Canadian Navy as a ceremonial vessel. Point said at the time, "Coast Salish peoples have traversed these waters for thousands of years, and this name pays homage to our collective history. Today's celebration reflects the growing understanding and appreciation of our cultures. It is another step in the bridge of reconciliation" (CBC News 2010). Three other Indigenous artists were also commissioned, without pay, to produce commemorative art that would reportedly be subsequently presented to the national governments of the peoples concerned. The process was intended to be an exercise in symbolic reclamation, these artworks, all canoes or canoe miniatures, to act as a statement of ownership over the newly named body of water.

One of the artists approached for this honour was Joe Gobin. Gobin decided to make a perfect miniature replica of a traditional Tulalip Westcoast canoe, reproducing the proportions and decoration of the large vessels he had made and unlike the exaggerated profile and colouration of the tourist items or toys that are commonly associated with miniature canoes in western Washington (Figure 4.4). In Gobin's words, he intended that "a hundred years from now someone can look at this and see what a [Tulalip] canoe looks like."

As a physical prototype, Gobin selected a large canoe on display at the Hibulb Cultural Center that had also been the inspiration for his full-sized canoes. This vessel was the last surviving intact Tulalip canoe made before the cessation of regular canoe construction in the early twentieth century.

Built by William Shelton, it had been stored for decades alongside a stack of totem poles beneath undergrowth in a garden on the reservation and had required considerable conservation work after being moved to Hibulb. It is now situated in the entrance hall of the centre and is probably the second piece of Tulalip material culture (after the welcome figures) that visitors encounter.

This worn and far-from-watertight canoe therefore stands for more than the sum of its parts. It is an example of the enduring skill and presence of one of the great Tulalip master carvers of the turn of the twentieth century and acts as a symbol for the endurance of the Tulalip people themselves, inspiring subsequent generations to create watercraft. To ensure the accuracy of the impression his miniature would elicit, Gobin also created paddles, a mast, and a tiny woven cedar-bark sail. Although the proportions of all these parts were determined by eye, he judged them to be the exact match of the canoe at Hibulb. Finally the miniature was painted in the same colours as his full-sized canoes.

Although the product was intended to be a precise replica, Gobin consciously did not reproduce the praxis and materiality. He did not, for

Figure 4.4 Joe Gobin working on his miniature canoe, 2010. | Photo courtesy of Joe Gobin

example, make separate stern and bow pieces that would be attached independently as on the full-sized canoe; nor did he steam the miniature, but instead carved it out by hand. And rather than attaching brass strips to the keel to protect it on a stony beach, he used highly polished hardwood to represent brass. When asked why he did not follow original practices, Gobin simply stated that there had been no need for them. The re-creation of the physical processes of construction was less important than producing a representative miniature that would have a particular effect on a viewer.

The canoe was presented to Steven Point at the Songhees ceremony, although Gobin did not attend. My subsequent attempts to discover its current whereabouts unfortunately met with no response from the Office of the Governor of Washington, to which it was entrusted. The eventual fate of the miniature is less important to this study, however, than is Gobin's understanding of its intended destination and of the cognitive and technical elements of his work. Gobin remarked that the miniature was "given to Obama," and although it was not clear whether this was a figurative or a literal description, his intention to send a message to American authority was evident. In Tulalip understanding, therefore, this canoe miniature operated as a statement of Tulalip identity and resource ownership, travelling to the seat of American power and tracing a journey not dissimilar to those of the Makah canoe miniatures.

Miniaturization and Tulalip Identity

The confederated Coast Salish tribes have instituted a modern, semi-industrialized art program through which they are conspicuously staking their claim to resources in opposition to historical repression. The provision of readily available equipment and training, coupled with the imaginative stimuli of a communal carving environment, are essential in developing contemporary Tulalip art as a recognizably distinct school of established Salish art, and thereby generating self-reflective statements of identity and authority.

Miniatures are a vital component of this process. By producing miniatures, Tulalip artists can learn through practice and develop their style before working on the larger statement pieces. In traditional Salish fashion, the latter decorate the parts of the reservation that are of greatest cultural, political, or economic importance as expressions of ownership by the entire community through the display of owned stories. By submitting miniatures

to the board of directors for approval, Tulalip artists are allowing the political authority on the reservation to exercise imaginative dominance over the creative process and, by selectively approving submitted designs, to influence the direction of Tulalip art as a defined form within these sites of contact. That this centralized process has not resulted in homogeneous art can be attributed to a combination of the skill of the individual practitioners, the freedom the board permits designers, and the thriving private art market, which effectively complements the public art of the reservation. By ensuring that the hotel and outlet mall require a constant stream of art production, the Tulalip Tribes have solidified the future of Tulalip material culture in a systematic way that few tribes can match, and in doing so have used miniaturization as an essential stage in the imaginative creative process.

Miniaturization on the Tulalip Reservation has another side, however, exemplified by Joe Gobin's canoe made for the Songhees ceremony. It enabled Gobin to create a powerful symbol of Tulalip (and by extension, Salish) ownership of tribal waters. In renaming this body of water to a collective term that encompasses thousands of Indigenous users of the sea, the Salish achieved a semiotic victory in the long-running battle marked by the Boldt Decision in 1974 and the Canoe Journeys twenty years later. Gobin's miniature, designed with the hope (if not the expectation) that it might find a home in the White House, the political centre of the United States, establishes these claims in categorically Indigenous terms. In the tradition of Salish totem poles, implanting weighty meaning at sites of political conflict, the miniature is a smaller, skilfully designed and created symbolic embodiment of Salish control of the seas and their wealth.

Unlike among Makah, Haida, or Kwakwa<u>ka</u>'wakw peoples, Tulalip miniaturization is not about memory so much as it is about the future. Tulalip artists willingly adopt new technologies, imagery, and ideology in their creative process; they are less hidebound by history and more focused on the movement of aspiration. Using art to make public statements of ownership and identity is a traditional Northwest Coast practice, but the systematized, commercial manner in which the Tulalip have pursued this program reflects a determination to build on the past and explore new realities – an ambition within which miniaturization is a vital component.

5
An Elemental Theory of Miniaturization

MINIATURIZATION EVIDENTLY CONTINUES to operate as an agent of internal and external non-verbal communication among Pacific Northwest Indigenous peoples. Each of the four communities discussed in the preceding chapters is distinguished by localized differences created by individual circumstances but common themes recur, suggesting that a more theoretical view of miniaturization is merited. How, then, can miniaturized material culture be approached from an analytical standpoint? And in particular, what role does it play in the relationship between the people of the region and the settler-colonial governments and societies that increasingly restricted and controlled their way of life from the nineteenth century onwards?

Nonsensical Art

At the beginning of this book, I noted that Franz Boas took a utilitarian view of Northwest Coast material culture, in which every object had a recognized function or "useful end": a fish hook, no matter how beautifully carved, was still a hook for catching fish. Boas was not wrong, but he does not adequately recognize that the beautiful decoration of the fish hook is not ancillary to the catching of fish but a fundamental part of its recognized function, and further that it widens the function of the hook to multiple roles, many of which cannot be observed by attention to its physical properties alone. Claude Lévi-Strauss developed this idea in relation to a fish

club, noting that its "useful end" requires not just mechanical properties but aesthetic ones. Lévi-Strauss extends the application of the idea to miniatures, noting that "the intrinsic value of a small scale model is that it compensates for the renunciation of sensible dimensions by the acquisition of intelligible dimensions" (1966, 22–26). By jettisoning sensible dimensions – and thus creating "non-sensible" or nonsense dimensions – the miniature assumes aspects that cannot be easily observed by the human senses. Just as with the fish club, the "non-sensible," intelligible dimensions of the miniature appear through collaboration between its physical properties and systems of intangible, non-sensical relations dependent on individually determined, culturally and temporally influenced decisions (Knappett 2012, 87). This collaboration allows many of the miniatures described in this book, from Alex McCarty's canoes to the satirical argillite of the Haida and the maquettes of the Tulalip, to incorporate vastly significant potential into diminutive proportions.

This text is therefore in search of intangible dimensions, or affordances, within miniatures. These are dimensions that are, to adapt Lévi-Strauss's parlance, "non-sensical" and cannot be observed by the senses alone, though the word *nonsensical* also has a useful secondary meaning in the present context, referring to dimensions that may appear ludicrous or abnormal, and thus beyond the senses of an unknowledgeable observer. Using our senses, we can make observations about a miniature's dimensions, weight, materials, and so forth. From a subjective analysis of these observations, we can also draw conclusions about the context in which a miniature was created and the environment in which it operates today. But the nonsensical dimensions of miniatures are by their nature difficult to define, let alone identify. Any object relies on the context within which it is expected to operate, but a miniature's small scale can obscure its tangible dimensions and distort reality, by tricking an observer into mistaking a miniature for the thing it resembles; for example, a miniature canoe is not a canoe, and cannot be used as one, but is consistently mistaken as one in its depiction in museum displays and publications (see Miller 2005, 5; Windsor 2004). This is how the argillite miniatures made by Haida artists in the nineteenth century can be both safe tourist art and satirical commentary on colonialism at the same time. Thus, to understand non-sensical dimensions an analysis of properties – or affordances – that are harder to observe is required. Additional contextual information must be applied for the dimensions to become "sensical" once more.

Figure 5.1 Billboard in Broadway Market, London, 2013.

The imaginative nature of intangible, nonsensical dimensions means that they are often interpreted as whimsical, or even facile – but that is a cursory observation. The bakery sign in Figure 5.1 touches in a flippant, humorous way on the intangible, subjective elements of baking: the effort, the experimentation, perhaps even the taste. Yet it has a more serious intent. By invoking nonsensical "imaginary" ingredients, the sign transmits an impression of the bakery and its staff that is designed to amuse and consequently to entice passing pedestrians to enter the store and purchase baked goods. It is therefore making use of intangible dimensions in a tangible and quantifiable commercial capacity. The deployment of intangible dimensions will be successful only if the practitioner has sufficiently understood the intended audience's ability to interpret these dimensions. The object (in this case, a sign) must be immersed in the tangible and intangible social contexts of a particular time and place to exert subtle influence on the minds of potential consumers (Mitchell 2005, 38).

In a similar way, miniature objects can be used as tools to achieve an action and, once used, as by-products. The technical process of miniaturization is designed to employ the miniature's intangible dimensions to influence an audience in much the same manner as the bakery sign. Thus the eventual destination of Joe Gobin's canoe miniature is less important than the act of its creation and public presentation, and the maquettes of Steven Bruce Sr. can be readily discarded once the project is complete because the miniatures have already circulated among their intended audiences.

Theories of Miniaturization

It is widely recognized that objects and images interact and influence other objects, including people; even the most everyday items contain what Pierre Lemonnier has called an "indivisible mix of ritual, myth and technical action," which they can share with knowledgeable observers (2013, 60; see also Appadurai 1986; Latour 1988). Miniature objects have nevertheless often been relegated to simple interpretation as toys or souvenirs by those incapable of comprehending their obscured meanings, such as Indian agents and colonial officers. In consequence they have at times been strongly criticized, denounced by curators because they "find their way to museums, just where they ought not to be, as generally, with a few exceptions, they are devoid of all scientific value" (Porsild 1915, 233), and clutter the museums with great numbers of models (Hawker 2016, 210). In European contexts, miniatures are often considered as examples of "pedagogy or popularization, but hardly in the mainstream of the history of science" (de Chadavarian and Hopwood 2004, 3). In this capacity, they are subject to strictly functionalist analysis, relying on "standard archaeological interpretation of miniatures as toys, ritual items or burial offerings" (Knappett 2012, 87).

A number of attempts to disentangle the meanings within miniatures have nonetheless been made, and thus to expose the apparent paradox of functionality that they embody. Lévi-Strauss remarks that miniatures "are 'man-made' and, what is more, made by hand. They are therefore not just projections or passive homologues of the object: they constitute a real experiment with it" (1966, 22). That these experiments rely on the relationship between the object and its observers has been identified by Susan Stewart, who notes that "a miniaturization is effected through the viewer's stance" (1984, 134), and Alfred Gell, who finds himself forced to "pay tribute to dexterity in [the] objectified form" of a matchstick cathedral even as he is

ironically surrounded by the medieval building that the miniature resembles (1992, 47).

A miniature can operate only within the relationship between audience and object that gives the miniature purpose. Carlo Severi describes this link as being formed primarily from visual stimulation but adds, "The act of looking, far from being passive, presupposes the establishment of a relation between a form of an external object and a formal, innate and unconscious model of the perception of space, which reflects a mental image of the body. Perception thus also, and always, involves projecting an image of oneself" (2015, 31). Thus for Severi, as well as Gell, Stewart, and Lévi-Strauss, it is the miniature – smaller, intimate, and approachable – onto which they could project themselves and which therefore produces a more powerful effect than the larger thing it resembles. Consequently the miniature's contextual relationships in the presence of an audience are the source of its power. Stewart dramatizes this idea: "We are able to hold the miniature object in our hand, but our hand is no longer in proportion to the world; instead our hand becomes a form of undifferentiated landscape, the body a kind of background" (1984, 70). The recipients of Mungo Martin's hunting canoe miniatures would have the same experience, each object being tailored to an audience that would inhabit the miniature and forge its own link with it.

These approaches recognize that the relationship between miniatures and their audience is dominated by specific powers of fascination. Acknowledging fascination requires accepting that physical properties have psychological effects on audiences (Domínguez Rubio 2016; Gell 1992). Ruth Phillips recognizes this in her study of Indigenous miniaturization in the American Northeast, calling miniatures "a gift beyond the ordinary" (1998, 73). She considers that miniatures have a "universality ... understood and appreciated by the Native and non-Native participants in the gift exchanges" and that a cognitive effect is achieved by "the reduced scale of the miniature which reveals the attributes of the object it represents with special clarity," an affordance hinging upon the "precise point on the continuum of miniaturization when its primary function becomes representational rather than utilitarian" (1998, 73–74, 91).[1] Such a model of miniaturization can be rendered simply:

Prototype → Artist → Miniature
Utilitarian → Representational

In Phillips's theory, when a miniature object crosses this barrier it has "facilitated its recontextualization within pre-existing or emergent frames of reference" for the audience, generating a visual dissonance that John Mack illustrates through the medium of a dollhouse, which can "create a functionless space, for which of us can sit down in a miniature library chair to read a book whose print is so tiny that it is unreadable?" (2007, 206). Such is true of Young Doctor's Makah canoe miniature, for example, in which the legless paddlers can exist only within the functionless space the miniature canoe creates for them.

In this interpretation, miniaturization as a process depends on the relationship between utility and representation (Foxhall 2014). By switching from utilitarian to representative objects through a reduction in size, miniatures are therefore an example of Gell's "symbolic 'commentary' on technical strategies in production, reproduction, and psychological manipulation"; they are a means of engaging with the world that is not based on bare functional utility as a "best possible compromise in the light of all the practical difficulties and restraints" (1998, 257) but is instead "an ideal standard, not to be approached in reality, towards which practical technical action can nonetheless be oriented" (1988, 8). Onto this standard can be projected subtle messages that depend on the spatial and temporal context of their conception but may be universally understood. These projections simultaneously incorporate and obscure the ideology embodied in miniatures, potentially allowing communication between people separated by significant temporal and spatial distances, communication privileged by an ability to accurately interpret the miniature.

In time many miniature objects have joined the broader corpus of "natural or artificial objects, kept temporarily or permanently out of the economic circuit, afforded special protection in enclosed spaces adapted specifically for that purpose and put on display" to operate as "intermediaries between their admirers and the world they represented" (Pomian 1990, 9, 24). In this environment, objects separate into "things, objects which were useful" and "objects which were of absolutely no use." As museum objects enter collections, they become so charged with imposed meaning that they reach a condition of fundamental uselessness, a condition in which they are known as *semiophores* (30).[2]

Carl Knappett's work on this subject connects with Phillips's, in that it identifies a methodology encompassing the properties of miniature objects: "frequency, fidelity, distance and directionality," which can be used to assess

miniaturization by considering the practice within a cultural context (2012, 103). Analysis of these properties provides "a *methodology* for bridging the gap between the local and the global in the generation of material culture meaning" (105). Although Knappett recognizes that "miniatures have certain physical and semiotic properties (or, in other words, affordances and associations) that enable them to bear meaning in an intensified fashion, while paradoxically being physically remote from those forms of which they are iconic or indexical," his theory still operates on a continuum: "A change in scale may not affect their form, but it does affect their function ... [There is a] loss of function with reduced scale" (103, 99).

The theory underpinning this book questions the implicit assumption in these analyses that miniatures operate on a continuum of scale or that they hold a universality of understanding. Instead, I argue that miniaturization is the result of individual decisions made by artists and directly informed by a range of cultural, technological, and economic considerations and interpreted by audiences according to the context of their observation. I further contend that there is a set of affordances, or elements, by which the physical and contextual evidence of miniature objects can be assessed and through which we can decrypt the "system of codes" in objects and images that W.T.J. Mitchell tells us "interposes an ideological veil between us and the real world" (2002, 91).

Semiotics of Miniaturization

In common with other material culture practices, miniaturization requires what Tim Ingold calls "not just the application of mechanical force to exterior objects, but ... qualities of care, judgement and dexterity" (2001, 21), and it is therefore enacted by a combination of technical activity and the expression of emotions and thought described by Franz Boas ([1927] 1955, 349). Miniaturization may therefore be thought of as a technical process during which significance is conferred and transmitted. Miniaturization is thus a way of "bringing order to things and facilitat[ing] our encounter with the world" (J.R. King 1996, 17).

Since miniature objects are tools to facilitate human interactions, it logically follows that understanding these interactions – not merely the objects themselves – is essential to discovering the "networks of meaning" the miniatures embody (Knappett 2012, 104). Miniature objects may be understood not as the final stage in, or result of, the process of miniaturization

but as the by-products of a form of human communication, a method of what Christopher Evans calls "the carrying and reproduction of knowledge" (2012, 370), even of embodying that knowledge. We must re-envision miniatures as a category of object operating through tangible and nonsensical properties as a form of communication.

Interpreting the network of meanings incorporated in objects from a perspective alien to that in which it was created is highly complicated, as illustrated by Lévi-Strauss:

> In the case of our own [European] art we think we know the code, and what we are interested in is mostly the message ... On the other hand, when we look at the art of tribal people, we do not know the code and we should first of all try to decipher it. However, when we succeed, or believe we have succeeded, it is only to discover that the message is not addressed to us. How can we be aesthetically moved by a message we neither know nor understand or, if we do understand it, does not concern us?
> ...
> I would suggest that we are more or less in the situation of somebody receiving a coded cable. We do not know the code, so we cannot understand the message. However, when we look at the message we recognize some properties characteristic of the way this unknown communication was coded. We notice groups of words or groups of letters or some ciphers that appear more often, others less. If I may say so, these external properties of an unknown message can be put to use as a makeshift code to guide our own reading. (1985, 5–6)

Comprehending Lévi-Strauss's notion of the transmission of "coded" ideas through intangible dimensions requires engagement with semiotics: the interpretation and mediation of signs. A full discussion of the intricacies of semiotics is unnecessary here, suffice only to acknowledge that it comprises at its core three types of sign – iconic, indexical, and symbolic – that operate within the relationship (semiosis) between sign (signum) and interpretant (signatum). Iconic signs bear direct physical relation to their prototype, indexical signs operate through a system of observational inferences, and symbolic signs are interpreted solely through socially convened understanding.

These three forms of sign are interconnected stages in a process of interpretation, each stage reliant on the one that came before. Objects participate in all three forms of sign simultaneously; "No painting is devoid

of ideographic, symbolic elements ... There is no question of three categorically separate types of signs, but only of a different hierarchy assigned to the interacting types of relation between the signums and signatum of the given signs" (Jakobsen 1971, 700). Moreover, the materiality of signs renders them active agents, "not simply message carriers in some pre-ordered social universe [but] ... the actual physical forces that shape the social and cognitive universe" (Malafouris 2013, 97).

I have demonstrated in multiple contexts above that miniatures are signs; through their affordances and the interactive process of miniaturization, they cooperate with obscured codes that do not rely on "factual proximity" to facilitate semiosis. As Gell and others have indicated, the process by which a sign is connected to a thing can occur only when an observer makes his or her own imaginative connection between sign and thing. When this semiosis is based on past experiences, it is known as *abduction*. This abductive connection may be created between any thing and observer, but the original codes incorporated in the thing, in this case a miniature, might not be clearly understood unless the observer is operating within, or at least knowledgeable about, the same semiotic ideology as the artist.

A good example of how this system operates, or fails to operate, is the canoe miniature I suggested earlier was given to Louis Sartori in 1869. The miniature would have been freighted with meaning for seafarers of Sitka and the northern Northwest Coast but little more than a curiosity to Sartori, who was presumably unable to grasp the complex indexical aspects of the object because he approached it from an entirely different context than its Indigenous carver.

Semiotic ideology, as defined by Webb Keane, dictates that a significative process, in this case miniaturization, occurs within a series of "background assumptions about what signs are and how they function in the world" (Keane 2005, 191–92; *cf* Keane 2003), "assumptions, either tacit or explicit, that guide how they do or do not perceive or seek out signs in the world around them" (Keane 2014, 314). For an observer to interpret the indexical codes incorporated in miniature objects accurately, the objects must therefore be adequately re-situated within the semiotic ideology of their original producers because "recognition is mediated by what you assume about the world" (Keane 2005, 192). Consequently it is necessary to examine the elements that artists may have considered important to their audience and thus essential to the miniature's construction, and to ensure as far as is possible that the miniature is figuratively re-situated within the environment from which it emerged.

With material culture from the Northwest Coast in particular, this chasm in understanding has only been compounded by the deliberate and essential unknowability inherent in miniatures, incorporated during their conception, which has inconsistently confounded curatorial efforts to neatly categorize Indigenous material culture (Storrie 2014). This has helped to preserve Indigenous control over aspects of material culture even as it circulates beyond Indigenous societies, for "the inalienable remains beyond them, beyond their reach. If this is so the protectionism can be effective" (Townsend-Gault 2004, 197). With the safety of this confusion in place, Knappett's contextual criteria cannot be easily applied, and without a new methodology neither the "psychological biases" (see Gell 1988, 8) in relation to which the object operates nor the processes essential in its creation can be observed, and thus its codes remain unbroken. In Cranmer Webster's terms, we cannot "read" a miniature object any more than one can read a rattle, and because non-Indigenous observers do not possess the contextual understanding or necessary authority, they cannot shake it either. To foreign observers the object remains mysteriously unknowable.

An object such as a miniature, which has supposedly moved from a utilitarian to a representational purpose, cannot easily be re-situated. Instead we must acknowledge that each instance of miniaturization can have taken place only within the specific environmental, cultural, and temporal context in which it actually occurred. This is because miniaturization is one of

> all those technical strategies, especially art, music, dances, rhetoric, gifts, etc., which human beings employ in order to secure the acquiescence of other people in their intentions or projects. These technical strategies – which are, of course, practised reciprocally – exploit innate or derived psychological biases so as to enchant the other person and cause him/her to perceive social reality in a way favourable to the social interests of the enchanter. (Gell 1988, 8)

In other words, just as with the bakery advertisement, efficient communication requires understanding a relationship within reality as it existed in the temporal and spatial circumstances in which the technical strategy was conceived and enacted. We must seek to understand the world from which the miniature came in order to effectively engage with it.

The miniature object and the technical processes that created it are only part of a much wider environment, to which the interactions of human and

non-human influences contribute (Latour 2005, 74). An imaginative object, such as a miniature, that incorporates intangible dimensions must be envisaged, created, and deployed within a set of relationships situated in a specific environment, and understanding these relationships allows an audience to accurately interpret the properties of the miniature and to engage with its intangible dimensions (Knappett 2012, 88). Not just the message but how the message is conveyed gives this process import (Malafouris 2013, 93).

Elements of Miniaturization

To draw together a complete analysis of physical affordances and semiotic ideologies during the miniaturization process necessitates going beyond the approaches just described to develop a new methodological hypothesis (see Davy 2015, 2018a, 2018b). In doing so my approach is to study the elements of mimesis (or resemblance), scaling, and simplification and to assume that the artist makes a sequence of decisions about each element. I deploy the metaphor of elements to illustrate that these are the foundational components of the miniaturization process, and that when combined in varied concentrations, they can form objects comprised of these elements, such as miniatures, that achieve different effects.

Resemblance

Resemblance, or mimesis, is an imaginative activity that allows for replication, "drawing on the power of the original, to the point whereby the representation may even assume that character and that power" (Taussig 1993, xiii).[3] A new object explicitly draws on the social connections of the original prototype it resembles, which permits replicas to "epitomize, echo and reverberate meaning captured in and associated with other objects, while creating new meanings of their own" (Foxhall 2014, 1).

A photograph taken near Lake Union in Seattle illustrates mimesis in action (Figure 5.2). A shop selling engraved trophies has on its roof an outsized piece of three-dimensional advertising in the form of a trophy, grandly proclaimed to be the "World's Largest Trophy Cup." This is prima facie an inaccurate statement: it is neither a trophy nor a cup, in the sense that it was neither awarded as a marker of achievement nor is it capable of holding a beverage. Instead, it is a gigantic, iconic mimetic device used to transmit a message to potential customers in much the same fashion and for the same reasons as the bakery sign in Figure 5.1, drawing on a socially

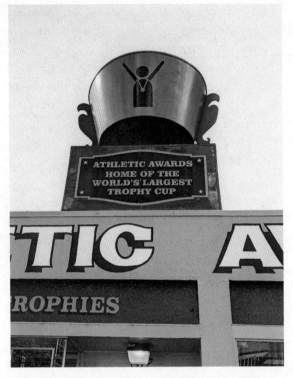

Figure 5.2 World's Largest Trophy Cup, Republican Street, Seattle, 2021.

convened notion of what a cup should look like for its prototype. It does not signify itself but instead acts as a sign for the trade conducted in the shop (Layton 2006, 32). Neither is it based on an individual object: a specific cup. In this circumstance the prototype of this cup is not *a* cup but all cups.

Similarly, by taking on the form of another object without assuming its function, a miniature bends reality to create the impression of the prototype and all its implications without requiring the same size, labour, materials, or utility, thereby acting as a sign of a more complex system. The giant cup is a sign of competitive sport. Miniature canoes are signs of all canoes, or even just the socially convened idea of a canoe.

The choice of prototype for a miniature reflects the requirements of the artist to embody particular powers of representation, which are interpreted by considering the expected relationship between the image and its intended audience. Since the power of objects "resides in the *symbolic* processes they provoke in the beholder" and is invoked as their creators intended only if

those processes are in place, miniaturization is geared toward the audience; once used, the miniature itself becomes a by-product (Gell 1992, 48, emphasis in original; Gell 1996). However, Gell also recognizes that the artist has choice in the selection of prototype, noting that the appearance of the *Mona Lisa* is not due to the model but to the artist: "Leonardo is seen as responsible for the Mona Lisa's appearance, or at least what is fascinating and compelling about her appearance," enabling the artwork "to dominate the spectator by subverting or deranging his or her petit bourgeois sensibilities" (1998, 53, 56). Thus the qualities of resemblance in miniatures are not dictated by their prototypes but by their artists – the choice to make the miniature resemble a canoe is not dictated by the large canoe but by the artist, and thus cannot exist on a continuum from large to small since the canoe prototype exists only in the artist's mind.

The term *prototype* refers to the mimetic inspiration for the miniature, but a physical prototype does not have to exist for the miniature to be created: witness Lévi-Strauss's example of the Sistine Chapel as a miniature for the end of the world (1966, 23), or the 15-metre-wide 1:24 scale model of the entirely imaginary Hogwarts Castle at Warner Bros. Studios (Bond 2012). Miniatures are embodiments of "things" that "serve as targets for a mind eager to project itself onto mirrorlike surfaces" (Küchler 2005, 207). These "things" can be physical objects, imaginative constructions, or a whole range of intangible, nebulous ideas, gestures, and concepts – the full extent of human imagination (see Connor 2008; Ishii 2012; Küchler 2005). No miniature can be created, or even conceived, without a larger thing already existing theoretically, if not physically, but the choice of thing relies on the artist, not the thing itself.

Although Michael Taussig conflates mimesis with representation, this is not automatically the case. Representation is an action in which something acts on behalf of or symbolizes something else. Mimesis, however, is only the formation of a visual link that may or may not have deeper purpose; in reality, the emphasis of the miniature – its message – does not necessarily correlate directly to the prototype. Representation also does not therefore automatically confer meaning; a miniature canoe may not actually be intended to represent a canoe, and an audience should not assume that it is.

Thus something representative does not have to look like the thing it represents, and something that has similarities to something else does not need to represent the thing it resembles; indeed, it is within this deception of mimesis that nonsensical dimensions may be obscured and meaning may

be developed. This raises the possibility of a mimetic object holding the potential to operate as a representative of much broader phenomena.

If miniaturization is a method of communication, and miniature objects the medium through which knowledge is communicated, then the knowledge, not the prototype, acts as inspiration for the miniature. Knowledge and its transmission, not the accuracy of depiction, is most prevalent in the artist's mind during the process of creation. In what follows, I use the term *emphasis* when considering the motivation for creation of a miniature and its operation in relation to the elemental choices outlined here, and reserve the term *prototype* for the iconic inspiration for mimesis – what the miniature physically resembles, not what it might mean.

Scaling

Sareeta Amrute (2016) refers to what she calls op-art anthropology, the use of small-scale "things" to illustrate and elucidate global phenomena:

> Anthropologists like to make big things out of small things. Small things can be details in a larger argument, or clues to follow. Small things reveal the scope of a problem. Anthropologists notice the small ... The small tells a bigger story ... As we move between these small things and the large things we know they are connected to, we make our texts both beautiful to read and difficult to follow.

It is a valuable rhetorical method, allowing small-scale studies to generate broader implications while simultaneously reducing the distance between the audience and much larger, almost intractable, patterns.

By its nature, a miniature object reflects this understanding, for it must always be of a reduced scale to its prototype. This may be effected through mathematical proportionality or a more informal reduction by eye, but always the scale slides downward. Knappett considers scaling as contingent on directionality: that larger objects might be scaled down to make miniatures but that smaller ones cannot be scaled up to create practical objects (2012, 92). I separate the question of scaling from a continuum of scale altogether, positing that other than exhibiting a downward trend, the scale of a miniature object need not be even notionally related to the prototype at all. As with the Sistine Chapel or young Gell and the matchstick cathedral, it is important to acknowledge that size alone is not the crucial characteristic: miniaturization requires a reduction of scale in relation to the larger prototype,

but there is no absolute barrier to size. A miniature can be large indeed, providing that it is smaller than the object it is intended to resemble.

Scaling operates in collaboration with functionality; in the terms adopted for this theory, a miniature by its nature cannot be created or used for the same purpose as the prototype. Miniaturization as a process depends on severing the relationship between utility and representation. A practitioner does not set out to make a smaller version of something that should (or generally could) be used for the same function as the prototype and inadvertently produce a miniature, but rather creates a miniature object with its own predetermined functionality, making use of the image of the prototype. Therefore, an artist could create an object perfectly capable of performing the function of the prototype but without intending it to be used in such a manner; such an object would still be a skeuomorph, adopting parts of the prototype unrelated to its function, but need not be a miniature. For example, during my fieldwork Tulalip carver Mike Gobin presented me with a "cod lure" that is not actually a lure for catching cod; it is a full-sized sculpture of a cod lure produced as a piece of modern Tulalip art. It is also worth noting that although I firmly believe he gave it to me as a genuine gesture of friendship and welcome, the object explicitly inserts Tulalip identity into the contact zone of research as an attractive agent, and thus successfully compels its appearance within this book.

The cod lure is not a miniature, because its scale has not changed. A reduction in scale is necessary to convert resemblance into miniaturization, a process that encourages direct engagement with both the object and, like Gell and the cathedral, through its wider network of social relations. Because "smallness as aggregating to bigness provides a framework in which the minutiae of everyday life can be classified, contained, and elevated in importance" through the action of observation, the first stage of miniaturization, in which objects resembling prototypes in reduced scale but without their functionality are created to generate a fascinating tactility for an intended audience, is not a continuum but an intention (Amrute 2016).

Knappett's concept of fidelity notes that "a change in scale may not affect their fundamental form, but it does affect their function: miniature [objects] clearly cannot function in the same way as the full-size versions" (2012, 99), but this assumes that miniaturization relies on the *functionality* of the prototype at any stage in the process. I contend that it does not, at least not consistently: that it relies only on its visual relationship to the prototype and its network of relations within a particular context. Miniaturization

does not need to consider the functionality of the prototype unless the particular process specifically demands it, such as architectural miniatures created in order to experiment physically with different phases of design. Abandoning functionality allows the artist to conduct imaginative experiments with proportion, resulting in unusual configurations by comparison with the prototypes.

Scaling is particularly important to an understanding of toys. There is a tendency to conflate miniature objects with toys, particularly in the study of Indigenous North American material culture, in which paternalistic assumptions have been common. Ruth Phillips notes that toys are associated "not only with play and childhood, but also with the trivial and ephemeral" (1998, 88). Since toys are also explicitly associated with the child, a figure often obscured in the historical record, they can appear invisible or sentimentalized (Soafer Derevenski 1994; 2000, 4). This is not necessarily a misapprehension: as Spencer McCarty, Helena Swan, and others described, some miniatures from the Northwest Coast certainly played a role in childhood games, such as those imitating adult ceremonial activities (De Laguna 1990, 208; Elmendorf 1960, 226; Ford 1941, 85–86), and most miniatures have an inherent "playability" that emphasizes their fascinating tactility (Phillips 1998, 73). This quality often oversimplifies the object type, but toys are not simple objects and cannot easily be transferred between semiotic ideologies with their meanings intact. They are in fact a medium though which adults seek to influence children's perceptions of and interactions with the world in ways they deem socially useful (Sutton-Smith 1986, 119). Miniatures made for the entertainment and education of children are designed to both represent and teach the roles that children are expected to undertake once they come of age.

If we recognize that toys have serious intentions, they are recast from facile playthings to semiotic influences on susceptible minds. The effects that miniatures have on children are described by Bill Sillar as a "process of engendering an attachment and sentiment for particular ideals that they will take with them into adult life," and which will re-emerge in markedly different contexts as childhood games become serious experimentation with cosmology and technology (1994, 52–53).

Simplification

For the third element under consideration, simplification, it must be acknowledged that miniature objects are always less detailed and less complex

than the object they resemble. David Clarke notes that they are only "partial representations, which simplify the complex observations by the selective elimination of detail incidental to the purpose" (1972, 2). The series of choices by which detail is reduced are ultimately some of the most important in miniaturization (Kiernan 2014, 46), providing the properties without which even an audience versed in the original environment would be unable to understand them accurately.

Simplification, even more so than resemblance or scaling, provides insight into the ideology of the artist because the range of decisions is wider, occurring on several levels. At the conceptual level, the miniature is simplified in its divorce from the context of the prototype, for while a prototype is usually surrounded by the environmental and mechanical contexts of its indexical relations, the miniature usually is not (Davy 2015, 9).

Furthermore, there is considerable physical simplification in the minutiae of the miniature's appearance; if the functionality of the prototype is severed during miniaturization, then many of the mechanical requirements of that functionality can be safely omitted as well. Alex McCarty provides an example in questioning whether a miniature watercraft can float (or, at least, float upright). If it does not, we can assume it does not need to and the qualities that promote upright flotation can be abandoned in the miniaturization process. If it does, there must be a reason that it does, and these qualities must be incorporated into or adapted to the miniature. In either case, this one choice provides crucial information about the intentions of the artist.

Part of the confusion is terminological, stemming from a failure in museums to draw a distinction between the terms *miniature* and *model*, which traditionally denote a difference between objects that prioritize aesthetics and those with more scientific practicality. Martine Reid complains that canoe miniatures were often wrongly catalogued as models and asks,

> How can we explain the significant number of eighteenth- and early-nineteenth-century [Northwest Coast] canoe miniatures ... Were they toys; as they seem to have been classified at [one] time? Were they early tourist items?
>
> Many of them are exquisitely executed and painted, fully equipped with realistically carved paddlers, dressed and with human hair; some are shown holding shaman rattles. Could they have been used by shamans during their visionary journeys to ensure successful fishing or sea-mammal

hunting? The peoples of the Northwest Coast knew that whales and other sea mammals have the power to transform their bodies into canoes. Perhaps the canoe miniatures represent the outer forms of these powerful sea creatures. (1987, 222)

Reid tentatively identifies the intangible, magical qualities of miniatures, which the scientific term *model,* rooted as it is in the European Enlightenment and referring to a precisely proportioned copy, may implicitly exclude. James Roy King also recognizes the issue, noting that models and miniatures "have much in common but much that sets them apart; models are intended to be deliberate representations of the full-sized object while miniatures are 'folk' art, intent on preserving the resemblance to the prototype without the attendant requirement for detail" (1996, 18–21). Since it is well understood that Northwest Coast miniatures are not generally accurately proportioned, Reid's distaste for the term *model* may be well founded (Boas [1909] 1975, 444; Holm 1983, 92; Holm 1987b).

Simplification also applies to the cognitive aspects of construction. Considerable effort – almost all of it divorced from the type of activity involved in the design and construction of the prototype – has gone into the mechanical processes of miniaturization. Details considered extraneous to the miniature's function and thus removed from the design are examples of the "distorted dimensionality" common to miniature objects (Foxhall 2014), which is how miniaturization obscures the fact that whatever its relationships with larger objects, the miniature is not and cannot be the prototype. The miniature canoe cannot be a functioning watercraft but repurposes the *idea* of a canoe for its representative task. Thus the actual goal of the miniaturization process may be unrelated to the prototype itself, utilizing its imagery for an entirely different purpose.

Simplification should not be misunderstood: the miniature itself, not its construction process, is the simplification. The construction is divorced from that of the prototype unless, again, the artist requires certain similarities for the miniature's function. Indeed, the technical skill involved in producing a miniature may be equal to or greater than that required for producing the object it resembles (Porsild 1915), and it is common for artists to express relish at the challenge miniaturization poses (see, for example, Phillips 1998, 75).

Simplification in design can provoke simplification in interpretation of a wider and significantly more complex concept through an accessible

medium. A miniature that forms an intimate link with an audience can through that connection embody or exemplify ideological concepts, or emphasis, more strongly and accessibly than its prototype, as it defies easy understanding on functionalist terms and encourages intimacy. This book tests the ways in which these concepts can be recognized, and the codes of miniaturization decrypted, by assessing the elemental relationships combined within the objects produced by miniaturization in relation to the semiotic ideologies of their creation.

Ultimately this theoretical framework enables the study of Northwest Coast miniaturization to be expanded to consider to what extent miniature objects from the region can operate as effective and authentic embodiments of ideology, and to suggest what this approach can offer a more general study of Northwest Coast material history and miniaturization as a material culture practice.

6
Analysis of Technique and Status

OF COURSE, NORTHWEST COAST communities did not practise a single, homogeneous type of material culture, nor did the practices in those communities remain static. The artists I spoke to gave considerable thought to what miniatures meant to them personally, and what they meant to their communities more broadly, repeatedly emphasizing that localized differences were crucial. Alex McCarty went further, pointing out that the museum record does not necessarily reflect differences in practice within a given community:

It hurts me when I see a canoe that says that it was made by the "Neah Bay Indians." The Neah Bay Indians didn't make that canoe. It was made by a particular artist and it needs to be recognized that it was truly a family design and it should be recognized that there is some ownership involved there.

I therefore want to avoid generalizations about "Northwest Coast culture" but instead to highlight recurring themes in regional data that appear to cross cultural boundaries and may reflect wide similarities in material culture production while still being subject to local variation and innovation.

My initial research determined that the most common forms of miniature in the museum collections were, in approximate order of frequency, totem poles, canoes, and houses. I also found other types of object that may be classed as miniatures, including hats, clubs, and fish hooks, although in numbers too small to be useful for statistical analysis, or in some cases

defying the generalizations that statistical analysis requires.[1] After some consideration, I decided to focus on the miniature types produced most frequently as being the most likely to return usable results from a sufficiently wide sample: canoes and houses. Totem poles were omitted from data analysis, although not from the conclusions of this work, as they have previously been the subject of a detailed study (Hall and Glascock 2011). My survey produced records on 944 miniature canoes, 64 miniature houses, and 9 miniature tombs. While not comprehensive, this list comprises a substantial majority of the museum holdings of these object types from the Northwest Coast. The numbers make it clear that miniaturization was not an isolated or exceptional practice but a common form of artistic expression in the region. All but 79 of the total 1,022 objects were accessible for analysis using images and data supplied by museums, and I examined over 200 examples in person for more detailed observational and dimensional analysis. From the data, I developed typologies of miniature canoes and houses based on a subjective analysis of their various affordances, and in combination with fieldwork interviews, this study has formed the foundation of a broad overview of Northwest Coast miniaturization practices.

My initial assessment of the data produced statistics on the regional production of certain miniature types, surveyed through a design analysis, and it was possible to isolate specific canoe and house designs and analyze them within the context of the geographic, temporal, and cultural circumstances in which they were made. This data set does not necessarily prove the precise point of origin for any given miniature, but since the designs were localized in particular parts of the Northwest Coast, it should give some idea of the importance of miniaturization in specific places at specific times, and the importance of certain themes to the practice of miniaturization in those environments.

Miniature Canoes

Restricted access or damage made it impossible to analyze every miniature canoe in the survey, but subjective analysis – in particular of the relationships between the miniatures and Northwest Coast canoe designs – could be conducted on 787 (see Table 6.1).[2] The seriation of these designs is based loosely on that featured in the seventh volume of the Smithsonian's *Handbook of North American Indians* (Suttles 1990), with amendments drawn from publications by Bill Holm (1987a) and Eugene Arima (2002). Together

Table 6.1 Miniature canoe seriations

Canoe style	Identified examples
Northern	284
Westcoast	280
Yakutat	64
Head canoe	58
Coast Salish	30
Munka	29
Salish racing	20
Riverine	8
Shovelnose	7
Ice canoe	3
Columbia River	2
European boat-style	2
Total	787

these sources outline the principal differences in canoe designs over time and across the region, enabling a simple seriation of the miniatures into the categories listed in Table 6.1.

The data shows an even spread between Northern and Westcoast (or Southern) styles, perhaps unsurprisingly also the two most frequent designs as they have the widest geographical spread. Certain historical styles (head canoes, Munka) are also well represented in the total despite having disappeared as designs for full-sized canoes early in the post-contact period. Some regionally specific designs are disproportionately common (Yakutat), while the most modern canoe designs (Salish racing) and smaller, more common, more utilitarian designs (Coast Salish, shovelnose, riverine) are significantly underrepresented in the total.

Miniature Houses

House designs on the Northwest Coast varied considerably by location and include the Northern two-beam longhouse, the larger six-beam longhouse, the Wakashan two-beam longhouse, and three types of Salishan house: shed-roof, gambrel, and Southern. Here again, I use the Smithsonian's 1990 seriation to determine styles. Examination of the miniature houses in the database threw up a quandary, however, as many did not fit the characteristics of a particular grouping (Table 6.2).

Northern-style family longhouses are overwhelmingly the most common type to appear in the survey of miniatures. Further, at least eight of the six-beam Northern houses and seven of the Wakashan houses – some 23 percent of the total analyzed – come from a pair of commissions for the 1893 World's Columbian Exposition in Chicago. Among those not built for this event and that have provenance, none dates outside the 1885–1925 range. Miniature house building was therefore spatially and temporally

focused within a particular cultural environment and among specific communities, with considerable external motivation, in contrast to the more general temporal spread of canoe miniatures. It is also significant that although Northwest Coast peoples adopted European-style clapboard houses from the 1880s onward, none appears in miniature.

Fidelity and Proportionality

As asserted above and observed by other scholars, miniatures on the Northwest Coast appear to be out of proportion with their full-sized counterparts (e.g., Boas [1909] 1975, 444; Holm 1983, 92). This is significant in considering whether such miniatures should be considered models (defined as scientific devices from an explicitly European Enlightenment context), or whether they belong to another, specifically Indigenous, category of object. The evidence makes it clear that miniatures from the Northwest Coast fall into the latter category, and indeed that disproportionality can contribute to the efficacy of miniaturization.

Strict proportionality has never been a regular part of Northwest Coast artistic consideration. As Bill Holm noted in relation to formline design, "We can be reasonably sure ... that the native artist uses no such system of ratios and proportions in his approach to composition, even though the results of his efforts invite one to analyze them in geometric terms" (1965, 69). In his study of the head canoe, he explained,

> Models, the only three-dimensional evidence we have for the form of the archaic canoes, are notoriously distorted in proportion ... It is abundantly

Table 6.2 Miniature house seriations

House style		Identified examples
Northern	Six-beam	27
	Four-beam	1
	Three-beam	4
	Two-beam	2
	Unknown*	8
	Argillite	3
	Paper	1
Wakashan		12
Salishan	Shed	1
	Shed**	2
	Southern	3
Total		64

* The eight examples listed as Unknown are Northern-style houses whose roof structure cannot be determined with the evidence available.

** The shed-style houses in this category were made by non-Indigenous people for museum displays in the mid-twentieth century. Their inclusion here highlights the differences in design between Indigenous and non-Indigenous miniaturization practices.

clear that native models were habitually made much shorter in relation to their width and height than full-size canoes. Knowing this, we can infer that the hulls of actual canoes were probably longer in proportion by perhaps half than they appear in models, and that many models probably exaggerate the size of the fins and height of the sheerline break ... Other than in those predictable distortions the forms of the old head canoe must have been much like the models. Most of the models were probably made after the full-size canoes ceased to exist, but knowledge of the traditional form persisted. (1987a, 147–50)

Examining the single dimension of length can help us to determine to what degree miniature canoes are out of proportion, and whether this lack of proportionality is uniform throughout the region or if localized differences are reflected in the record. Few full-scale canoes survive for the purposes of comparison, and some types are missing entirely from the contemporary record, including the ancient head canoe and Munka designs. The proportions outlined in Table 6.3 are therefore taken from Eugene Arima's 2002 study, which provides detailed architectural plans for specific canoe specimens. These are of course only a guide to the proportions of full-sized canoe types: the great variety of pre-contact designs, the modern paucity of examples, and their relative inaccessibility today render a comprehensive survey impossible, and observations are indicative rather than conclusive, with an acknowledged margin of error. Immediate comparisons can nonetheless be

Table 6.3 Full-sized canoe lengths

Design	Bow	Midsection	Stern	Ratio (bow:midsection:stern)
Northern A*	152.4	823.0	121.9	14:75:11
Northern B*	78.7	406.4	85.0	14:71:15
Westcoast A	73.7	655.3	48.3	10:84:6
Westcoast B	91.4	625.2	25.4	12:84:4
Salish racing	91.4	1402.1	50.8	6:91:3
Coast Salish	111.8	619.8	106.7	13:74:13
Yakutat	25.4	426.7	61.0	6:82:12

Source: Data from Arima (2002). Measurements in centimetres.

* Northern A is a large Kwakw<u>a</u>ka'wakw canoe, while Northern B is a small Haida coastal canoe.

made between the proportions of the full-sized canoes and their mimetic depictions in miniature (Tables 6.3 and 6.4, and Figure 6.1).

From this qualitative sampling, significant alterations in proportionality can be identified throughout the coast, and these are substantially more pronounced among canoe designs from the Northern region. The proportionality of the Westcoast miniatures shows more variation, while the Salish racing canoe miniatures are roughly proportional. These observations suggest that the importance of proportionality varied across location: that some miniature canoe designs in some places rely more or less on proportionality to convey their information, depending on purpose, in a manner entirely divorced from the full-sized canoes, and thus that scale itself has been simplified in the course of the miniature's production. Widespread discrepancies in proportionality can be discerned between miniature canoes and their full-sized prototypes; the bows and sterns of the miniatures are usually drastically out of proportion. Even those commissioned as models by anthropologists have exaggerated features. This evidence conclusively indicates that miniature canoes were not and cannot have been architectural models in a European sense, nor can they have been preparatory models for full-sized canoe construction except in the most abstract way. It would have been impossible to take a miniature and scale it up, or to learn how a full-sized vessel was made by making a miniature in isolation from other production strategies.

Table 6.4 Selected miniature canoe lengths

Design	Museum number	Bow	Midsection	Stern	Ratio (bow:midsection:stern)
Northern A	NMNH 156844	22.5	105	31.3	14:66:20
Northern B	MoA A1529	12.9	35.1	10.7	22:60:18
Westcoast A	MoV AA 1669	11.44	24.6	5.72	27:59:13
Westcoast B	MoA A1529	8	49	3.5	13:81:5
Head	PMAE 69-2010/1244	29.8	110.8	42.6	16:61:23
Munka	PM 1167	21.4	71.7	12.8	20:68:12
Salish racing	Mov AA 1669	8.4	165.3	3.3	4:94:2
Coast Salish	BM Am1961,04.5	8.3	32.4	3.6	19:73:8
Yakutat	PM 1157	4.1	37.2	5.9	9:79:12
	MoA A1534				
	AMNH 50.2/886				
	BMNH 1728				

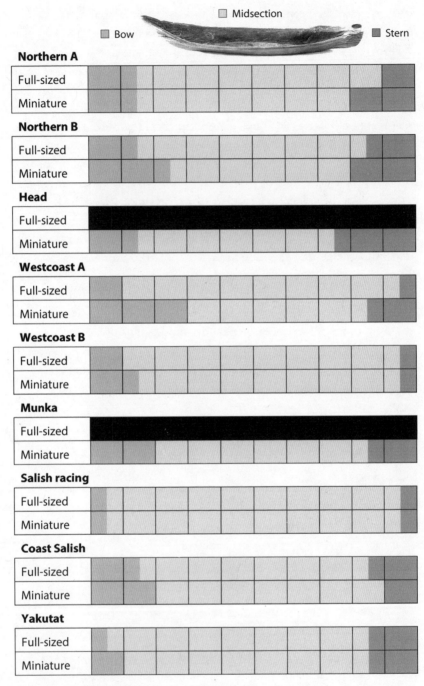

Figure 6.1 Comparison of full-sized and miniature canoe dimensions | Image from Makah Cultural and Resource Center, 93.IV.39

Miniature houses, although made predominantly under the direct influence of scientifically minded American and European purchasers, likewise give little sense that they are generally intended to be scale replicas. Measurements of full-sized Haida longhouses taken by James Deans (1887) provide a range of typical dimensions (Table 6.5). Obviously the variation between villages and between individual longhouses would have been considerable, but the ratios of these measurements are illustrated in Tables 6.5 and 6.6. The construction of Salish houses was so idiosyncratic that it was not possible to find useful representational measurements for them; one publication lists ranges of 520–1,500 feet (158–457 metres) in length and

Table 6.5 Haida longhouse dimensions

	Width (ft)	Width (m)	Length (ft)	Length (m)	Ratio (width:length)
Minimum	25	7.62	30	9.14	45:55
Average	37	11.28	55	16.76	40:60
Maximum	50	15.24	80	24.38	38:62

Source: Data from Deans (1887).

Table 6.6 Selected miniature house dimensions

Design/provenance	Museum number	Width (cm)	Length (cm)	Ratio (width:length)
Haida* (1892)	FM 17864	107	96	53:47
Haida* (1892)	FM 17822	92	86	52:48
Heiltsuk* (1892)	FM 18664	99	81	55:45
Northern	MoV AA 696	41	43	49:51
Kwakwakawak'w	MoV AA 695	46	54	46:54
Tsimshian (c. 1920)	MoV AA 698	30	29	51:49
Haida (1885)	MQB 71.1885.78.11	69	61	53:47
Haida	NMAI 071120	47	50	48:52
Haida	NMAI 218865	65	64	50:50
Tsimshian (c. 1879)	CMH VII-C-92	29	37	43:57
Haida (1890s)	BM Am1898,1020.1	42	39	52:48
Non-Indigenous Northern (1970s)	RBCM Eth36	40	50	45:55

* Miniature commissioned for the 1893 World's Columbian Exposition.

60–90 feet (18–27 metres) in width – the latter, from the Coast Salish, is a contiguous "fort" created by attaching several houses together (Waterman and Coffin 1920, 17).

A comparison of full-sized and miniature houses reveals a stark disparity in ratios. Most miniature houses are square or rectangular, with the façade – the painted, carved decorated statement of ownership – given undue prominence from an architectural standpoint, while the precise mechanics of construction were abandoned as unnecessary to the functionality of the miniature.

A few non-Indigenous-made examples of house miniatures exist, produced in the late twentieth century for museum displays, and these provide an interesting point of comparison. Indigenous examples are generally almost square and usually slightly wider than they are tall, to an approximate ratio of 9:10, such as MQB 71.1885.78.11. The non-Indigenous miniatures show much more realistic proportions, such as RBCM Eth36, in which the ratio is reversed. In terms of construction, the planks on the non-Indigenous miniatures are accurately scaled to look realistic, while on the Indigenous-made miniatures, small planks are cut to fit the miniature without reference to the planks used on full-scale houses. One is an attempt to create a model, the other to draw on the loose visual properties of the house for other, less obvious purposes. These distinctions suggest that figurative, rather than architectural, fidelity was important to Indigenous carvers.

The degree of disproportionality is greater in some typologies than others, signifying that miniaturization is a deliberate strategy in which different properties are key to different functionalities. Thus, the features of canoe miniatures from Sitka or the Skidegate houses are highly exaggerated, Martin's miniature canoes and the work of Young Doctor demonstrate an approximate proportionality, and Scow's dancing figures and Tulalip maquettes are made with accurate proportionality that is crucial to their effective operation. This variety is not accidental or careless; miniaturization involves selecting affordances based on the effects they will have with defined audiences. Lack of or adherence to proportional scaling is directly linked to carvers' understanding of their audience and the imaginative effect they wish to provoke. These imaginative elements of miniaturization freed carvers right along the coast from practical physical restrictions and allowed them to simplify the designs of the prototypes in the process of miniaturization, emphasizing some characteristics and diminishing others, identifying a correlation between mimetic exaggeration and indexical significance.

Alex McCarty cautioned against mistaking the miniature canoe for a metaphor, noting that it is "its own being" and that the bow and stern allow it to be identified as such:

JACK DAVY: *So you are saying that the bow and stern are exaggerated to give the object more presence?*
ALEX MCCARTY: *Yeah.*
JD: *What's the significance to those particular parts of the canoe in giving it the presence?*
AM: *Yeah well, the canoe, the Makah canoe is a chiputz is what it is called. And the canoe is its own being. Because people say "Oh, the canoes are wolves" or "The canoes are sea serpents," but the canoes are "chiputz" and that's what the head and the tail or the back represent.*

McCarty also described how the modern miniatures he made were intended to be broadly proportional without relying on careful measurement:

JD: *So what scale is this canoe here?*
AM: *I don't know. It's the same scale of all these other model canoes.*
JD: *What I'm saying, is, do you ... have you tried to accurately scale it to a full-size canoe, or is it by eye?*
AM: *It's been by eye.*

Other carvers took a similar view. Joe Gobin also explained his approach to proportionality in miniature production as being "by eye." Referring to measurement, Spencer McCarty remarked, "You know, if it's a miniature you can't really do that. They're just small and you have to guess the size and stuff." Steven Bruce Sr. noted that approximate proportionality is important because the miniatures themselves are inherently imaginative:

JACK DAVY: *But it's important that they are proportionate?*
STEVEN BRUCE SR.: *Yes, it's very important, yeah.*
JD: *And with the poles, when you make little poles, are you making little versions of poles you know, poles that are standing, or are they, if you like, poles you have invented for the miniature? Do you see what I am saying?*
SB: *Yeah. The poles I made were, all the model ones, were distinct characters that I had chosen for that pole. I didn't necessarily copy any pole.*

As Bruce suggests, key to this question is the degree to which miniatures are imaginative objects, as Spencer McCarty describes:

JACK DAVY: *Are the miniatures you make based on a particular object? For example, when you make a miniature canoe, is it based on a canoe that you know, or on the idea of a canoe?*
SPENCER MCCARTY: *No, it's just the idea.*
JD: *And the same is true of totem poles and that kind of thing?*
SM: *Yeah. When I look at my work for sale to the public, I call that examples of possibilities within the rules of our people. It's what's possible.*

When artists from the Northwest Coast make a miniature, they are not usually deliberately re-creating a larger object for the purposes of European-style modelling, which requires accurate measurements. They are instead relying on an imaginative interpretation of the idea of a thing, as determined by cultural context. The disproportionality revealed in my survey of museum collections suggests that this has been the case throughout most of the history of miniature production, and is as true of miniatures made from physical prototypes, such as the houses of Skidegate, as it is of wholly imaginative "possibilities within the rules of our people."

If miniatures are unbound from physical constraints beyond that needed for simple similarity, and if they therefore need only a few basic features to become "their own being," then other rules, such as those of materiality or social convention, need not apply either. This allows the miniatures to operate independently of the scale or complexity of their prototypes and take on new, less tangible or visible functionalities.

Materiality

Materiality is essential to any study of Northwest Coast material culture because, as anthropologist Charlotte Townsend-Gault puts it, "the materials from which they are made ... are inseparable from wider histories of material, their properties and circulation, as determining the shape and scale of cultural expression" (2011, 42). The choices at play are most notable in the corpus of miniature canoes. Full-sized canoes were usually carved from red cedar, which is a soft wood, or yellow cedar, which is hard. There are no statistics on the proportion of red to yellow cedar in full-sized canoes, but

Arima (2002, 101) is clear that the latter was rarely used, and almost all of the full-sized canoes I observed, both historical and contemporary, were carved of red cedar.

Moreover, wood can be tight- or loose-grained, depending largely on whether it is of old growth or secondary growth. By charting when different species and qualities of wood have been used, then matching these occurrences with other properties, one can identify any correlations in quality of materials and quality of production to determine where and when changes occurred. Historically, trees suitable for large carvings were relatively rare and had to be carefully harvested. The ideal carving wood has grown over at least five hundred years in dense forest, forming a hard structure of tight growth rings that give it stability and a smooth finish. Cedar naturally stores large quantities of water and takes months or years to dry. As it does so, the wood can shrink or crack, so careful management of the drying process – and ensuring that only seasoned timber is used – is a crucial part of a carver's skill. Cedar also contains natural pesticides that preserve it far longer than other woods in the insect-rich environment of the Northwest Coast. Where other woods rapidly degrade, cedar can remain untouched by boring beetles for years, although it will still slowly rot if left to the elements.

I opened this book with a description of the forests of the Northwest Coast, looking especially at how the remains of ancient forests lie amid the sprouting new growth of younger trees, and reflecting how, from the late nineteenth into the early twentieth century, large-scale logging devastated the forests of the Northwest Coast. The region was logged so heavily and repeatedly that ecological systems in many places broke down (Marchak 1995). Today most of the forests, particularly those accessible by road, are secondary or tertiary generation, growing in radically different circumstances to the former old-growth forests.

Old-growth wood is from trees that grew in pre-contact times, rising slowly in the tangled rainforests over centuries. The rings are close together due to the slow growth of the tree, making the wood denser, stronger, and consequently more effective as a carving medium. Secondary-growth wood is from trees that have grown since the advent of mass logging, which began in the nineteenth century and substantially reduced the density of the forests. Consequently, these trees have grown much more quickly and are much younger, with rings spaced farther apart. This creates a major problem for carvers. As James Madison explained, rapid growth can make wood spongy

and punky when cut with a knife. While it is generally strong enough to be suitable for building materials, it is not an effective carving medium, particularly at small scale, as it is impossible to render fine detail. The key factor is not the age of the wood per se but the rate of growth.

Contemporary carvers must rely on naturally fallen trees among the few remaining old-growth groves or on commercially cut trees from surviving forests in Alaska. The carvers of Tulalip described the process of locating a fallen old-growth cedar high in the Cascade Mountains. Alerted by the United States Forest Service, the carvers drove into the mountains on a logging road to get to the location of the tree, then drove back and forth for some time searching for it before realizing that they were driving up and down its trunk, buried in the undergrowth. Extracting the tree was expensive and time consuming, but the carvers were able to produce three totem poles and dozens of smaller carvings from its wood.

Acknowledging Christopher Evans's observation (2012) that examination of miniatures will inevitably be partial and anecdotal, and thereby subjective, it is still possible to identify material similarities among the miniatures surveyed, the most important of which is the overwhelming preponderance of yellow cedar. A sampling of the data set suggests that yellow cedar is six times more likely to be used than red cedar, for reasons readily apparent to carvers. Spencer McCarty noted that yellow cedar

is a lot more delicate when it's cut small. And then sometimes we could use different kinds of wood. For a mask we'd use red cedar, but when you get it small like that, red cedar's hard to carve on. So you'd want a little bit harder of a wood and you might use yellow cedar because it's more stable for miniatures.

Gary Peterson remarked on the importance of selecting the right material for the purpose:

If you make it of softwood, and you make one little mistake with the tip of your blade — pink! This chunk busts off the nose, gone ... It's going to show, you know, anything that breaks off. So you use, for face masks, you use red cedar and we use alder sometimes ... For bowls we'll use yellow cedar, yew wood, alder, harder woods for conventional things ... If you are making poles and canoes, you know, then it's red cedar. And you can have tight grain for red cedar — the cracks will open and close — but if it's wide-grain red cedar,

it doesn't close. But yellow cedar is opposite: if you are going to carve a yellow cedar pole you have to use wide grain. Otherwise it won't close again because it's classified as a hardwood.

Other carvers echoed these comments on density and grain, noting that soft wood and wide grain made detail harder to carve effectively and the wood more prone to stretching, cracking, or splitting during carving. On a small carving such as a miniature these defects will be painfully obvious.

Where red cedar does appear in the object record, it is concentrated in a handful of specific contexts, predominantly lower-quality early-twentieth-century pieces from the northern coast, such as MoA 2791/8 and MoA A157. From the southern coast the record contains a small number of red cedar canoes, such as SFU 2006.001.001, which shares probable temporal origins with other red cedar examples. Red cedar was much more common in the so-called dark years of the early twentieth century, when traditional material culture practices became obscured and art was of generally lower quality.

The observations regarding the grain within yellow cedar are intriguing. Figures 6.2 and 6.3 for example are of a similar provenance: late-nineteenth-century Northern-style canoe miniatures in the UBC Museum of Anthropology collection. They have a similar design and bear similarly conceived formline on their sides, although with substantial differences in quality. Figure 6.2 has well-connected formline with no negative space and clearly defined crest figures, while Figure 6.3 exhibits much looser, free-floating figures, with crudely executed traditional crests. The carving quality is generally high in both examples, although compromised in the latter by the much wider grain of the wood quality.

Another example is a second pair of miniatures, at the British Museum, numbers Am,+.299 and Am,+.230. These are also Northern-style canoes in yellow cedar, acquired together in 1874 as part of the Sandeman collection and depicting similar styles and designs but unequal quality of painting. The rings in Am,+.299, a piece of high carving and painting quality are 0.8 millimetres apart on average, whereas those on Am,+.230, of lower carving and painting quality, are 3 millimetres apart. Other canoe miniatures in the same collection corroborate this discrepancy: Am,+.231, which is of comparable painting quality to Am,+.230, has rings 4 millimetres apart, while Am1564, which has a different origin but similar vintage and very high-quality carving and painting, has rings only 1.7 millimetres apart.

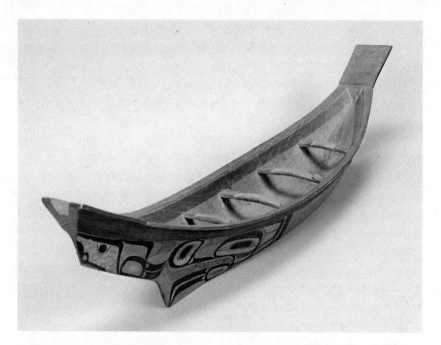

▲ **Figure 6.2** Northern canoe miniature of tight-grained yellow cedar, c. 1880s. | Reproduced by permission of the University of British Columbia Museum of Anthropology, MoA A7098

▼ **Figure 6.3** Northern canoe miniature of loose-grained yellow cedar, c. 1880s. | Reproduced by permission of the University of British Columbia Museum of Anthropology, MoA A7097

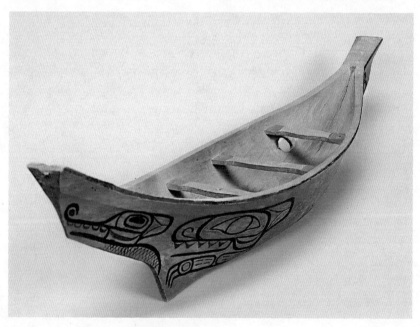

These examples illustrate a correlation between the quality of wood and the quality of carving and painting. The implication is that a carver's choices about scale, complexity, and quality of both materials and design are all factors in a miniature's construction. As the examples just discussed were made at a similar time and place, the materials were evidently not always dictated by necessity. Miniature makers could make an ideological choice about quality that depended on the intended audience and the effects they hoped to provoke. Modern carvers are quite familiar with this practice, and sometimes express frustration that their choices and the physical implications are not always valued. When Wayne Alfred used miniaturization to experiment with material, he found his efforts unappreciated:

Just now and then I make them [miniatures]. I prefer alder, but I made four or five just recently out of red cedar, just to show that I could make those little ones out of red cedar. Yellow cedar's another one. Another thing is that I made a miniature out of yew wood. Nobody gave a shit, but it's the hardest wood on this side of the world. Nobody really cared that I made it, so I would never make it out of that again. You do these amazing things and people don't understand it. Yew wood. And that one person that got that one piece will be the only one ever to get it, so they should appreciate it.

The relationship between imagination and materiality in miniaturization becomes clearer when it is recalled that not all miniatures from the Northwest Coast are made of wood. Argillite miniature totem poles were one of the most common items of commercial material culture production in the late nineteenth century, a development that has been directly attributed to the artistic aftermath of the epidemics of the 1860s and the concentration of the Haida population in the villages of Skidegate and Masset under restrictions against traditional cultural practices. In this environment, argillite poles permitted the carvers a safe outlet through which they could "render images of the familiar past in an acceptable form" (Macnair and Hoover 1984, 113).

Though sometimes based on existing standing totem poles, these argillite miniatures are often imaginative constructs that play with traditional figures and designs to create new formulations. That they are works of imagination is poignant, but it does not mean the designs are whimsical; as Carol Sheehan notes, they display "an intensity of feeling and perhaps an equally intense commitment to presenting a no-nonsense view of structures fundamental

to Haida thought and society [which] was matched by the artists' demonstration of high technical proficiency" (1980, 97). Most noticeably, the poles incorporate skeuomorphic design elements, such as a concave back, important for full-sized cedar poles but mechanically irrelevant on argillite miniatures (p. 113).

At the time it became popular, argillite was not used extensively in Haida ritual practices as a traditional carving medium, and for this reason it became a safe and accessible material with which to experiment in miniature and to create, over a short time, a large body of work that has travelled farther and may be more readily recognized than any other material culture from the region. As Gwaai Edenshaw explains, argillite has very particular properties that permitted carvers to experiment with form and design beyond the bounds of the traditional carving art form:

Yeah well, there's a couple of things about argillite. One is that it is a slate, so it behaves differently [depending on] how you act with it. You have to be cognizant of the fact that it has a real grain and it's a very brittle material, so you'll find a lot of argillite carvers carve a very flat form, but obviously that is not universal, right? If you look at Christian [White]'s stuff and if you look in the historical record there is a lot of depth and stuff like that, but it's all done wily, so they are creating all that depth, but it's done in such a way that they are not creating big fragile bits and stuff like that, so the pieces, the best pieces have a sort of a sense that they are compact as well as free.

Argillite therefore facilitated greater experimentation in Haida carving and has consequently encouraged the rapid creation and distribution of ideological messages to new audiences in a manner previously unavailable to the carvers of the Northwest Coast, without raising the suspicions of the colonial authorities.

Choice of materials is an essential component of miniaturization that bears no direct relationship to the prototype. Instead, the *emphasis* of the miniature drives its materiality, combined with an understanding of the audience that will receive it. A carver creating a miniature for sale to outsiders – with less investment of effort and skill than in another piece that may be a gift – will select inferior materials; in this way the entire object, including its materiality and not solely its shape or design, sends a message. As a non-traditional carving medium, argillite permits artists to test the "possibilities within the rules of our people," unbounded by tradition or

restriction. Thus it allows them to play with form in wildly imaginative ways, creating new realities within which to experiment.

Ceremony and Inspiration

As an imaginative process dependent on intangible, often non-sensical factors, miniaturization bears comparison with the broader corpus of Northwest Coast carving more generally. Imaginative carving entails both the essential physical techniques of practical creation, and a series of techniques that leave no physical mark on the finished work but that are nonetheless crucial due to the intervention of supernatural agents, such as spirits. Ethnographies of canoe building alone illustrate an array of intangible steps, from songs and rituals practised throughout the process to physical activities (Holm 1991, 243). Franz Boas recorded that during canoe construction Kwakwa̱ka̱'wakw carvers would not comb their hair as this would cause the wood to split, nor would their wives boil anything with hot stones for fear of dampening the wood. He also wrote that the carver "must be continent, lest he find rotten places in the wood" (1966, 32), an idea that may be connected to Haida belief in the celibacy of carvers during construction as "a canoe is like a woman, it demands your undivided attention. If you fool around it gets jealous" (Collison 2014, 59).

Contemporary carvers are no less concerned with essential ritual and mental preparation as a crucial stage in the carving process, particularly for objects with ceremonial importance. For example, Kwagiulth/Squamish carver :klatle-bhi (Cloth-Bay) recounts that when carving,

I'll tend to – sometimes I put paint on my face, close out all the windows and put paint on my face, black out your face. Because when you are carving those things the spirits are always around. They come and watch, they come and watch and you have to paint your face to protect yourself and keep your identity anonymous, I guess, so that energy, whatever it is, doesn't latch on to you, doesn't latch on to you, doesn't latch on to you ... This is about serving a purpose for the spirit of whatever my family sees fit and how to use it, in the ceremony or in the potlatch. So there are some traditions. I do approach it a little more carefully. I am more culturally aware and will go a step farther spiritually in terms of preparation. When I walk away from the mask at the end of the day, the things I say, the things I do: walking softly, gently, always kind and loving, never coming back to them with anger and hate, anything like

that, because those things are going to show up in your work. So you really have to conduct your life in a really good way.

Makah carver Spencer McCarty also has techniques to express gratitude, emphasizing that these are a personal choice, not necessarily universal across the Northwest Coast or even among his people:

SPENCER MCCARTY: *It's different nowadays than it used to be ... There's prayer for when you are going to gather bushes or leaves or animals or whatever. You call up your friend [the tree], and when I do it and the way my family does, whatever I say concerns only for my family. It doesn't really consider other tribes, [or] other parts of this tribe.*
JACK DAVY: *Of course. I understand.*
SM: *My family, because everybody's got their little quirks ... You say to it, my friend, I need some of your body, some of your fingers, whatever you are cutting. I need this to feed my family and I'm sorry, I know it's going to hurt, but there it goes, I'm going to do it. And the bigger, the bigger the object, the more prayers you are going to need. Like if you were making a whole house, you are going to need way more prayers because you are taking the whole tree. But same thing for, like, a whaling canoe or something, it would be prayerful right from the start to the end. But I still impart prayers to the ... not to the wood exactly – it's hard, for the wood, because when it was cut down the tree wasn't talked to. The tree was just taken, so when I get the wood I tell it the same thing. Tell him I'm sorry you got cut down, the people might not have told you they were going to cut you down, but know that I'm going to use you and you'll live forever as a beautiful art piece and maybe you'll be dancing, you'll lie in this family forever, for generations. You'll be a great treasure for the family, so that it understands you better.*

Some feel the spirits as a present force while they carve, driving and influencing their work. James Madison reported that he had "seen things inside the wood – ghosts or spirits" that told him what to make; Lummi carver Felix Solomon commented, "There's nobody doing this kind of work here in Lummi ... Something's driving me to do it" (Relyea 2009, 24).

None of the carvers described the same rituals. On the contemporary Northwest Coast there is little formalized communal ritual activity within carving itself, and the form and contents of rituals are the choice of the

individual carvers or carving families. But although not all carvers described spiritual steps and motivation in such detail, all recognized that these techniques were as important a part of the process as physical ones.

Ceremonial versus Mundane Miniatures

Given the dearth of useful analysis of historical miniature production on the Northwest Coast, it is necessary to be creative in considering whether miniatures had ceremonial aspects – not only in terms of being used ceremonially but in the sense of having ceremonial elements among their affordances and/or ritual components in their construction. One way to investigate this question is to consider whether their prototypes are everyday objects or ceremonial or exceptional objects or events. In the opinion of Haida canoe maker Guujaaw, ceremonial canoes would have been more elaborate and employed more ornamentation and experimentation in their construction (Ramsay and Jones 2010, 13). They would also have been closely associated with specific families or events and borne correspondingly greater personal and ritual significance than everyday canoes. Photographs of canoe fleets from the nineteenth century demonstrate clearly that most canoes used for everyday transport and subsistence were stained black or painted with simple identifiers (MacDonald 1983, 90–91).

Determining whether miniature canoes use ceremonial or everyday vessels for their prototypes is far from simple but can be best achieved by observing the nature of the decoration: elaborately painted examples may be considered ceremonial for these purposes. This is not the case with many Northwest Coast canoes made in recent decades, most of which carry crest designs, although in a sense all such canoes can be considered ceremonial as none is used for everyday purposes – their construction and use are acts of cultural and educational resistance and intent.

Ignoring quality, which does not affect the prototype, and eliminating outliers that make the statistics overly complex, I have used the typology of miniature canoes derived from my survey to estimate numbers of miniatures that can be considered ceremonial, or not, although some could fit either category and some cannot accurately be said to fit at all. The first and most noticeable conclusion is that despite the relatively small number of dedicated ceremonial canoes that operated on the Northwest Coast (or, more accurately, the relatively small number that were decorated for ceremonial purposes some of the time), some 53 percent of miniature canoes – 384 out of

727 – bore indications of ceremonial decoration, including 199 of the 275 Northern-style canoes and all 66 head and 32 Munka designs. Only 343 (47 percent) did not, including all 21 of the modern Salish racing canoe designs, 48 of the 62 Yakutat, and 188 of 255 Westcoast canoe miniatures.[3]

The appearance of ceremonial miniatures therefore exhibits considerable regional variation. Some 72 percent of Northern-style canoe miniatures bore ceremonial decoration, whereas only 26 percent of the Westcoast variety did so. The evidence of the Yakutat, coming from the far north of the region, suggests a design-specific choice based on purpose rather than dictated by a simple north-south geographical split. Among the miniaturized versions of canoe types that disappeared early in the post-contact period, and for which no full-sized examples now survive, all were highly decorated, perhaps reinforcing the notion that these had acknowledged cosmological or spiritual components.

The analysis indicates that miniature canoes do not depict watercraft so much as an ideal of what a canoe signifies in a very particular role, and that the significance of this role depends on the canoe-building region of the coast. In the Northern-canoe regions of the Haida, Tlingit, Tsimshian, and neighbouring groups, where a large canoe symbolized a chieftain's status, the vessel itself bore the most significance. In the Westcoast-canoe regions of Washington State and Vancouver Island, the daily activities linked with the vessel, such as fishing, hunting, or trading, were considered more important. This distinction illustrates that the relationship between the decoration of a miniature and its prototype and its ability to convey information is culturally dependent on the links that the miniature forms, and that these links are created by different properties producing different effects among different audiences, all depending on localized context.

Frequency of Design

Determining the ratio of everyday vessels to ceremonial canoes in miniature also requires consideration of the shovelnose and riverine designs. Initial analysis determined that certain designs appeared with more frequency, and that transcultural designs were almost non-existent.

Shovelnose canoes appear in coastal and estuarine contexts throughout the Northwest Coast. They had a rounded bow and stern and straight, horizontal gunwales made from a single log with no attachments, the ends closely resembling shovels (Drucker 1955, 64; Waterman and Coffin 1920,

19). An old design, canoes of this type were identified by Vancouver in 1792 at Bainbridge Island (Holm 1991, 238), and are commonly remarked upon as ubiquitous vessels for short fishing, gathering, and communication journeys in sheltered waters. Few have survived, but the documentary record makes clear that they were probably among the most common vessels on the coast. And yet only seven miniature examples were located. Spoon canoes, for which no miniature examples were found, were another simple, common design among the Salishan groups of southern British Columbia. They had thick hulls for improved balance and rounded bow and stern rising in a curve that Drucker compares to a "goat-horn spoon" (1950, 253). Riverine canoes, also endemic throughout the coast for use on inland waterways, appear only eight times in miniature form. Thus three of the most common canoe designs produced on the Northwest Coast appear as a tiny proportion of the total miniature canoes surveyed, and their quality was subjectively lower than the majority of other designs. Other, more localized inshore canoe types, such as the cottonwood or the Northwest Coast birchbark, appear not at all in the survey of miniatures, while the specialist Tlingit ice canoe is found only three times, and all are explicitly associated with ethnographic commissions.

Thus mundane canoes, whether decorated or not, hardly ever appear in miniature. Instead, the larger, more dramatic canoes are more typically used as prototypes for miniatures, often decorated ceremonially. The choice of prototype focused on the designs that bore greatest registers of ceremonial, and thus presumably self-reflective, meaning for the artists who made the miniatures. In addition, aside from abstract, often satirical, portrayals in argillite, Indigenous people of the Northwest Coast produced no miniature representations of European ships. Sailing vessels, paddle steamers, and then steamships were common on the coast from the 1780s onward, and commercial fishing vessels were enthusiastically adopted from at least 1870, and yet aside from examples made of argillite (and argillite imitations in wood), they do not appear in the miniature record from the region.[4] European-style wooden boats were produced from the mid-nineteenth century – Lake Union in Seattle was noted for its large numbers of boat workshops and skilled boat builders – and yet my survey revealed only two European-style Indigenous-made miniature canoes (MoA AA2463 and RBCM 11181). This demonstrates that miniaturization on the Northwest Coast could be transcultural but not acculturated; that the intangible elements so essential to miniaturization had no resonance with non-Indigenous technologies and

design within the semiotic ideologies in which the miniatures were intended to operate.

Amulets

If miniatures draw on the ceremonial prototypes most closely linked to authority and identity, they may have held power in their own right as objects connected to cosmological powers. Unlike miniatures produced by other Indigenous North American groups (e.g., Fenton 1987, 60–63; Krech III 1989, 131–32), Northwest Coast miniatures are not generally held to have the power to intercede with spirits or other supernatural beings, with the exception of amulets. Used sparsely in the region, amulets are predominantly the preserve of shamans and "did not so much act as receptacles [of magical qualities] as provide a catalyst through which they could be called upon" (Wardwell 1996, 71). Shamanistic practices on the Northwest Coast encourage engagement with multiple realities; the ability of things to be in more than one state simultaneously is common among North American Indigenous groups, who, like other non-European societies, do not need to differentiate between magic and practical application (see Turner 1994, 87–91).

One of the smallest of the canoe miniatures I surveyed, 82.V.135 from the Makah site of Ozette (Figure 6.4), raises questions about amuletic qualities. It is a compact piece, only 10 centimetres long and 1.5 centimetres wide, with clearly defined and preserved features. Unlike other examples from the site it has not been hollowed out and therefore would not have floated true; judging from the structure of its bow and stern sections it seems to have been designed to be worn around the neck. Makah miniatures historically pertained to ceremonial preparation for whaling (Black 1999, 32; Kirk 1974, 44), and Spencer McCarty considered the piece to be highly enigmatic:

Some of them nobody knows, whether it's a charm or a necklace for his girl-friend, we don't know. And there is one in there that looks like some kind of a hideous sea monster creature, it's about this big, and it looks like it is part whale and part something else, and nobody knows what that is.

Amulets held secret properties that were not often acknowledged or shared, and it is widely understood that talking about the efficacy of an amulet could negate its power (Coté 2010, 29). This power is very real and not to be lightly discussed:

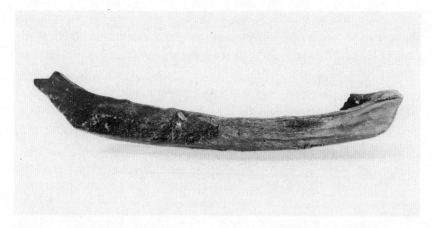

Figure 6.4 Makah canoe miniature found at Ozette, c. 1560. | Reproduced with permission of the Makah Cultural and Resouce Center, 82.V.135

GREG COLFAX: *It wouldn't surprise me that there was far more extensive use of miniatures found within females of different species and used in a ritualistic way to provide the person doing the ritual with more power and more access to advice: advice to avoid starvation, advice to avoid being killed.*

JACK DAVY: *So it sounds almost like you are talking about amulets.*

GC: *Amulets are power.*

JD: *Is that what you are saying? That they have an amuletic power?*

GC: *Yes, but you wouldn't display it as an amulet, you would hide it. You wouldn't show it.*

...

JD: *Do Makah people use miniatures in potlatches and ceremonies today? Or is that not a common feature?*

GC: *[long pause] I think if they did you wouldn't know it, you wouldn't see it. It would be something in the background that would be used to control what is in the foreground, and you wouldn't see it. Just something you wouldn't ... It's really not safe, it's not. It causes so many troubles, so many differences of opinion.*

As objects of power, these are magical creations, dangerous intermediaries through which successful supernatural activity could be mediated by intangible means. In this one distinct category, miniature objects operate as potential vessels of or catalysts for ideological efficacy, as communicators.

They create an environment within which the object, even one not explicitly imbued with magical authority, is acknowledged as a powerful agent in human-superhuman social relations, a way of speaking with deities and spirits.

Miniature Canoes at Potlatch

If some miniatures held powers, others might have been used in the exchange of powers. T.F. McIlwraith describes one such ceremony among Nuxalk people (1948, 469–71). In this case, miniature totem poles operated as indexes for the transfer of hereditary privileges, although he acknowledges that this ritual was a twentieth-century adoption. Similarly, Gordon Scow's miniature figurines described above could re-enact forbidden Kwakwa̱ka'wakw ceremonial dances.

Full-sized canoes certainly had a role in ceremonial activities as a high-value unit in potlatch gift exchange, an element of the process called *sā'k•a* in Kwak̓wala (Boas 1966, 81), and were one of the most prominent status symbols of the region. Aldona Jonaitis writes, "Although some may associate canoes simply with means of transportation, the natives of the Northwest Coast ascribed to them a deep spiritual significance ... The canoe symbolized wealth" (1986, 104). This ceremonial value has survived into the modern era, in which canoes have been used in potlatch dances (Arima and Dewhirst 1990, 405). The importance of canoes in ceremonial roles is not surprising; Bill Durham noted, for example, "Canoes were so important to the material culture of the Northwest Coast that it was inevitable that they should figure in much of [its] intellectual life" (1960, 41). The potlatch was also just the place where consciously anomalous objects such as miniatures could exert power through non-sensical qualities, an environment where the "real isn't and the unreal is and anything in between can happen" (Fleischer 1981, 223).

It has been noted that many feast bowls took canoe form, including one bowl that was collected on the Cook expedition of 1778 (S.C. Brown 2008, 251; Cabello Caro 2000, 54). Feast bowls and canoes have been tentatively linked in the literature – "Small canoes made impressive serving dishes for feeding the multitude at a potlatch" (Durham 1960, 42) – and the use of canoes as ritual food containers (Hunt 1906, 108) has led to speculation that miniature canoes might have held a similar position (J.C.H. King 1999, 157). The close stylistic relationship between miniature canoes and feast bowls has also been widely noted (Boas [1909] 1975, 422; S.C. Brown 2008,

251; Holm and Reid 1975, 76; M.J. Reid 2011, 62), an observation that U'mista curator Trevor Isaac repeated:

A lot of the smaller canoes that we have, that I have seen, from the Kwakwaka̱'wakw culture is mainly used for feast dishes. And the reasoning is to emphasize the canoefuls of food at your feasts, when you are inviting people to feast with them and to feed them. So a lot of times you'll see smaller canoes carvings and that's what that represents.

Kwakwaka̱'wakw carver Wayne Alfred, too, sees miniature canoes as having a role within feasting:

But some of these aren't just miniatures, there not just models, are they? They're used for feast dishes ... So these, these are also grease dishes. They're also for fish, for herring eggs, for berries.

These are descriptions of contemporary practice, but if miniature canoes operated as feast bowls at potlatch historically there should be physical evidence. Most surviving Northwest Coast feast dishes bear considerable traces of use. Examples such as BM Am1861,0312.36, collected by the Russell commission in 1861, are still sticky to the touch 170 years later. Even dishes that were not used specifically for grease, such as BM Am1898,1020.3, show the staining of earlier contents.

Analysis of miniature examples, however, gives little indication that they were ever used in this way. Only one miniature canoe of the 944 initially surveyed has clear indications that food was held inside. This is a naturalistic Westcoast-style example in a Canadian private collection, in which cooking residues are firmly caked on the bottom of the interior. Thus while miniature canoes are occasionally used as ceremonial food containers in modern Northwest Coast societies, there is no evidence that it was a widespread or common historical practice. When something resembling a canoe was desired for a feast, a canoe-shaped bowl was made and used instead. This analysis conclusively demonstrates that there was a clear distinction in Northwest Coast material culture between a bowl with a physical relationship to canoes and a miniature canoe.

Given the substantial body of ethnographic writing on Northwest Coast ritual practices, it is striking that the ubiquitous miniature canoes appear almost nowhere as accessories to these events. I can assert with some

confidence that miniature canoes (as opposed to other objects, such as bowls, that use canoe imagery) were neither routinely deployed on ceremonial occasions nor generally considered to hold specific supernatural or ceremonial powers in their own right. This is not of course to suggest that they were not symbolically and ideologically significant, only that they were not explicitly used as such in the feast setting.

Altogether, it is clear that miniature canoes resemble ceremonial canoes far more frequently than their workaday counterparts; that they were not feast dishes, which form a separate (if connected) object type; and that miniatures in general did not habitually operate as amulets, although when they did, they could do so with considerable power. Together these affordances suggest that as a corpus miniatures, especially canoes, are a distinct category of objects and function as indexes of ritual practice – they reflect power and may facilitate it in certain circumstances – but do not usually explicitly hold it in their own right, and are only rarely acknowledged as capable of powers of magical intervention. What powers they do wield are incorporated via their processes of production, their relationships, and their usage, but these are usually subtle and obscured, particularly for non-Indigenous audiences.

Miniature as Diorama

Although miniatures are not consistently part of Northwest Coast ceremonial life, there are indications that their design routinely reflects ceremonial life. Unconstrained by physical requirements beyond those needed for simple association, they can incorporate imaginative qualities according to intended function, audience, and effects. Imagination is essential if a miniature is to be effective. This is reflected in miniatures as dioramas, embodiments not only of emphasis and prototype but of events: objects in which movement and memory are preserved as mimetic moments, real or imagined. Dioramas are commonly understood to be a static reproduction of a typical or particular scene, usually used for display, and in this regard they are generally a form of scientific or educational model, although there is no strict requirement for dioramas to be made in miniature, or if they are so, to appear to scale.

Dioramas have been defined by curator Jane Insley as "a form of 3D model, showing a scene, an event or a landscape, which has been commissioned for a particular exhibition purpose" (2008, 27), and are thus tableaux designed with specific public audiences in mind. Examples have appeared

repeatedly in this text, from Makah whaling scenes to Tlingit spirit canoes and Martin's seal hunters. These miniatures are ostensibly reflexive of aspects of the societies from which they come, but while this interpretation is not inaccurate it should be treated with caution. As Alex McCarty noted earlier, canoes are their own thing, not a metaphor for something else, and I question whether the same may be particularly true with regard to dioramas.

As a scene, a diorama requires action, and action requires population; and this enables me to draw a distinction between the overlapping categories of miniature and diorama. Figures are a common Northwest Coast typology and figures within canoes and houses are a regular design feature of miniatures from the region. It is therefore valuable to consider the proportion of miniature canoes that contain figures, broken down by the more popular canoe designs (Table 6.7). As is evident, those featuring figures are less frequent among Northern-style miniatures than among the Westcoast style, corroborating the observation that Northern canoe miniatures rely mostly on the imaginative, almost supernatural relationships they maintain, while those from farther south are more focused on their connections to events and actions.

In Table 6.7 I analyzed a selection of miniature canoes to determine which held figures performing actions and which did not (the numbers in this table differ from those in Table 6.1 as 99 examples were either not accessible or not suitable for this analysis).

This blunt statistical approach nonetheless overlooks specifics and needs to be refined by analysis of what is happening in the scenes portrayed. For example, some of the miniatures have a range of figures performing various

Table 6.7 Miniature canoes with and without attached figures

Canoe type	With figures	Without figures	Proportion with figures (%)
Northern	27	226	11
Head	10	49	17
Westcoast	64	190	25
Coast Salish	5	23	18
Yakutat	1	43	2
Munka	2	24	8
Salish racing	1	19	5
Total	110	574	16

actions, whether paddling (RBCM 12010) or hunting (NMNH E73740-0) or racing (RBCM 16668). Others illustrate less typical scenes, such as two naturalistic-looking men drinking or formline spirit figures paddling, in each case probably illustrations of specific stories or legends. There is also a considerable variation in the appearance of the figures: those in BrookM 07.468.9366 and RBCM 16668 are almost realistic, while those in EMK 154-7 and RBCM 12010 are highly stylized with clearly depicted ceremonial attire, including masked faces. Determining when a figure is naturalistic and when it is mythical is not simple, as the identity of the figure is unclear in many examples. In BMNH 4659, exaggerated figures are clearly having an exchange, but the design makes it difficult (possibly deliberately) to determine whether they are supernatural creatures or exaggerated humans.

While 16 percent of Northwest Coast miniature canoes have figures, and thus the attributes of dioramas, the number with a naturalistically representative display of the activity they resemble is considerably smaller. This raises the question of the extent to which the mimetic qualities of the canoes in these scenes are crucial to the qualities of the diorama as a whole. That is, if the figures can be so dramatically exaggerated, then there is no reason for the dimensions of the canoe miniature itself to be any more realistic or relevant; the whole scene is an exaggerated miniaturized image of a real or imagined moment, stretched in reality as it is stretched in time and thought. The dioramas may have multiple realities, both as reflections of memory or imagination of one specific scene and in wider representative qualities obtained from the scene. They thus move even further from the conception of European models and closer to the intangible dimensions of imagination.

The prevalence of dioramatic miniatures therefore enhances the argument that miniatures are imaginative constructs, in which the internal ideologies of the carvers responsible have been allowed to influence the construction processes for personal purposes that rely on semiotic understanding. A good illustration of this point can be made by returning to Haida miniature house FM 17822, from the 1893 World's Columbian Exposition, and the ceremonial scene tucked inside. This diorama, in which a large figure dressed in regalia stands before a semi-circular crowd of smaller, similarly dressed figures, with a box drum hanging in the corner, depicts a Haida ritual in progress, inaccessible without inserting oneself into the house. It is a concealed world that demands tactile engagement to be discovered.

Such scenes are not static moments; there is a sense of movement, of music, of life. The hidden figures illustrate that a miniature can be more

than a static functional tool. It can be an object in which "memory is no longer recollection, which still preserves a sense of distance, but reactualization," not a metaphor or stand-in but the literal reliving of the past as a movement of the present into the future (Ginzburg 2002, 141). As dioramas, miniatures can be the physical embodiments of events, of frozen moments outside time, and thus recognized as indexes of whole systems dependent on those moments, from Makah whalers to Haida potlatches and to Kwakwa̱kwa'wakw Hamat'sa dancers. All these examples operate as potential ideology, even emotion, and as powerful agents for the transmission of information in unexpected and imaginative ways through interactions with knowledgeable observers.

Practice and Training

Beyond the affordances and functionality of miniatures, a full analysis must encompass the stages of production as practised on the Northwest Coast, with particular consideration of praxis, the actual physical and cognitive processes of production, and the pedagogical (or educational) role of miniaturization within which these processes occur. This in turn allows for wider consideration of the effects of miniaturization on the development of artists and art production in the region.

Miniatures as Maquettes

Among the carvers I interviewed it was common to use miniatures as maquettes, sometimes termed *minuettes:* practice pieces to examine form and design in preparation for larger pieces of work. Even carvers who denied making miniatures as defined by this project often produced maquettes that would be later discarded, creating and destroying the object *as part of the miniaturization process,* in which the audience is the carver and no one else.

The process varies according to the carver. For some the creation of the miniature is an imperative, even a supernatural demand: Lummi carver Felix Solomon described in detail how he created a miniature diorama developed from a dream in which he was approached by a snake while tending a fire in his garden. The dream, interpreted as a vision, encouraged him to create a miniature of the scene (dual-purposed as a fishing gaff), which he subsequently developed into a plan for a totem pole (Figure 6.5). The miniature acted as an intermediary between the carver's dream and the large pole in an unplanned way; it was created by the carver and in turn acted on him

Figure 6.5 Felix Solomon in his workshop, 2015, with the gaff miniature resting on the unfinished totem pole it inspired.

as its audience. The miniature (and through it the dream) thus had direct agency in the creation of the totem pole, a scenario that can be rendered in a *chaîne opératoire,* an operational sequence of technical actions:

$$\text{Vision} \rightarrow \text{Carver} \rightarrow \text{Miniature} \rightarrow \text{Carver} \rightarrow \text{Totem pole}$$

James Madison of the Tulalip also commented on the ex-human imperatives of carving, the ways in which images in his head, which he referred to as "hieroglyphics," speak to him as a carver and direct his work, allowing him to "draw with a chainsaw." His colleague Mike Gobin referred to carving as "bringing my thoughts to life." For other carvers, the process is more systematic; Kwakw<u>a</u>ka'wakw carver Steven Bruce Sr. recalled that when he made his first totem pole, to stand in the Alert Bay cemetery, he was initially intimidated by the cedar log and responded by reducing its scale:

I was walking around and around this log for days and days and I was looking at it and looking at it so I said, "OK, I know what I'll do," so I went home, grabbed my picture again, my drawing, and I downscaled it and I grabbed a small piece of wood, about 12 inches roughly, and I would do one cut on my small piece and then I come down here to the woods and do my big cut. And I worked my way through the pole that way.

Kwakw_a_ka'wakw carver Wayne Alfred described a similar process:

When I made a totem pole, I started making a miniature first. And then each time I made a cut I'd go to the pole and do the same thing to the pole and make my next cut. I'd get about four or five cuts further and then go to the pole, do the same thing, back and forth, measuring it all the way. Doesn't turn out exactly the same, but it's pretty close, yeah, pretty close.

Bruce saw his miniature pole through to completion and under persuasion eventually sold it to a dealer, an experience similar to that described by Kwakw_a_ka'wakw/Squamish carver :klatle-bhi, who noted, "I really like the way they look. The little stuff looks really wonderful, it really has its own spirit. It really moves people; it moves me." Nonetheless, he does not always follow the miniature through to completion:

Sometimes the maquettes will only get so far. I'll make a few crucial cuts on the maquettes and then I'll make the same on the log for the totem pole and at that point I already know what I'm doing. I've got half a dozen unfinished maquettes, just got little cuts on them like that and they'll just sit on the side. And I'll use them for future reference, for future reference I have used them. And then the pole itself takes you over. You know what do, where it's gonna go, and you just kinda go with it.

Haida carver Gwaai Edenshaw describes a similar technique in a less permanent medium:

What I'll do is, all the way through the pole – obviously not a traditional thing but – I'll keep a slab of Plasticine around and I'll rough out a miniature of a certain figure. See, we do a blueprint and we generally stick to that blueprint when we are carving, but everything changes as you start carving,

and you know as you start to move the material ... it all changes, and there is a window that you have to get and after a certain point the kind of law that governs the art, those principles ... they take over.

Although Edenshaw is of the opinion that his technique is not traditional, and while his materials certainly are not, it is widespread among carvers on the Northwest Coast and can be rendered in the following way:

Commission[5] → Carver → Maquette → Carver → Totem pole

Maquettes act on their creators (their direct audience) both through their physical properties and the effects they inspire and through the specific imaginative qualities of miniaturization itself. Susan Stewart identifies these qualities as making the miniature "a device for fantasy" (1984, 56), and they are also key to modular miniature toys such as LEGO (Davy 2015, 9). That Edenshaw's Plasticine miniatures do not survive his artistic process does not make them any less significant to that process than those of Solomon, Bruce, or :klatle-bhi. Indeed, as a jeweller who practises the lost-wax technique, Edenshaw is familiar with the concept that cycles of creation and destruction often form an active part of material culture development.

Evidence that historical miniature objects formed part of a similar creative, imaginative process is unfortunately rare. Ethnographies and early accounts do not describe maquette production and museum collections contain few unfinished miniatures, although this is unsurprising, perhaps, given the desire of the collecting community for readily displayed representatives of specific cultures. More commonly accepted than the idea that individual miniatures can change carvers is the idea that miniaturization can develop carvers over their lifetimes.

Miniatures and the Development of Carvers

In *Smoke from Their Fires*, Charley Nowell describes how as a young Kwakwaka'wakw boy, he exchanged miniature canoes in games that mimicked potlatch gifting (Ford 1941, 85). Nowell bought his miniatures with tobacco rather than making them himself, but he was engaging in a self-taught educational process that developed his understanding of ritual behaviour through praxis.

Makah carver Alex McCarty notes that creating miniatures helps young and developing carvers to become proficient in the physical techniques

required to carve anything else in the Northwest Coast material culture corpus. Others, such as Kwakw̲ak̲a'wakw artist Steven Bruce Sr., describe how making miniatures as apprentices taught them the skills essential to their professional development:

When I first started, I carved little masks – five and a half inches, like I said earlier, like my first one – and I kept them at that size, but throughout the time of carving those, it helped me to get my knife skills down, how to draw, and design the mask after it was carved, the cedar bark. And I also learned how to do a number of masks in a short period of time, which helped me when I jumped into bigger pieces.

As a sixteen-year-old apprentice to Bill Reid, Gwaai Edenshaw recalls, "I had a practice of trying to finish a carving a day for a few years ... carving toothpicks and avocado seeds and stuff, and I'd finish one of those every day," honing his skills as a carver through the production of tiny objects, even in non-traditional media. James Madison, who comes from a carving family, claims the practice "is like walking for us," that "it is knowledge" gained by carving miniatures and little pieces around the kitchen table with his grandfather and other relatives. He notes that miniatures were an essential component of learning to carve because they provided "so many avenues for purpose." Saʔbaʔahd (Steven Madison) recalls a similar situation, learning from his father and making a tiny totem pole at twelve years old. Even artists who did not specifically make miniatures as defined in this text began their careers with the small: Gary Peterson's first carvings were berry spoons cut from driftwood.

The common practice of learning the craft by producing miniature objects has a number of advantages: they represent minor investments of time and materials and so can be discarded if they break or are of inadequate quality; they enable an artist to develop the range of cuts required in Northwest Coast carved material culture; they encourage experimentation in style, technique, and material; and they are appropriately scaled to young artists, who typically begin their careers in their pre-teen years.

Thus, Northwest Coast artists from diverse backgrounds learned their trade on miniatures and were in turn partially developed into artists by practising the process of miniaturization. Miniaturization is more than just an imaginative artistic method of conveying ideological information; it also shapes Northwest Coast carvers physically, artistically, and culturally.

It provides them with a safe way to experiment, learning the designs and technical skills necessary to pursue their craft through praxis and consequently operating as tools in a traditional educational system.

The Role of the Carver

The position occupied by carvers in Northwest Coast societies, and in particular how carvers understand their role within their communities, is an important element in the creation of miniature objects, although inevitably substantial localized differences can be found between peoples and across time. As other recent scholarship does, my examination of this issue directly challenges the notion that by being sold as souvenirs miniatures became somehow less significant as objects of cultural importance (Glass and Jonaitis 2011; Townsend-Gault 2011).

The carvers I interviewed expressed their opinion of their own status in different ways. James Madison described his role as one of "keeping our culture alive," demonstrating an awareness of the cultural significance of his work in terms of both supporting the continuity of culture and providing practical support to ritual practices, such as potlatch. Cultural imperatives are important, but all the carvers I met were also commercial artists operating within an international art marketplace. None saw a contradiction between these roles, as Trevor Isaac explains:

There's two kinds of aspects of carving. There's the professional side, like for a sale to tourists or galleries or collectors, and then there is the cultural aspect. Depending on the family's potlatch, upcoming potlatch, lots of the carvers they all associate with each other and work together to assist the family's upcoming potlatches. So that family's rights and privileges would determine what the carvers were to make. Even me not being a full carver, I've made pieces out of wood, you know, cutting them out, painting them, and designing them for ceremonial purposes. So that kind of is your guide to ... the family's privileges is your guide to what you are going to create. And then there is the other side of it for the commercial aspect, so you kinda have a bit more free will to carve more things that you want to experiment with, or maybe other language group's art form. You know, a piece you have always admired in a museum or private collection, replicating those gives you a bit more freedom.

In fact, the nature of modern Northwest Coast art is such that there need be no contradiction. For the carvers, power usually lies not in the carved

object but in the rights and privileges of which the carved object is an index. In this understanding, if a person with the rights to an object decides to dispose of it outside the community, they effectively withdraw the power from that object, which can now be sold without danger and another made to assume its place, with the rights and privileges transferred to the new object (Hawker 2016, 212). To contemporary Indigenous artists this is simply part of the lifecycle of the object. Thus the sales of commercially produced carvings that are not designed for use within the community are effectively no different from traditional cultural artifacts that are willingly sold, and consequently of no less significance or authenticity. (Of course when an Indigenous person is forced to dispose of a powerful object unwillingly, such as in the aftermath of the Cranmer potlatch in 1921, and has not been able or willing to withdraw rights from it, then the object remains restricted and powerful.)

Indeed, all those I interviewed expressed pride in the commercial viability of their work or emphasized its necessity. Kwakwaka'wakw artist Gary Peterson recounted of his childhood artworks:

So here's this eight-year-old kid taking four days to paint these things and one day to sell them, made 450 bucks. That's 90 bucks a day, in the '80s, as this little boy. My Dad made me put 10 percent of everything I made into an account and I got to spend the rest. When I was seventeen years old I had $45,000 saved up. That's 10 percent of everything I made from the age of seven to seventeen. In ten years I made $450,000!

Among some groups, such as the Salish, carving was open to anyone and most men had knowledge of carving techniques, although canoe making was a reserved skill limited to those with familial rights to it (Barnett 1955, 107–10). Canoe carvers come from families with long carving traditions and learn to carve at a young age. Among other groups, such as the Makah, the Kwakwaka'wakw and the Haida, carving was and remains a distinct profession. Makah carver Greg Colfax noted that he had "raised three children on my carving, was able to provide my wife and I with a way to survive. That's how I did it," while Makah weaver Melissa Petersen-Renault went further by identifying the commercial imperative as essential in the development of an artist.

Makah carver Spencer McCarty continues this commercial narrative, returning to the subject of miniatures and their elevated importance in the economies of commercial art production, sale, and transportation:

When I first started to become a commercial carver to make my living, to become an artist, I had a hard time selling big items because nobody knew who I was. They didn't know my name, nobody seen my stuff before. And though I'd learned how to make masks and canoes and totem poles, sales were difficult because [of] the higher price of the full-size object. And I had a friend who used to run the museum and he run the craft store, too, and he gave me the idea to carve everything I can and make it small. And learn how to carve everything and make it small and it won't take time if I wreck it and have to throw it away. But if I learn how to make it small then I'll have learned how to make everything. And then in the meantime my name will get out there and my art will get out there, and people will say, "Hey, this guy is pretty good at carving." And it worked. I made miniatures for probably four years, little masks, little canoes, little totem poles. Just anything we had that was small.

To carvers and other artists from the Northwest Coast, commercial art production is not only a source of pride and income. It is connected in a vital and direct way with art production for cultural ritual practice, and is moreover an important part of the development of an artist. Since miniaturization is also a key element in a carver's training, and souvenir art includes substantial numbers of miniature objects, these two aspects of carving are intrinsically linked. Indeed, Spencer McCarty made it clear that working in miniatures can directly further the commercial appeal of a carver's work. Considering miniaturized objects, including hybridized pieces made for commercial sale, as inauthentic or acculturated is therefore a false assumption. They are instead a fundamental part of the development and continuation of traditional Northwest Coast material culture practice.

Understanding the Process of Miniaturization

The artist is an active imaginative agent in the process of miniaturization, making a series of culturally informed choices in order to communicate a particular message to a defined audience. And although miniaturization is pursued in different ways by different tribes and even by different individuals, depending on cultural, temporal, and spatial circumstances, the practice also unites the Indigenous peoples of the Northwest Coast.

The miniature objects produced in the region do not require a rigorous or even approximate scaled relationship with their prototypes as long as necessary similarities are preserved. This dissonance between miniature and

prototype is not accidental but a deliberate choice to enhance some dimensions at the expense of others. A similar process attaches to the material aspects of miniature objects. Although the choice of material is determined partially by the availability and quality of resources, decisions based on intended function are far more important, while the materiality of the prototype appears almost irrelevant. Moreover, by utilizing non-traditional materials, the artist is freed from culturally imposed artistic restrictions and can allow imagination to develop the work. This is illustrated by the fact that as quality of carving diminishes, so does quality of materials, even when better-quality materials are readily available. The artist is making an imaginative choice about the quality of the miniature they are creating based primarily on audience, not on skill or resources.

Another offshoot of my analysis concerns miniatures as ritual objects. Evidence for their use in ceremonial activity is not strong, although there are hints that a small number of them may have been supernatural objects of power. Miniatures do, however, often incorporate qualities that draw on their *relations* with ceremony. The practice of miniaturization also has supernatural aspects; carving is itself a ritual activity in which cosmology is an essential component, and miniaturization is thus indelibly linked with the ritual aspects of life in the region. Further, when miniature objects take the form of dioramas, they become imaginative objects rooted in specific moments and actions, acting simultaneously as temporally detached reproductions of events and as reflections of Northwest Coast peoples more generally. These conclusions demonstrate that miniaturization is not restricted by the physical properties of the prototype, more typically embodying information through intangible, imaginative engagement.

An examination of how miniaturization operates within carving culture – and of carving as a professional art form within the wider social and material culture structures of the region – reveals it to be a crucial part of a carver's technique. Miniaturization acts to shape carvers not only on a personal level, helping to develop their skills and production, but also on a broader level, educating them through repetitive praxis. Carvers are central to Northwest Coast societies; if they do not produce artworks for ceremonial events, the culture starts to fail. Only by making their work commercially viable, however, can they pursue their craft full time and thereby attain the skill to achieve the required quality. Enmeshed with these imperatives is the recognition that through their art and the ritual cultural life that it makes possible, carvers are of particular importance to the process of ensuring that

traditions are passed from generation to generation. This role is keenly felt and taken seriously by Northwest Coast carvers.

Whether as a training method, a commercial product, or an educational tool of cultural transmission, miniaturization operates subtly but crucially in the background not only within Northwest Coast carving practice but also within the wider process of developing, reflecting on, reproducing, and continuing traditional cultural practice over an extended and highly disruptive period, often as an agent of resilience and survival. Localized contexts for miniaturization reveal both similarities that unite them and key differences that distinguish them, embodying a material culture process of communication across time, distance, and peoples on the Northwest Coast.

7
Miniature Realities

THE PEOPLES THIS BOOK has described have experienced similar post-contact narratives of demographic and economic collapse followed by aggressive colonial government, and have all responded, in part, through the medium of miniaturization. The first stage of the miniaturization process is to imbue objects with the diminutive tactility, simplicity, and relationship to prototypes necessary to accomplish this goal, and the second is to distribute them to their intended audiences. These responses have differed in each society, as befits the essentially localized nature of miniaturization. As communicative actors, miniatures from the Pacific Northwest can transmit, preserve, and protect information in a subtle and fascinating manner, remaining unapproachable if the observer has no understanding of the environments within which they were conceived and are embedded.

Three elements of a methodology for miniaturization on the Northwest Coast are considered here: the connections between the affordances, or physical features, of the object; the emotional and sensory effects aroused by the object; and the relationships between artist, miniature, and audience. All three are understood to operate within the process of miniaturization, challenging the notion that miniaturization is a continuum from large to small and instead positing that it relies on an imaginative combination of elements to become a medium of non-verbal ideological communication. Once this has been understood, it becomes possible to present a new approach to interpreting miniature objects.

I reconsider miniatures from the Northwest Coast in terms of their authenticity, their changing abilities as they circulate outside the communities in which they originated, and ultimately what they reveal about the ideological intentions of their original artists. These intentions and the cultural resilience, resistance to colonialism, and thirst for communal survival they reveal forms the core of my research. They open possibilities for new understanding of the methods by which Indigenous peoples of the region have preserved those ephemeral and yet utterly essential things that make them who and what they are: the curve of a knife blade, the right to fish a waterway, and the stories and dances handed down through generations.

Studying Affordances

The affordances, or physical properties, of miniatures from the Northwest Coast in the records of museums reveal a striking dissonance with their full-sized prototypes throughout the post-colonial period. While the range of miniatures at Ozette was broad, in the post-contact period only larger, more significative forms of colossal material culture – canoes, houses, and totem poles – were routinely used as prototypes for miniaturization. Moreover, the proportion of examples that demonstrated ceremonial or religious significance was far higher in miniature than in the full-sized examples, particularly for canoes, and the prototypes pertained almost exclusively to traditional, if often hybrid, forms of material culture. Rather than producing the European designs of houses and boats that began to replace the longhouse and canoe in the late nineteenth century, with a few exceptions artists focused on miniatures of prototypes they recognized from their own traditions. On the rare occasions when artists did miniaturize culturally alien forms, they usually did so satirically, as with argillite carvings, and often within a traditional medium, as Charlie James's Pepito pole exemplifies.

This dissonance is accentuated by a loose proportionality, as miniature houses demonstrate. Even when they were made under commission as ostensibly proportional models, the houses have exaggerated, highly decorated frontages and door poles and lack accurately scaled depths. Their carvers made no effort to reproduce the schemata of a full-sized house or to use the same materials. Carvers of miniature canoes likewise enjoy imaginative freedom in materials and proportions, for example, altering the scale to emphasize the bow and stern, so often decorated with formline crests, or to emphasize the status of the crew by exaggerating their size.

These disproportionalities are deployed in different ways in different communities, but dimensional exaggeration is a unifying feature, implying that the relationship between miniature and prototype, the supposed continuum, is not rooted in linear scale but in imaginative effect.

The carvers I interviewed corroborated this observation, making it clear that for most miniatures their intention was not to accurately reproduce the scale, materials, or functionality of the prototypes but only to make them "look right." In a similar vein, miniaturization does not at any stage require using the same techniques and processes as the prototypes; it is a separate process entirely. The notion that Northwest Coast miniatures are technical reproductions or scaled architectural models in the scientific sense can thus be confidently rejected. They are evidently imaginative objects, subject to artistic decision making that is unconnected to the mechanical requirements of their prototypes.

As imaginative constructs, miniatures need engage only with the properties necessary for their purpose. Extraneous details can be eliminated or altered on the judgment of the artist, and by considering which details have been retained an observer can begin to engage with the miniature. Detail is not simplified in a uniform or mathematical way; some elements are eliminated, others are unchanged. Some aspects of the miniature have no mechanical purpose but can be understood as imaginative representations, incorporated for a specific purpose. The hidden faces on Gordon Scow's Hamat'sa dancers, for example, give them identity and personality, while the ability of Makah canoe miniatures to float serves a cultural purpose as a conveyor of information. Although they are not uniform, the physical properties of miniatures provide clues about the intended message and audience. For example, Mungo Martin's dioramas depict traditional hunting practices in differing and particular ways that reflect quite distinct messages, and late-nineteenth-century makers of miniature canoes selected wood of varying quality depending on the purpose of their carvings.

Intimately tied to these considerations is the issue of scaling; miniatures exhibit disregard for proportionally accurate scale but also a wide diversity of sizes. The only constant is that the miniature must be smaller than the prototype. Young Doctor's four-metre-long Makah miniature is a case in point; at that place and at that time he chose to create a miniature that was substantially larger than any other ever produced, and he did so in part in order to engage with a glutted tourist market that prized innovation. Ellen Neel took the opposite extreme with the "world's smallest totem pole,"

creating an object that fascinated through its diminutive intricacies. That both of these objects were subsequently presented to prominent outsiders is not a coincidence – they were ambassadors for the skill of the artists and the cultures from which they emerged, and intended to be observed in this context.

In miniaturization, affordances are based on three categories: mimesis (or resemblance), scaling, and simplification. These operate in relation to one another under observation by an audience in order to provoke specific effects. They are not incidental but have been carefully selected by the artist during the developmental stages of the process.

Reconsidering Prototypes

Throughout this book I have used the word *prototype* to refer to the larger thing from which the miniature has drawn its shape. As noted, it can be a physical object, an imagined element, or a broad category. Selecting the prototype is the foundation of the process because the miniature cannot exist without at least some of the qualities of its prototype. These are then imaginatively manipulated through simplification and scaling to create an object possessed of the affordances necessary to achieve the intentions of its maker.

It would be incorrect to assume that the prototype is the inspiration for or origin of the miniature, or that miniaturization is a process that takes the prototype along a continuum from large to small. The construct of a continuum positions the prototype as the central focus of the process, rather than just one of its contributory factors. This is problematic because it obscures the emphasis, the intangible ideology, contained within miniatures. As an example, to assume that the miniature head canoes made by Northern tribes in the late nineteenth century depend on earlier canoe design for anything more than basic resemblance fails to account for the social and political conditions under which they were made and therefore the nostalgic ideology for which they were created.

It is important to recognize that mimesis, or similarity, is not dictated by the prototype but by the artist. Since the artist takes only those parts of the prototype that are needed, there is no continuum, no direct trajectory of scale, only a refracted scattering of affordances among which scale is but one. The trajectory is provided by the intention, the motivation I have termed *emphasis*. Thus we can now see the first stage of miniaturization as a formula:

Artist → Emphasis → Prototype → Scaling
and simplification → Miniature

The physical creation of the miniature need not start until the final stage, although in practice it is often begun earlier, the initial tentative stages of shaping the miniature coinciding with decisions about scaling and simplification.

Decoding Miniatures

Although the artist makes decisions that are integral to miniaturization, these are informed by cultural context, which determines the environment or environments within which the artist expects the miniature to circulate and thus the effects it will provoke. Michael Hall and Pat Glascock articulate the widely acknowledged idea that, with respect to Northwest Coast miniatures, "the nuances of form defining a style are heavily coded with the life experience of a carver working in a specific time and place" (2011, 55). As used here and earlier by Claude Lévi-Strauss, the term *code* should be clarified. It does not suggest that the miniatures provide a system of interpretable symbols; indeed, as Cranmer Webster illustrated, one can never simply "read" an object as one would a book. Like the rattles she described, miniatures respond instead to interaction through physical tactility and cognitive fascination within a proper context. This allows for an interpretation of their physical properties within a partially re-situated environment (a semiotic ideology), to draw out the intangible qualities that make them "nonsensical" – capable of simultaneously revealing and obscuring sensitive and deeply personal knowledge, depending on the observer. The elements of mimesis, scale, and simplification combine to expose information to knowledgeable observers and conceal it from the uninitiated. For that reason, the metaphor of a code is apt, and even more so when it is recalled that so many post-contact occurrences of miniaturization on the Northwest Coast take place within a context of external repression of traditional practices, as defined by the colonialist other.

This thread can be traced through the work of artists such as Young Doctor, Edenshaw, Martin, Neel, Scow, and Reid, whose miniatures were either characterized as a permissible Indigenous tradition or overlooked by authorities, and were therefore packed with information that would be impermissible or dangerous in other contexts. This was possible because the

authorities viewed miniatures as a hybridized art form, European inspired and therefore, crucially, inauthentic and harmless. Even sympathetic European observers such as Franz Boas or George Heye seem to have fallen for this assumption, relegating miniatures to the status of inaccurate tourist art and consequently beneath the study of serious academics or collectors. Museum displays have borne considerable responsibility for this problem, eliminating tactility and dismissing Indigenous imagination in favour of a "read" seriation within European Enlightenment categories, and thereby re-creating the miniatures as semiophores – useful objects made useless.

Once the notion that miniatures are inauthentic expressions of Indigenous ideology has broken down, it becomes possible to tentatively "decode" them: to rediscover the obscured ideologies within as metaphors and representations, and their operation as ethnodramatic satire in alien environments. Thus a Makah whaling diorama becomes not just a commissioned model of canoe building but an expression of threatened Makah identity; a head canoe miniature given to a Russian trader is a depiction not just of a Tlingit watercraft but of the spirit canoes that protect the coast, acting as a warning understood by the Tlingit but not by the Russians; Martin's comparative hunting dioramas illustrate how miniatures can negotiate Indigenous and non-Indigenous spaces safely; and Tulalip miniaturization, although superficially mechanical, is ultimately an imaginative process of developing a distinct and unifying communal identity.

Identifying Audience

A simplistic interpretation of miniatures as holding one defined function is unsupportable. Miniatures were not only, or not simply, souvenirs, toys or curios, artworks or architectural experiments. Although some of them fit some of these categories, or may at various times have fitted all of them, this functional terminology consistently fails to account for the intangible, the non-sensical, information that miniatures contain.

Tying all the miniatures discussed here together is the fact that they were made to be observed, to be engaged with mentally and sometimes physically, but not to have a physical "use." This intention was paramount among their makers: artists who lived and worked within explicitly visual cultures, with a strong grasp of subtle, satirical commentary. Every example of miniaturization discussed in this book has involved the consideration of audience; if the audience can be determined, then the effects of the miniature and the

intentions of the artist can be analyzed. This is to incorporate semiotic ideology, or context, into the framework of miniaturization study. If the environment within which the miniature was created can be understood, the concealed information it contains may be interpreted.

The large miniature canoes obtained by Malaspina or Sartori, for example, can be understood as portable statements of identity and ownership, extensions of the Haida mind. The work of Martin and Neel is a method of disseminating Kwakwa̱ka'wakw imagery to non-Indigenous society to protect it, and Gobin's canoe miniature is revealed as a political demonstration of ownership. Miniatures produced for internal tribal audiences, such as Scow's figurines or the Tulalip maquettes, are tailored to the semiotic ideologies of the communities in which they are made. This is a straightforward interpretation of miniaturization as a process of communication:

Ideology → Artist → Miniature → Audience

Here, the ideology informs the artist's work on the miniature in order to convey information to the audience. The equation is an oversimplification of the process, however, because it does not consider differences between domestic (or emic) and foreign (or etic) audiences or account for the ways in which miniaturization can torque meaning to create unexpected effects as its products move through society.[1]

Consider the miniature canoes of Young Doctor and his contemporaries and of the modern Makah carvers I interviewed. These miniatures are routinely described as commercial products made for an artistic marketplace. They are additionally understood as ambassadors for the Makah, and specifically for particular Makah families. Nonetheless, they also unify a number of significative processes into one material culture practice. And they do all this at the same time. One facet of their role is as educational tools, used to teach young Makah about traditions that are historically important for preserving identity in the face of aggressive assimilation. Through the technical process of creation, through the cuts needed to make a miniature canoe, miniaturization teaches Makah carvers how to preserve and communicate these physical practices and knowledge through art. This creates an intriguing loop – whereby miniaturization helps create artists who then distribute cultural knowledge more widely in their own community – a sequence that may collectively be considered one multigenerational material culture process, a "movement of thought" exhibiting temporal differences in intent

and affordance but physical, and thereby cultural, consistency in technique. This loop is unique to miniaturization; their small size and inexpensive production mean that the objects can be completed quickly and with minimal risk, and their child-friendly tactility encourages imaginative inhabitation, which stimulates play, generates effects, and consequently forms a familiar relationship with the prototype and a relationship with the artist's emphasis.

Significantly, some miniatures are disseminated away from the community, literally and metaphorically travelling long distances. A canoe cannot successfully travel unless it floats, so a miniature canoe cannot successfully travel to its intended destination or communicate knowledge and identity unless it too is able to float. These metaphorical affordances are embedded in the process of miniaturization and explicitly understood by the artists. What makes them possible is the inherently imaginative nature of the miniature and its relationships.

In the technical act of miniaturization, the artist draws on and manipulates the process to generate a self-sustaining educational loop within the community and loosely to direct the dissemination of cultural information beyond its boundaries. These effects can be achieved only if the decisions made during miniaturization have been correctly judged. This is why post-contact Makah artists focused predominantly on miniaturized whaling canoes, using the most significant example of historical material culture available as a prototype to make use of that prototype's significance through an acceptable medium. In this interpretation the miniature does not represent whaling canoes per se but the Makah themselves. As a synecdoche, a part that represents the whole, the miniature embodies the most powerful image in Makah society using only those physical affordances necessary to succeed. A *chaîne opératoire* for this process might be as illustrated here:

Emphasis → Artist → Miniature → External Audience

Emic semiotic ideologies → *Etic semiotic ideologies*

The artist practises the same miniaturization process for three different audiences at the same time: the Indigenous community in which they are used as learning devices; the artist him or herself; and the global audience buying the miniatures as artworks. The first two operate as a feedback loop that reinforces mechanical and cultural knowledge in both the person of the artist and his emic (or domestic) semiotic ideology within the Indigenous

community. The global or external audience generates etic (or foreign) semiotic ideologies in its engagement with the work.

Domestic Audiences

The miniaturization practices of the Indigenous communities discussed throughout this text demonstrate this range of audiences, with localized alterations. Ellen Neel carved predominantly for an external art market of predominantly unknowledgeable observers, but her work also had significant observable effects on her personally and on knowledgeable Kwakwaka'wakw observers more widely. Gordon Scow, conversely, focused strongly on (potentially) knowledgeable observers in his own community and was uninterested in an external market. And the Tulalip carvers I interviewed do not display their miniatures publicly, yet acknowledge the profound effect of miniaturization on themselves as carvers and on the Tulalip as a community.

Indeed, miniaturization plays a significant role in the development of carvers across the region. James Madison, Gary Peterson, :klatle-bhi, Wayne Alfred, and Gwaai Edenshaw all recalled how their earliest carving experiences were with miniatures, and how miniatures shaped them. In permitting apprentice carvers to practise with little expense and without any noted religious or ceremonial expectation or danger, miniaturization plays a practical role in developing their skills. Miniatures also affect the cognitive development of artists, reinforcing engagement with traditional media and design while facilitating innovation and experimentation due to the low cost/low risk nature of the art form.

Miniaturization can also act as a bridge between the imagination – or indeed spiritual inspiration – of the artist and a large-scale artwork. Using maquettes, carvers experiment with form and design, developing the physical properties of the miniature in relation to the imaginative dimensions they wish to create in the larger artwork. In this process, the miniature works on the artist as the artist works on the miniature; miniaturization has agency as a sub-process within longer-term carving projects. Interestingly, none of the carvers who described this practice intended to make a miniature *for sale* (i.e., for etic, or foreign, audiences) – the miniature was a tool of the process, and often a short-lived tool at that. Gwaai Edenshaw destroyed his Plasticine maquettes during construction; :klatle-bhi never finished them, making only the few practice cuts he needed before moving on to the larger

object but keeping the miniatures for future reference. Steven Bruce Sr. later decided to finish and sell his maquettes, but only after being persuaded to do so by a non-Indigenous dealer.

Whether it is part of a longer creative process or focused on the creation and distribution of a miniature object, miniaturization on the Northwest Coast reflects different processes that operate in similar ways. The processes that created Joe Gobin's miniature canoe and Steven Bruce Sr.'s miniature totem pole are oriented toward different audiences – the former was a deliberate vehicle of knowledge and ideology, the latter a tool functioning symbiotically with the artist but with no recognized value once its purpose had been fulfilled – but intangible influences on human behaviour are present in both.

Bridging the gap between these roles is the in-house miniaturization practised by Tulalip carvers. Their miniatures serve dual purposes within a commercial art production facility. First, they hold technical significance for the artists, enabling the same experimentation as other maquettes: consider Joe Gobin's welcome figure and its broken paddle. Second, they hold communal significance as agents in the cultural development of Tulalip people. In combination with digital designs and sketches, the miniatures are presented to the board of directors, who in turn make suggestions for alterations that will affect the finished full-sized pole. Since the Tulalip Tribes, like other Salish peoples, have historically placed large-scale artworks at points of cultural dissonance such as courthouses, government buildings, and schools as markers of identity and non-violent resistance, these artworks can be seen as overtly political cultural statements. The miniatures therefore become important agents within the negotiation of manifest displays of Tulalip identity, a liminal point of consideration at which the directors and the artists decide on the most effective direction for the imagery with which they decorate tribal institutions of authority as an assertion of autonomy.

Other communities have also employed miniatures as a safe medium for negotiating and altering historical cultural trajectories. Kwakwa̱ka'wakw boys play-potlatching with miniature canoes in the nineteenth century and their descendants recreating the Hamat'sa with Scow's figurines were fulfilling a similar, if less official, role than that of Makah children playing with miniatures on the beach in order to learn whaling. Miniaturization thus has a well-understood educational role in Northwest Coast societies, in which miniature objects are used in play to stimulate the imagination of children and in doing so transmit cultural information between generations.

As Bill Reid and those who have followed him demonstrate, this process continues over long stretches of time, even when the support of knowledgeable elders, the "books of knowledge" who provide oral histories, has been nearly severed by cultural or demographic collapse and repression. The physical affordances of miniatures can still be interpreted and acknowledged by subsequent generations of Indigenous people, and the information contained within them can be understood.

Foreign Audiences

Beyond artists themselves and the communities from which they come – their emic (or domestic) audiences – miniatures have a third, equally important audience. Northwest Coast artists have often created high-quality miniatures of high-status material culture items as ambassadors to outside audiences: an etic (or foreign) audience. These are significant examples of material culture intended to convey ideological information to audiences known to operate in substantially different environments from the carvers who made them.

Artists were not ignorant of the ideologies within which their miniatures would be observed beyond their communities. As members of a cosmopolitan trading society and bearers of an intensely visual culture, the carvers of the Sandeman miniatures or the Skidegate houses at the World's Columbian Exposition in Chicago would have had sufficient experience of Americans at the time of commission to recognize that this was an opportunity to impress – to create a small but lasting attachment to the Haida among a very large number of people. They also knew – as Louis Shotridge, Ellen Neel, and Mungo Martin all later understood – that the way in which Indigenous Northwest Coast peoples are presented to the North American public matters. If positive, accurate information is disseminated, if the traditions that artworks spring from are preserved in the object record, and if the practices and ideologies by which they were created are continued, the culture can survive. As prominent and explicit bearers of culture, artists still pursue this role. As Gwaai Edenshaw notes, some carvers have pursued their art not from individual inclination but because the role is so crucial, and the information to be transmitted so irreplaceable, that they had no choice.

That artists producing material for foreign audiences were aware of the limited extent to which those interacting with the objects would understand

them is well illustrated by the prevalence of satire in Northwest Coast souvenir art. Edenshaw and his contemporaries were comfortable inserting parodies of Europeans into their argillite artworks because they recognized that Europeans would only understand and appreciate affordances that were comprehensible within their own contexts. Indigenous satire, and the caricatures it featured, was not likely to be such an affordance, certainly not to be understood by non-Indigenous viewers in the same way as Indigenous audiences would. Encoded with life experience, miniatures were not always intended to be overtly satirical, but they retain the subtlety of that artistic device, obscuring ideological information within misleading affordances. Thus it was that miniature devices of communication were obtained by Europeans, misunderstood as simple models, and ultimately deposited in museums.

Over time and space the relations between miniatures and audiences will torque; Krzysztof Pomian's (1990) description of previously useful objects becoming semiophorically useless once they enter the museum contact zone is highly relevant here. The ways in which the objects are interpreted change as they circulate and as observers become less knowledgeable and the environments around them shift. This explains why miniatures in museum settings inevitably become representative proxies for their prototypes rather than imaginative communicative constructs. They shift from solid objects to more nebulous things, their resemblance to larger objects obscuring their connections to intangible ideologies.

Unless curators take great care, a miniature becomes a semiophore when it enters a museum and its ideological information can be lost (or at least unobserved). A long history of decontextualizing or radically recontextualizing ethnographic objects results in curators effectively remaking the miniature, the dramatic alteration in context forcing new and unfamiliar interpretations onto the object and generating new, uninformed effects. Bill Holm (1986) described the violence of the curatorial process, the squeezing of imaginative, representative objects into foreign functionalist seriation, a phenomenon against which Shotridge struggled during his tenure at the Penn Museum. To pursue the metaphor further, when semiotic pressure is placed on the object, it can torque unexpectedly, as happened when unknowledgeable curators studying text-free miniatures confused the bow and stern of head canoes (Harper 1971, 238; J.C.H. King 1976). It can also have wider societal ramifications. Charlie James's "idiot sticks" and Ellen Neel's miniatures contributed, probably inadvertently, to a transformation of totem

poles from a Kwakwaka'wakw or specifically Northwest Coast object type into a pastiche of etic pan-Indian identity once they entered the uninformed environment of broader American society (Davy 2019).

When new generations of carvers, led by Bill Reid, began to turn to museum collections to rediscover lost art forms and techniques, miniatures were again problematic. Out of context or unreliably contextualized, their place in museums hindered their restitution within Indigenous semiotic ideologies. It took time and experimentation to realize that they were not scaled models but metaphorical ideological devices, and only recently have carvers acknowledged the more unusual affordances that speak to obscured ideological information. Alex McCarty's work on the buoyancy of the Makah miniature canoes is an example. In this respect, it is contemporary artists who are now the etic, or foreign, audience, the miniatures having become so embedded within museums that their new contexts can effectively obscure the original intentions of their carvers.

Yet recontextualization is not a permanent feature of the miniature. When miniatures are figuratively isolated from the institutions that hold them and studied not as models within a continuum of scaling but as objects of imaginative communication, their original purposes can be partially understood. Paying attention to the context of the environments where they were made, it becomes possible to develop insight into the imagination or ideology of the carvers, and even into their emotions and ambitions. Miniaturization on the Northwest Coast can be understood as a technical process oriented toward the preservation and communication of traditional culture and practice through both domestic and foreign audiences. It is a material culture practice with a formidable ability to cross generations and contact zones, with the intangible, non-sensical information inherent in its operation intact and waiting to be acknowledged.

A Model of Miniaturization

The process of miniaturization can be explained using a formula in which artists determine an emphasis, informed by the environment within which they work and by knowledge of the context within which their audience will interpret the object. They select a prototype capable of transmitting this emphasis and make a series of decisions regarding scale and simplification. The result is the miniature. In some cases, when the only audience is also the artist, the miniature goes no farther, squashed like Gwaai Edenshaw's

Plasticine. In most cases, however, the miniature continues, deployed to a specific audience as required and then continuing unaided to new and unsuspected audiences. Once the stages of conception, construction, and deployment are complete, the miniature object itself can survive, being remade in new contexts and torquing as it passes through contact zones like museums.

Throughout this work, the relationship between a miniature and its prototype has been demonstrated to rely on selective incorporation of simplified physical properties, chosen to emphasize the features of the prototype that most effectively communicate the emphasis behind the miniature. The prototype is therefore selected for the miniature; the miniature does not spring from the prototype. Although, as with carvers' maquettes, this relationship can be symbiotic, miniaturization usually draws on the idea of the prototype for quite another purpose than that of the prototype. The miniature and prototype are therefore two separate things, operating in different systems and sharing only those qualities necessary for the miniature to look like the prototype. The conceptual and ideological changes that have occurred in conceiving of the miniature take place before the prototype is even selected, the prototype decided by the artist within a cultural context and prompted by the emphasis.

Any miniature object typically fits one or more definitions within seriated museum terminology – toys, souvenirs, models, and so forth – but it also possesses affordances that convey an artist's emphasis, evoking relationships and thereby transmitting information. When audiences, knowledgeable or not, interact with the miniature, they impose their own understanding on it. Such is true of all objects, but miniatures are unique in that their diminutive tactility and imaginative fascination actively encourage the imposition of interpretation. Claude Lévi-Strauss's fish club is and will always be "read" as a fish club (1966, 26), even if its decorative features are poorly understood, but miniatures withstand such functionalist analysis, fascinating and obfuscating. In a museum, a miniature canoe becomes an icon for all canoes without consideration of its particular origins, or it becomes a trade carving, "just where it should not be," a dissonant, "cluttering" object of derision and worse, inauthenticity.

To explain this clearly, I present below an original formula for the study of miniaturization, designed to be an effective tool of analysis in the examination of any miniature object for which even the simplest contextual information can be discerned (Figure 7.1).

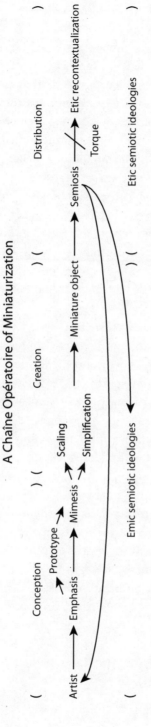

Figure 7.1 Methodological model for the study of miniaturization. | Designed by author, drawn by Steven Boden

Miniaturization, Authenticity, and Resistance

Despite strong evidence that miniatures should be considered authentic expressions of Indigenous ideology, this is not a blanket affirmation. Authenticity is not an absolute. Unlike miniaturization itself, however, authenticity on the Northwest Coast *is* a continuum. Decisions made during the process bear this out, such as the choice not to use European prototypes – a choice made by artists concerned with ensuring authenticity of production. Yet miniatures produced with non-traditional materials or techniques are not inauthentic; Bill Reid's tiny tea set is an inescapably Western subject rendered in a non-traditional medium, but Reid's own Indigenous identity renders it authentic. Conversely, Halliday's sale of the Cranmer potlatch regalia was inauthentic despite the provenance of the materials because there was no Indigenous agency over the transaction and no safe transfer of privileges. James Madison's inclusion of Tlingit motifs on a Tulalip pole is not inauthentic because the artist has the right and authority to make use of those designs.

The question of authenticity extends beyond tribal specifics. In the summer of 2014, I met a carver of undefined Indigenous identity named Raymond outside Ye Olde Curiosity Shop in Seattle, carving generic totem poles from cheap balsa wood (Figure 7.2). Yet his work is authentic in that carvers of his ability have carved poles of similar quality in exactly the same spot for more than 140 years. Their knowledge of this tradition appears to grant them a legitimacy (by no means universally acknowledged) that their lack of knowledge of traditional pole designs does not automatically eradicate.

At just two moments in my fieldwork, miniaturization appeared to cross the continuum into inauthenticity. The first and most blatant was at the Seattle Aquarium, one of the most popular tourist destinations in Washington, where generic Northwest Coast-style miniature canoes, mass-produced cheaply in Indonesia, were offered for sale at the astonishing sum of US$179.99, displaying breath-taking ignorance and disregard of authentic local art traditions (and good taste) in favour of overtly inauthentic works purchased from overseas.[2] The second was more subtle and arose in an interview with Steven Bruce Sr., who discussed his unease with commercially available mass-produced resin miniatures based on totem poles he had carved in the Netherlands:

Figure 7.2 Raymond (right) and unidentified associate, Seattle waterfront, 2014.

I don't like mass-produced myself; it's not original. But you know from, I guess if you look at it ... How am I going to word this? ... It's just a money maker, that's all it is. And for some people it works, but from my point of view, if you look, the, like how they did the paint and all, it looks like it was made in China. You know what I mean? They're not ... What it does for me, in a way, you know, I did the originals and looking at this it's not putting a good name to myself from it. I don't like it at all, mass-producing, unless you are going to ... See I haven't done it myself, and I would not accept it if that was for me; I would not put my name on that.

Ultimately, as Paige Raibmon rightly concludes, "adjudication of authenticity is a task for Aboriginal communities" (2005, 208), and with respect to miniaturization it is a communally or individually determined consideration along a continuum. For Bruce, the resin miniatures have breached the liminal point at which Northwest Coast–style art slips from authentic to inauthentic. Since miniatures themselves do not exist on a continuum, miniaturization itself cannot render an object inauthentic, so long as

MINIATURE REALITIES 185

the artist is satisfied that the affordances promoting their emphasis are retained.

Miniature objects act as non-verbal communicative devices precisely because they lack an easily defined practical functionality and can therefore function imaginatively. Their portability is important to this purpose; on the Northwest Coast houses, canoes, and totem poles were miniaturized most often and as a result these highly important representatives of authority and wealth can be found in museums across a substantially larger geographical range than their prototypes. As the Makah examples demonstrated, miniature objects are designed to make long journeys, their diminutive dimensions making them not just fascinatingly tactile but easily transportable. Thus miniatures act as synecdoches, or representatives, of the societies from which they came. At the same time, their small size encourages close engagement with their affordances and generates effects for wide audiences. The inherent portability of miniature objects enables them to reach distant audiences and retain, as far as is possible, their ability to communicate in their new environment. This factor is one of the decisions encompassed by the element of scaling, which requires consideration not only of the intangible effect on an audience but also of tangible weight and dimension for the purpose of travel.

This book has taken Alfred Gell's notion of art as "social relations in the vicinity of objects mediating social agency" for its own definition (1998, 7). Miniaturization is interpreted as an artistic process that provokes social relations between carver and audience, and mediates the social agency of these relations. As an intangible, imaginative process that relies on non-sensical dimensions, the relationship between artist and audience can develop only through aesthetic decisions regarding mimesis, simplification, and scaling to communicate ideological messages. I recognize, as others have, that Indigenous Northwest Coast art encodes information within its aesthetic qualities that actively contributes to its function. Where my argument goes further is in demonstrating that on the Northwest Coast an object need not have any practical functionality in order to be an effective tool; that the aesthetic qualities of the miniature are capable of provoking potentially magical fascination, which give it the power to intervene in human social relations over long distances despite systemic shocks and temporal divisions.

This encoded information, routed through the elements of miniaturization, has myriad purposes and functions in Northwest Coast societies.

Nonetheless, the essentially imaginative nature of miniaturized material culture is a common thread, marking miniatures as objects of particular importance that have consistently been misunderstood and underestimated by scholars working within non-Indigenous systems of seriation. In such systems, miniatures have often been assumed to be toys or souvenirs, items without high status or value in European artistic hierarchies, and at the same time the non-sensical nature of their construction often causes them to be evaluated as crude examples of Northwest carving practice.

The truth is that wherever they appear on the coast, miniatures carry significance that is immediately apparent only to Indigenous audiences schooled in the visual and material culture of the region, those capable of "shaking" the objects. Miniatures contain evidence of techniques often in abeyance or under prohibition, as Alex McCarty demonstrated. Their design and decoration tell stories that might otherwise be lost, as Gwaai Edenshaw described. They allow for the re-creation of practices outlawed by colonial governments, as the work of Gordon Scow illustrates. They make possible experimentation with form and style, as shown by the works of Charlie James, Ellen Neel, and their compatriots.

Moreover, they often do so in ways that make bold statements; Young Doctor's whalers were produced in the era when whaling was coming to an end for the Makah. The Sandeman canoe miniatures from Sitka speak to Indigenous claims of historical access to waterways, and the fishing and hunting privileges that brings, at a time of drastic social and political change. The Haida houses of the 1893 World's Columbian Exposition reflected the traditional family way of life contained within Indigenous architecture, even as it was being actively suppressed. Miniatures, and the process by which they were conceived, created, and distributed to selected audiences, were a form of subversive resistance, a way of preserving parts of material culture under threat and making satirical commentary about colonial authorities in a manner safe from persecution. Like the policeman who raided James Sewid's Hamat'sa ceremony, those authorities were incapable of understanding the mockery. When, years later, traditional material and ceremonial culture were again safe, miniatures were preserved in museum collections and private homes to help guide carvers back to practices that might otherwise have vanished.

I began this work by comparing the new growth of the post-deforestation Northwest Coast with the stumps of old trees reaching through the litter of the forest floor as ghostly reminders of the world that was nearly destroyed.

Around them new trees grow more quickly and less densely than their ancestors, but once again form a spreading canopy that covers the region in green. The peoples of the Northwest Coast also endured devastation on a catastrophic scale, a demographic and cultural genocide. They resisted in myriad non-violent ways: through commerce, through community, through political and social advocacy, and through art. By drawing on traditional visual material culture in acts of defiance and resistance, miniaturization has played an important role, operating when other techniques were impossible or unattainable, and working with other forms of concealment and subversive engagement to ensure that as much as could be saved was preserved.

I hope that the methodologies laid out in this book make it possible to garner new insights into Indigenous responses to colonial oppression that have simply not survived in the written historical record, to approach the thought processes, communication strategies, and perhaps even the emotions of Indigenous participants, otherwise lost to history. I can be sure about the historical role of miniaturization in these engagements because in many places it continues; carvers along the coast still make miniatures encoded with cultural information for audiences external and internal, for themselves, for their peoples, and for non-Indigenous audiences beyond those environments. Their work often fulfills the same roles as that of their predecessors, such as Joe Gobin's miniature canoe commemorating the renaming of the Salish Sea or the miniatures of Makah carvers like Alex McCarty, which needed to float since they were going on long journeys with heavy loads.

Evaluating miniature objects and the processes that created them in the context of an elemental theory of miniaturization can reveal obscured meanings within their affordances and ultimately bring insight into the ideological intentions of their creators and the owners who followed. Using this model it becomes possible to recognize global patterns in miniaturization practice, informed by local ideologies that influence the precise process and have done since the emergence of artistic imagination. Indeed, it is important to recognize that the audience for miniaturization may be gods, spirits, or other supernatural entities with motives quite different from those of human audiences. The artists in such cases are attempting to create objects that will resonate far outside human experience, generate supernatural effects beyond human conception, and yet still relate to the artist's own understanding, forming a communicative bridge of even greater length than that required for human audiences.

Miniatures are categorically not the facile, inauthentic inaccuracies that Eurocentric anthropologists and curators have considered them, but Indigenous objects capable of imagination, communication, and resistance. Within sympathetic contexts they become communicative actors in human social relations, with the ability to impart information over long distances and time spans.

Miniatures surround us, so often part of the background to everyday human life. They appear in many guises and fill many roles. They operate as toys, souvenirs, or models, and in doing so they teach us by allowing us to imprint our own interpretations on their forms. But they do not do so passively; they fascinate us through the relationships they hold with their prototypes, and allow us to inhabit their affordances with our own ideologies. We do not see them for what they are but for what we wish to see in them, and it is only by systematically considering the elements of their conception, construction, and distribution, and the specific contexts of their origins that we can begin to reconstruct the reasons for which they were created. Because they are ideological constructs, made as tools without practical use, this reconstruction can expose layered and subtle information carefully encoded within the miniatures by those who created them. Miniatures are designed to speak to specific audiences and subsequently torque for new ones, on whom they operate independently and in often unexpected ways. Even when subject to this often-violent process, miniatures never lose their essential ability to fascinate and communicate, and the knowledge within them is never truly lost.

Notes

Introduction

1 The organizer of this event, Laura Peers, was very conscious of this contact zone issue, and describes at length the efforts she took to mitigate them in the book *This Is Our Life: Haida Material Heritage and Changing Museum Practice* (Krmpotich and Peers 2013). I use the scene illustratively, not critically, recognizing that the project itself was a major advance in museum-Indigenous relations in Britain.

Chapter 1: Practice and Play

1 Colfax's story bears considerable similarities to some of the whaling stories in the Makah oral histories recorded by Edward Curtis in 1915, demonstrating the enduring nature of these tales and their importance to Makah identity (Curtis [1916] 1974).
2 I gave serious consideration to the possibility of including basketry within this study, to the extent of compiling basket data sets, as small baskets, commonly referred to as trinket baskets, are common particularly among Nuu-chah-nulth peoples of Vancouver Island. Ultimately, I concluded that the evidence showed the baskets do not usually change in functionality as scale decreases; the essential qualities of a basket remain, and they are still intended to hold items and consequently rely on this functionality in their design. None were so small they could no longer comfortably hold materials or showed indications of being made without that intention. There were none on the scale of the miniature Pomo baskets of California, for example, woven at such tiny sizes they could no longer usefully carry anything but were instead produced as a demonstration of skill in order to obtain commissions from traders (Furst and Furst 1982, 87). Consequently, since the body of miniaturized wooden material culture held in museum collections was both larger and more easily defined, my research focused on carved miniatures. This is not though to dismiss examinations of scaling in Northwest Coast weaving, which would provide valuable comparative data.
3 The word *skeuomorph* has hitherto been used to describe an object that imitates the aesthetic effect of another, such as Mediterranean ceramic vessels made to look similar to more

valuable metal vessels during the production process (Knappett 2012, 99). I have adapted the term to refer to miniaturization, in which the miniature bears iconic resemblance to another thing, a prototype, without necessarily adopting the techniques, materials, or affordances of that object.

Chapter 2: The Haida String

1. This was actually most likely not the first encounter between Native Northwest Coast peoples and European sailors, but it is the first for which substantive evidence survives (White 2006).
2. It's hard to be sure whether these were the only examples. Thirteen of the houses were lost after the Exposition, and of others, such as FM 17990, only the façades survive. Other miniature houses made at approximately the same time and place also contain figures, including AMNH 16.1/1164 and the roofless NMAI 218856, while the interiors of NMAI 071120 and BM Am1898,1020.1 have no figures but feature carved and painted house posts and realistic firepits.
3. The renaissance analogy is routinely critiqued in academic literature as a non-Indigenous construction, one which is dismissed by Indigenous commentators (Glass 2013; Jonaitis 2004). Bill Reid himself rejected the term (Summers 2004, 133), and yet it has endured in regular parlance both among scholars and on the Northwest Coast itself as a useful shorthand for post-1950s alterations in Indigenous art – just as Gwaai Edenshaw uses it here.
4. Though written by a non-Indigenous person, *Raven's Cry* is acknowledged as an important document for the Haida. It was written in collaboration with Bill Reid, and in 1992 Robert Davidson referred to it as "good documentation ... certainly a book I would keep on the shelf for reference" (Harris [1966] 1992, x).

Chapter 3: Tiny Dancers and Idiot Sticks

1. Academic literature referred to Kwakwa̱ka'wakw people as Kwakiutl for more than a century. More recently, scholars have recognized that Kwakiutl accurately refers only to the Kwagu'ł band of Kwakwa̱ka'wakw people, and so the latter term, which translates as "Kwak̓wala-speaking people," is preferred (Codere 1990, 376; Macnair 1986). It is used as such here except in direct quotations.
2. Some have been sold in recent years, retailing at auction in 2016 at approximately $160, but there is no record or suggestion that Scow sold any himself.

Chapter 4: Small Foundations

1. Puget Sound is the official name of the large body of water that reaches south from the Strait of Juan de Fuca into western Washington, separating the Olympic Peninsula from the mainland. As will become apparent, the name Puget Sound is controversial and has in some respects been superseded by Salish Sea. Tulalip people generally spoke of the Salish Sea during fieldwork conversations relating to the body of water. Technically, however, Salish Sea actually refers to a much wider collection of water bodies, and I therefore use Puget Sound in a strictly geographical sense.
2. The term *Porucs* apparently derives from *Padraig*, reflecting the heavy Irish settlement of the region in the late nineteenth century. While I was preparing this manuscript for publication, a reader suggested that the term is not widely used among the Tulalip and may have been a joke at my expense.

3 See the biographical note appended to the Charles Milton Buchanan papers held in the University of Washington Libraries Special Collections, http://digital.lib.washington.edu/findingaids/view?docId=BuchananCharlesMilton3907.xml.
4 Both these vessels have holes bored into their hulls to prevent them filling with water in case the emergency sprinkler system of the council chambers is activated, but the holes are designed to be easily patched with prepared plugs.

Chapter 5: An Elemental Theory of Miniaturization

1 In describing a similar process, Pierre Lemonnier refers to "nontechnical functions" (2013, 58–60, 142), but I prefer Phillips's terminology as it does not exclude the idea that intangible functions are technical.
2 I believe that the idea of usefulness and uselessness in this theory may be a mistranslation of Pomian's argument, and that John Mack's description of such objects as "functionless" (2007) is more accurate in context.
3 While agreeing with the thrust of this statement, I take issue with Taussig's view of representation as an automatic consequence of mimesis.

Chapter 6: Analysis of Technique and Status

1 For example, museums hold a body of miniature figures from the Northwest Coast, but it is often very difficult to determine without context whether a given figure depicts a human or a spirit. In the case of a spirit, given their inherent spatial uncertainty, it becomes near impossible to gauge whether the figure is in fact a miniature, life-sized, or even colossal.
2 Please note that the tables in this chapter are not directly comparable. For this study I examined 944 miniature canoes in museums all over the world. However, I only visited approximately 285 of them in person – the others were viewed either on online databases or through published catalogues and collection lists. For a proportion of this latter body of work, more than 200, there was not enough information available to determine its canoe style, either due to inaccessibility or damage to the object. In each of the tables which follows I have only included those examples for which a specific analysis of the subject of the table was possible, and eliminated the others. Each sample was large enough to be representative, but they do not directly correspond with one another.
3 These totals refer to those examples which could be successfully analyzed for these purposes, and the totals consequently differ from those given in Table 6.1.
4 A body of material exists in argillite (or wood made to look like argillite), usually satirical and never naturalistic, depicting European steamships, complete with figures and action. These dioramas emerged from Haida Gwaii onto the souvenir market in the late nineteenth century. Though clearly a form of miniature, the scenes are markedly distinct from the canoe miniatures discussed elsewhere in this text, being produced in one specific context and period and for a defined tourist audience. They are remarkable reflections of how Indigenous artists viewed European travellers and sailors, and have been subject to detailed study in Drew and Wilson (1980), Macnair and Hoover (1984), and Sheehan (1980).
5 For Felix Solomon and James Madison the commission may have come from non-human, potentially supernatural sources.

Chapter 7: Miniature Realities

1 In using the term *torque* here I am specifically following Pinney (2005, 268–70), who argues that an image's "time is never necessarily that of the audience" but that it is instead

a "device ... characterized by jolts and disjunctions." This suggests the messages miniatures send to audiences can twist unexpectedly ("torque") when placed into different environments (or semiotic ideologies), creating meanings that were never intended by their makers.

2 I was explicitly prohibited from taking photographs of these items by aquarium staff citing "copyright" concerns.

References

Amrute, Sareeta. 2016. "Op-Art Anthropology and My Grandmother's Shoe." Paper presented at Small Things, 115th AAA Annual Meeting, Minneapolis, 19 November.
Appadurai, Arjun. 1986. "Introduction: Commodities and the Politics of Value." In *The Social Life of Things: Commodities in Cultural Perspective*, edited by Arjun Appadurai, 3–63. Cambridge: Cambridge University Press.
Aradanas, Jennifer Sepez. 1998. "Aboriginal Whaling: Biological Diversity Meets Cultural Diversity." *Northwest Science* 72, no. 2: 142–45.
Arima, Eugene. 1983. *The West Coast (Nootka) People*. Special Publication no. 6. Victoria: British Columbia Provincial Museum.
—. 2002. "Building Dugouts." In *The Canoe*, edited by John Jennings, 97–119. Toronto: Firefly Books.
Arima, Eugene, and John Dewhirst. 1990. "Nootkans of Vancouver Island." In *Northwest Coast*, edited by Wayne Suttles, 391–411. Vol. 7 of *Handbook of North American Indians*. Washington, DC: Smithsonian Institution.
Barnett, Homer G. 1955. *The Coast Salish of British Columbia*. Eugene: University of Oregon Press.
Berezkin, Yuri. 2007. ТЛИНКИБІ: КАТАЛОГ КОЛЛЕКЦИЙ КУНСТКАМЕРБІ [*The Tlingit People: Catalogue of the Kunstkamera Collections*]. St. Petersburg: Kunstkamera.
Berman, Judith. 2013. "That Which Was Most Important: Louis Shotridge on Crest Art and Clan History." In *Native Art of the Northwest Coast: A History of Changing Ideas*, edited by Charlotte Townsend-Gault, Jennifer Kramer, and Ki-Ke-In, 166–203. Vancouver: UBC Press.
Black, Martha. 1999. *Out of the Mist: Treasures of the Nuu-chah-nulth Chiefs*. Victoria: Royal British Columbia Museum.
Blackman, Margaret B., and Edwin S. Hall, Jr. 1986. "Snakes and Clowns: Art Thompson and the Westcoast Heritage." *American Indian Art Magazine* 11, no. 2: 30–45.
Boas, Franz. (1909) 1975. *The Kwakiutl of Vancouver Island*. New York: AMS Press.
—. 1927. "Art of the North Pacific Coast of North America." In *Primitive Art*, Instituttet for Sammenlignende Kulturforskning, Serie B: Skrifter, 183–294. Oslo: H. Aschehoug.
—. (1927) 1955. *Primitive Art*. New York: Dover Publications.

—. 1966. *Kwakiutl Ethnography*, edited by Helen Codere. Chicago: University of Chicago Press.

Bond, Anthony. 2012. "Harry Potter and the Film-Makers' Magic: Incredibly Detailed Model of Hogwarts Castle Used for Every Film in Blockbusting Series Is Revealed for the First Time." *Daily Mail*, 2 March 2012.

Borlase, William Copeland. 1878. *Sunways: A Record of Rambles in Many Lands*. London: General Books.

Boxberger, Daniel. 2007. "The Not So Common." In *Be of Good Mind: Essays on the Coast Salish*, edited by Bruce Granville Miller, 55–81. Vancouver: UBC Press, 55–81.

Boyd, Robert. 1999. *The Coming of the Spirit of Pestilence: Introduced Infectious Diseases and Population Decline among Northwest Coast Indians, 1774–1874*. Seattle: University of Washington Press.

Bracken, Christopher. 2002. "The Language of Things: Walter Benjamin's Primitive Thought." *Semiotica: Journal of the International Association for Semiotic Studies* 138: 321–49.

Bringhurst, Robert. 1999. *A Story as Sharp as a Knife: The Classic Haida Mythtellers and Their World*. Vancouver: Douglas and McIntyre.

Brown, Jovana J. 1994. "Treaty Rights: Twenty Years after the Boldt Decision." *Wicazo Sa Review* 10, no. 2: 1–16.

Brown, Stephen C. 2002. "Vessels of Life." In *The Canoe*, edited by John Jennings, 75–96. Toronto: Firefly Books.

—. 2008. "More than Transportation: The Traditional Canoes of Puget Sound." In *S'abadeb, The Gifts: Pacific Coast Salish Art and Artists*, edited by Barbara Brotherton, 246–57. Seattle: Seattle Art Museum.

Bunn-Marcuse, Kathryn. 2015. "Tourists and Collectors: The New Market for Tlingit and Haida Jewellery at the Turn of the Twentieth Century." In *Sharing Our Knowledge: The Tlingit and Their Coastal Neighbours*, edited by Sergei Kan, 417–40. Lincoln: University of Nebraska Press.

Cabello Caro, Paz. 2000. "Eighteenth Century Spanish Expeditions, Discoveries, and Collections in the Northwest Coast." In *Spirits of the Water: Native Art Collected on Expeditions to Alaska and British Columbia, 1774–1890*, edited by Steven C. Brown, 18–33. Seattle: University of Washington Press.

CBC News. 2010. "B.C. Waters Officially Renamed Salish Sea." *CBC News*, 15 July 2010. https://www.cbc.ca/news/canada/british-columbia/b-c-waters-officially-renamed-salish-sea-1.909504.

de Chadarevian, Soraya, and Nick Hopwood. 2004. "Dimensions of Modelling." In *Models: The Third Dimension of Science*, edited by Soraya de Chadarevian and Nick Hopwood, 1–15. Redwood City, CA: Stanford University Press.

Clarke, David. 1972. "Models and Paradigms in Contemporary Archaeology." In *Models in Archaeology*, edited by David Clarke, 1–60. London: Methuen.

Clifford, James. 1999. "Museums as Contact Zones." In *Representing the Nation: A Reader*, edited by David Boswell and Jessica Evans, 435–57. London: Routledge.

Codere, Helen. 1956. "The Amiable Side of Kwakiutl Life: The Potlatch and the Play Potlatch." *American Anthropologist* 58, no. 2: 334–51.

—. 1961. "Kwakiutl." In *Perspectives in American Indian Culture Change*, edited by Edward H. Spicer, 431–516. Chicago: University of Chicago Press.

—. 1966a. "Daniel Cranmer's Potlatch." In *Indians of the North Pacific Coast*, edited by Tom McFeat, 116–18. Seattle: University of Washington Press.

—. 1966b. "Fighting with Property." In *Indians of the North Pacific Coast*, edited by Tom McFeat, 92–101. Seattle: University of Washington Press.

—. 1990. "Kwakiutl: Traditional Culture." In *Northwest Coast*, edited by Wayne Suttles, 359–77. Vol. 7 of *Handbook of North American Indians*. Washington, DC: Smithsonian Institution.

Cole, Douglas. 1985. *Captured Heritage: The Scramble for Northwest Coast Artifacts*. Vancouver: Douglas and McIntyre.

Cole, Douglas, and Ira Chaikin. 1990. *An Iron Hand upon the People: The Law against the Potlatch on the Northwest Coast*. Vancouver: Douglas and McIntyre.

Collins, Cary C. 1996. "Subsistence and Survival: The Makah Indian Reservation, 1855–1936." *Pacific Northwest Quarterly* 87, no. 4: 180–93.

Collison, Nika. 2014. *Gina Suuda Tl'l Xasii/Came to Tell Something: Art and Artist in Haida Society*. Skidegate, BC: Haida Gwaii Museum Press.

—. 2016. "An Unbroken Line: Haida Art and Culture." Paper presented at the Canada Seminar, University of Oxford, Oxford, 12 February.

Colson, Elizabeth. 1953. *The Makah Indians*. Manchester: University of Manchester Press.

Connor, Steven. 2008. *Thinking Things*. Paper given at European Society for the Study of English (ESSE) Conference, Aarhus, Denmark, 25 August 2008. Accessed 11 January 2021. http://www.stevenconnor.com/thinkingthings.

Coté, Charlotte. 2010. *Spirits of Our Whaling Ancestors: Revitalizing Makah and Nuu-chah-nulth Traditions*. Seattle: University of Washington Press.

Cranmer Webster, Gloria. 1990. "Kwakiutl since 1980." In *Northwest Coast*, edited by Wayne Suttles, 203–28. Vol. 7 of *Handbook of North American Indians*. Washington, DC: Smithsonian Institution.

—. 2013. "The Dark Years." In *Native Art of the Northwest Coast: A History of Changing Ideas*, edited by Charlotte Townsend-Gault, Jennifer Kramer, and Ki-Ke-In, 265–69. Vancouver: UBC Press.

Criscione, Wilson. 2014. "Nooksack Tribe Gifts Totem Pole to School District." *Bellingham Herald*, 20 November 2014.

Crosby, Marcia. 2004. "Haida, Human Beings and Other Myths." In *Bill Reid and Beyond: Expanding on Modern Native Art*, edited by Karen Duffek and Charlotte Townsend-Gault, 108–30. Vancouver: Douglas and McIntyre.

Curtis, Edward S. (1916) 1974. *The North American Indian*. Vol. 11. New York: Johnson Reprint.

Davy, Jack. 2015. "A LEGO Snowmobile and the Elements of Miniaturisation." *Anthropology Today* 31, no. 6 (December): 8–11.

—. 2018a. "Lars Hætta's Miniature World: Sámi Prison Op-Art Autoethnography." *Journal of Material Culture* 23, no. 3 (September): 280–94.

—. 2018b. "Miniature Dissonance and the Museum Space: Reconsidering Communication through Miniaturisation." *International Journal of Heritage Studies* 24, no. 9: 969–83, DOI: 10.1080/13527258.2018.1428669.

—. 2019. "The 'Idiot Sticks': Kwakwaka'wakw Carving and Cultural Resistance in Commercial Art Production on the Northwest Coast." *American Indian Culture and Research Journal* 42, no. 3: 27–46.

Dawn, Leslie. 2004. "Re: Reading Reid and the 'Revival.'" In *Bill Reid and Beyond: Expanding on Modern Native Art*, edited by Karen Duffek and Charlotte Townsend-Gault, 251–80. Vancouver: Douglas and McIntyre.

Deans, James. 1887. "Inside View of a Haidah Dwelling." *American Antiquarian, and Oriental Journal*, No. 9, 309–10.

De Laguna, Frederica. 1990. "Tlingit." In *Northwest Coast*, edited by Wayne Suttles, 203–28. Vol. 7 of *Handbook of North American Indians*. Washington, DC: Smithsonian Institution.

Domínguez Rubio, Fernando. 2016. "On the Discrepancy between Objects and Things: An Ecological Approach." *Journal of Material Culture* 21, no. 1: 59–86.

Dover, Harriette Shelton. 2013. *Tulalip, from My Heart: An Autobiographical Account of a Reservation Community*. Seattle: University of Washington Press.

Drew, Leslie, and Douglas Wilson. 1980. *Argillite: Art of the Haida*. Vancouver: Hancock House.

Drucker, Philip. 1950. "Culture Element Distributions: XXVI Northwest Coast." *Anthropological Records* 9, no. 3.

—. 1955. *Indians of the Northwest Coast*. New York: American Museum of Natural History.

—. 1966. "Nootka Whaling." In *Indians of the North Pacific Coast*, edited by Tom McFeat, 22–27. Seattle: University of Washington Press.

Duffek, Karen. 1986. *Bill Reid: Beyond the Essential Form*. Museum Note no. 19. Vancouver: UBC Press.

Duffek, Karen, and Charlotte Townsend-Gault, eds. 2004. *Bill Reid and Beyond: Expanding on Modern Native Art*. Vancouver: Douglas and McIntyre.

Duncan, Kate C. 2000. *1001 Curious Things: Ye Olde Curiosity Shop and Native American Art*. Seattle: University of Washington Press.

Durham, Bill. 1960. *Indian Canoes of the Northwest Coast*. Seattle: Copper Canoe Press.

Elmendorf, William W. 1960. *The Structure of Twana Culture*. Washington State University Research Studies 28, no. 3, Monographic Supplement 2. Pullman, WA: Washington State University.

Erikson, Patricia Pierce. 2002. *Voices of a Thousand People*. Lincoln: University of Nebraska Press.

Errington, Shelly. 1998. *The Death of Authentic Primitive Art and Other Tales of Progress*. Berkeley: University of California Press.

Evans, Christopher. 2012. "Small Devices, Memory and Model Architecture: Carrying Knowledge." *Journal of Material Culture* 17, no. 4: 369–87.

Feder, Norman. 1971. *Two Hundred Years of North American Indian Art*. New York: Praeger Publishers.

Fenton, William N. 1987. *The False Faces of the Iroquois*. Norman: University of Oklahoma Press.

Fleischer, Mark S. 1981. "The Potlatch as Public Art Form." *Anthropos* 76, no. 1–2: 222–25.

—. 1984. "Acculturation and Narcissism: A Study of Culture Contact among the Makah Indians." *Anthropos* 79, nos. 4–5: 409–31.

Ford, Clellan S. 1941. *Smoke from Their Fires: The Life of a Kwakiutl Chief*. New Haven, CT: Yale University Press.

Foxhall, Lin. 2014. "Introduction: Miniaturization." *World Archaeology* 47, no. 1: 1–5.

Furst, Peter T., and Jill Furst. 1982. *North American Indian Art*. New York: Rizzoli.

Garfield, Viola E., and Linn A. Forrest. 1948. *The Wolf and the Raven*. Seattle: University of Washington Press.

Gell, Alfred. 1988. "Technology and Magic." *Anthropology Today* 4, no. 2: 6–9.

—. 1992. "The Technology of Enchantment and the Enchantment of Technology." In *Anthropology, Art and Aesthetics*, edited by Jeremy Coote and Anthony Shelton, 40–66. Oxford: Clarendon Press.

—. 1996. "Vogel's Net: Traps as Artwork and Artwork as Traps." *Journal of Material Culture* 1, no. 1: 15–38.

—. 1998. *Art and Agency: An Anthropological Theory*. Oxford University Press.

Gibson, James J. 1986. *The Information for Visual Perception*. Hillsdale, NJ: Lawrence Erlbaum Associates.

Ginzberg, Carlo. 2002. *Wooden Eyes: Nine Reflections on Distance,* translated by Martine Ryle and Kate Soper. London: Verso.

Glass, Aaron. 1999. "Review: *Aboriginal Slavery on the Northwest Coast of North America* by Leland Donald." *American Indian Quarterly* 23, nos. 3–4 (Summer–Autumn): 191–93.

–. 2013. "History and Critique of the "Renaissance" Narrative." In *Native Art of the Northwest Coast: A History of Changing Ideas,* edited by Charlotte Townsend-Gault, Jennifer Kramer, and Ki-Ke-In, 487–517. Vancouver: UBC Press.

Glass, Aaron, and Aldona Jonaitis. 2011. "A Miniature History of Model Totem Poles." In *Carvings and Commerce: Model Totem Poles 1880–2010,* edited by Michael D. Hall and Pat Glascock, 11–20. Seattle: University of Washington Press.

Goodman, Linda J., and Helma Swan. 2003. *Singing the Songs of My Ancestors: The Life and Music of Helma Swan, Makah Elder.* Norman: University of Oklahoma Press.

Graburn, Nelson H.H., ed. 1976. *Ethnic and Tourist Arts: Cultural Expressions from the Fourth World.* Berkeley: University of California Press.

Gunther, Erna. 1972. *Indian Life on the Northwest Coast of North America.* Chicago: University of Chicago Press.

Hall, Michael D., and Pat Glascock. 2011. *Carvings and Commerce: Model Totem Poles 1880–2010.* Seattle: University of Washington Press.

Halliday, W.M. 1935. *Potlatch and Totem and the Recollections of an Indian Agent.* London: J.M. Dent and Sons.

Harper, Russell J., ed. 1971. *Paul Kane's Frontier.* Austin: University of Texas Press.

Harris, Christine. (1966) 1992. *Raven's Cry.* Vancouver: Douglas and McIntyre.

Hawker, Ronald W. 2003. *Tales of Ghosts: First Nations Art in British Columbia, 1922–61.* Vancouver: UBC Press.

–. 2016. *Yakuglas' Legacy: The Art and Times of Charlie James.* Toronto: University of Toronto Press.

Henderson, John R. 1974. "Missionary Influences on the Haida Settlement and Subsistence Patterns, 1876–1920." *Ethnohistory* 21, no. 4: 303–16.

Herem, Barry. 1998. "Bill Reid: Making the Northwest Coast Famous." *American Indian Art Magazine* 24, no. 1.

Holm, Bill. 1965. *Northwest Coast Indian Art: An Analysis of Form.* Seattle: University of Washington Press.

–. 1983. *Box of Daylight: Northwest Coast Indian Art.* Seattle: Seattle Art Museum.

–. 1986. "The Dancing Headdress Frontlet: Aesthetic Context on the Northwest Coast." In *The Arts of the North American Indian: Native Traditions in Evolution,* edited by Edwin L. Wade, 133–40. New York: Hudson Hills Press.

–. 1987a. "The Head Canoe." In *Faces, Voices, and Dreams: A Celebration of the Centennial of the Sheldon Jackson Museum, 1888–1988,* edited by Peter L. Corey and Lydia Black, 143–56. Sitka, AK: Sheldon Jackson Museum.

–. 1987b. *Spirit and Ancestor: A Century of Northwest Coast Indian Art at the Burke Museum.* Seattle: University of Washington Press.

–. 1990. "Kwakiutl: Winter Ceremonies." In *Northwest Coast,* edited by Wayne Suttles, 378–86. Vol. 7 of *Handbook of North American Indians.* Washington, DC: Smithsonian Institution.

–. 1991. "Historical Salish Canoes." In *A Time of Gathering: Native Heritage in Washington State,* edited by Robin Wright, 238–47. Thomas Burke Memorial Washington State Museum Monograph no. 7. Seattle: University of Washington Press.

Holm, Bill, and William Reid. 1975. *Indian Art of the Northwest Coast: A Dialogue of Craftsmanship and Aesthetics.* Seattle: University of Washington Press.

Hoover, Alan. 1983. "Charles Edenshaw and the Creation of Human Beings." *American Indian Art Magazine* 8, no. 3: 62–67.

—. 1993. "Bill Reid and Robert Davidson: Innovations in Contemporary Haida Art." *American Indian Art Magazine* 18, no. 4: 48–55.

—. 1995. "Charles Edenshaw: His Art and Audience." *American Indian Art Magazine* 20, no. 3: 44–53.

Howay, Frederic W., ed. (1941) 1990. *Voyages of the Columbia to the Northwest Coast 1787–1790 and 1790–1793*. Portland: Oregon Historical Society Press.

Huelsbeck, David R. 1988. "Whaling in the Precontact Economy of the Central Northwest Coast." *Arctic Anthropology* 25, no. 1: 1–15.

Hunt, George. 1906. "The Rival Chiefs: A Kwakiutl Story." In *Anthropological Papers Written in Honor of Franz Boas*. New York: G.E. Stechert.

Ingold, Tim. 2001. "Beyond Art and Technology: The Anthropology of Skill." In *Anthropological Perspectives on Technology*, edited by Michael B. Schiffer, 17–31. Albuquerque: University of New Mexico Press.

Insley, Jane. 2008. "Little Landscapes: Dioramas in Museum Displays." *Endeavour* 32, no. 1: 27–31.

Inverarity, Robert Bruce. 1976. "The Inverarity Collection at the Museum of Mankind." Unpublished manuscript, Anthropology Library and Research Centre, British Museum, London.

Ishii, Miho. 2012. "Acting with Things: Self-Poeisis, Actuality, and Contingency in the Formation of Divine Worlds." *HAU: Journal of Ethnographic Theory* 2, no. 2: 371–88.

Jakobsen, Roman. 1971. *Word and Language*. Vol. 2 of *Selected Writings*. The Hague: Mouton.

Jensen, Ronald J. 1975. *The Alaska Purchase and Russian-American Relations*. Seattle: University of Washington Press.

Jonaitis, Aldona. 1986. *Art of the Northern Tlingit*. Seattle: University of Washington Press.

—. 2004. "Reconsidering the Renaissance Narrative." In *Bill Reid and Beyond: Expanding on Modern Native Art*, edited by Karen Duffek and Charlotte Townsend-Gault, 155–74. Vancouver: Douglas and McIntyre.

Jonaitis, Aldona, and Aaron Glass. 2010. *The Totem Pole: An Intercultural History*. Seattle: University of Washington Press.

Jusquan. 2009. "Tom Dyer Is My Name." *Haida Laas: Journal of the Haida Nation* (March): 41–45.

Kane, Paul. 1859. *Wanderings of an Artist among the Indians of North America*. London: Longman, Brown, Green, Longmans and Roberts.

Keane, Webb. 2003. "Semiotics and the Social Analysis of Material Things." *Language and Communication* 23, nos. 3–4: 409–25.

—. 2005. "Signs Are Not the Garb of Meaning: On the Social Analysis of Material Things." In *Materiality*, edited by Daniel Miller, 182–205. Durham, NC: Duke University Press.

—. 2014. "Rotting Bodies: The Clash of Stances toward Materiality and Its Ethical Affordances." *Current Anthropology* 55, supp. 10: 312–21.

Kiernan, Philip. 2014. "Miniature Objects as Representations of Realia." *World Archaeology* 47, no. 1: 45–59.

King, J.C.H. 1976. "Rise and Fall of Northwest Coast's Consumer Culture," *British Museum Bulletin*, no. 22 (July): 12–15.

—. 1986. "Tradition in Native American Art." In *The Arts of the North American Indian: Native Traditions in Evolution*, edited by Edwin L. Wade, 65–92. New York: Hudson Hills Press.

—. 1999. *First Peoples, First Contacts: Native Peoples of North America*. London: British Museum Press.

—. 2012. "Art, Ambiguity and the Haida Collection at the British Museum." *American Indian Art Magazine* 38, no. 1: 56–65.

King, James Roy. 1996. *Remaking the World: Modeling in the Human Experience*. Chicago: University of Illinois Press.

Kirk, Ruth, with Richard D. Daugherty. 1974. *Hunters of the Whale: An Adventure in Northwest Coast Archaeology*. Norman: University of Oklahoma Press.

Knappett, Carl. 2002. "Photographs, Skeuomorphs and Marionettes: Some Thoughts on Mind, Agency and Object." *Journal of Material Culture* 7, nos. 1: 97–117.

—. 2012 "Meaning in Miniature: Semiotic Networks in Material Culture." In *Excavating the Mind: Cross Sections through Culture, Cognition and Materiality,* edited by M. Jensen, N. Johanssen, and H.J. Jensen, 87–109. Aarhus, Denmark: Aarhus University Press.

Koppert, Vincent A. 1930. "The Nootka Family." *Primitive Man* 3, nos. 3–4: 49–55.

Kramer, Jennifer. 2012. *Kesu': The Art and Life of Doug Cranmer*. Vancouver: Douglas and McIntyre.

Krech III, Shepard. 1989. *A Victorian Earl in the Arctic: The Travels and Collections of the Fifth Earl of Lonsdale, 1888–89*. London: British Museum Press.

Krmpotich, Cara, and Laura Peers. 2013. *This Is Our Life: Haida Material Heritage and Changing Museum Practice*. Vancouver: UBC Press.

Küchler, Susanne. 2005. "Materiality and Cognition: The Changing Face of Things." In *Materiality,* edited by Daniel Miller, 182–205. Durham, NC: Duke University Press.

—. 2010. "The Prototype in 20th Century Art." *Visual Communication* 9, no. 3: 301–12.

Latour, Bruno (as Jim Johnson). 1988. "Mixing Humans and Non-Humans Together: The Sociology of a Door-Closer." *Social Problems* 35, no. 3 (June): 298–310.

Latour, Bruno. 2005. *Reassembling the Social: An Introduction to Actor-Network-Theory*. Oxford: Oxford University Press.

Layton, Robert. 2006. "Structuralism and Semiotics." In *Handbook of Material Culture,* edited by Christopher Tilley, Webb Keane, Susanne Küchler, Michael Rowlands, and Patricia Spyer, 29–42. London: SAGE Publications.

Lee, Molly. 1999. "Tourism and Taste Cultures: Collecting Native Art in Alaska at the Turn of the Twentieth Century." In *Unpacking Culture: Art and Commodity in Colonial and Post-Colonial Worlds,* edited by Ruth B. Phillips and Christopher B. Steiner, 267–81. Berkeley: University of California Press.

Lemonnier, Pierre. 2013. *Mundane Objects: Materiality and Non-Verbal Communication*. Walnut Creek, CA: Left Coast Press.

Lenz, Mary Jane. 2004. "No Tourist Material: George Heye and His Golden Rule." *American Indian Art Magazine* 29, no. 4.

Levell, Nicola. 2021. *Mischief Making: Michael Nicoll Yahgulanaas, Art and the Seriousness of Play*. Vancouver: UBC Press.

Lévi-Strauss, Claude. 1966. *The Savage Mind*. Chicago: University of Chicago Press.

—. 1985. "Introductory Address." In *Art as a Means of Communication in Pre-Literate Societies,* edited by Dan Eban, 1–6. Jerusalem: The Israel Museum.

Losey, Robert J., and Dongya Y. Yang. 2007. "Opportunistic Whale Hunting on the Southern Northwest Coast: Ancient DNA, Artifact, and Ethnographic Evidence." *American Antiquity* 72, no. 4 (October): 657–76.

MacDonald, George F. 1983. *Haida Monumental Art*. Vancouver: UBC Press.

Mack, John. 2007. *The Art of Small Things*. London: British Museum Press.

Macnair, Peter L. 1977. "Inheritance and Innovation: Northwest Coast Artists Today." In *Stones, Bones and Skin: Ritual and Shamanic Art,* edited by Anne Trueblood Brodzky, 150–57. Toronto: artscanada.

—. 1986. "From Kwakiutl to Kwakwa ka'wakw." In *Native Peoples: The Canadian Experience,* edited by R. Bruce Morrison and C. Roderick Wilson, 501–20. Toronto: McClelland and Stewart.

Macnair, Peter L., and Alan L. Hoover. 1984. *The Magic Leaves: A History of Haida Argillite Carving.* Victoria: British Columbia Provincial Museum.

Macnair, Peter L., Alan L. Hoover, and Kevin Neary. 1980. *The Legacy: Continuing Traditions of Canadian Northwest Coast Indian Art.* Victoria: British Columbia Provincial Museum.

Madison, James. 2014. "Teachings from My Grandfather." Paper presented at Poles, Posts and Canoes: The Preservation, Conservation and Continuation of Native American Monumental Wood Carving symposium, Hibulb Cultural Center, Tulalip, WA, 20–22 July.

Malafouris, Lambros. 2013. *How Things Shape the Mind: A Theory of Material Engagement.* Cambridge, MA: MIT Press.

Marchak, Patricia. 1995. *Logging the Globe.* Montreal and Kingston: McGill-Queen's University Press.

McIlwraith, T.F. 1948. *The Bella Coola Indians.* Toronto: University of Toronto Press.

McLennan, Bill. 2004. "A Matter of Choice." In *Bill Reid and Beyond: Expanding on Modern Native Art,* edited by Karen Duffek and Charlotte Townsend-Gault, 37–43. Vancouver: Douglas and McIntyre.

Milburn, Maureen. 1986. "Louis Shotridge and the Objects of Everlasting Esteem." In *Raven's Journey: The World of Alaska's Native People,* edited by Susan A. Kaplan and Kristin J. Barsness. Philadelphia: University Museum, University of Pennsylvania.

Miller, Daniel. 2005. "Materiality: An Introduction." In *Materiality,* edited by Daniel Miller, 1–50. Durham, NC: Duke University Press.

Mitchell, W.J.T. 2002. "Showing Seeing: A Critique of Visual Culture." In *The Visual Culture Reader,* 2nd ed., edited by Nicholas Mirzoeff, 86–101. London: Routledge.

—. 2005. *What Do Pictures Want? The Lives and Loves of Images.* Chicago: University of Chicago Press.

Monks, Gregory G., Alan D. McMillan, and Denis E. St. Claire. 2001. "Nuu-Chah-Nulth Whaling: Archaeological Insights into Antiquity, Species Preferences, and Cultural Importance." *Arctic Anthropology* 38, no. 1: 60–81.

Neel, David. 1995. *The Great Canoes: Reviving a Northwest Coast Tradition.* Seattle: University of Washington Press.

Niblack, Albert P. 1888. "The Coast Indians of Southern Alaska and Northern British Columbia." In *Report of the United States National Museum for the Year Ending June 30, 1888* (Pt. 2 of the Annual Report of the Board of Regents of the Smithsonian Institution for the Year Ending June 30, 1888), 225–386.

Nuytten, Phil. 1982. *The Totem Carvers: Charlie James, Ellen Neel, and Mungo Martin.* Vancouver: Panorama Publications.

Peers, Laura, and Alison K. Brown, eds. 2003. *Museums and Source Communities: A Routledge Reader.* London: Routledge.

Pelton, Mary Helen, and Jacqueline DiGennaro. 1992. *Images of a People: Tlingit Myths and Legends.* Englewood, CO: Libraries Unlimited.

Phillips, Ruth B. 1995. "Why Not Tourist Art? Significant Silences in Native American Museum Representations." In *After Colonialism: Imperial Histories and Postcolonial Displacements,* edited by Gyan Prakash, 98–128. Princeton, NJ: Princeton University Press.

—. 1998. *Trading Identities: The Souvenir in Native North American Art from the Northeast, 1700–1900.* Seattle: University of Washington.

Piddocke, Stuart. 1965. "The Potlatch System of the Southern Kwakiutl: A New Perspective." *Southwestern Journal of Anthropology* 21, no. 3: 244–64.

Pinney, Christopher. 2005. "Things Happen: Or, From Which Moment Does That Object Come?" In *Materiality*, edited by Daniel Miller, 256–72. Durham, NC: Duke University Press.

Pomian, Krzysztof. 1990. *Collectors and Curiosities: Paris and Venice, 1500–1800*, translated by Elizabeth Wiles-Portier. Cambridge: Polity Press.

Porsild, Morten P. 1915. "Studies on the Material Culture of the Eskimo in West Greenland." *Meddelelser on Grønland* 51, no. 7.

Poulter, Emma. 2011. "The Real Thing? Souvenir Objects in the West African Collection at the Manchester Museum." *Journal of Material Culture* 16, no. 3: 265–84.

Powell, I.W. 1882. "General Report on Indian Affairs in British Columbia for the Year 1882–1883." In *Annual Report of the Department of Indian Affairs, 1882*. Ottawa: Department of Indian Affairs.

Pratt, Mary Louise. 1991. "Arts of the Contact Zone." *Profession*, 33–40.

Preucel, Robert W. 2015. "Shotridge in Philadelphia: Representing Alaska Peoples to East Coast Audiences." In *Sharing Our Knowledge: The Tlingit and Their Coastal Neighbours*, edited by Sergei Kan, 41–62. Lincoln: University of Nebraska Press.

Raibmon, Paige. 2005. *Authentic Indians: Episodes of Encounter from the Late-Nineteenth-Century Northwest Coast*. Durham, NC: Duke University Press.

Ramsay, Heather, and Kwiaahwah Jones, eds. 2010. *Gina 'Waadluxan Tluu: The Everything Canoe*. Skidegate, BC: Haida Gwaii Museum Press.

Reid, Bill. 2000. *Solitary Raven: The Selected Writings of Bill Reid*, edited by Robert Bringhurst. Vancouver: Douglas and McIntyre.

Reid, Joshua L. 2015. *The Sea Is My Country: The Maritime World of the Makahs*. New Haven, CT: Yale University Press.

Reid, Martine J. 1987. "Silent Speakers: Arts of the Northwest Coast." In *The Spirit Sings: Artistic Traditions of Canada's First Peoples*, edited by Julia D. Harrison, 201–36. Toronto/Calgary: McClelland and Stewart/Glenbow Museum.

–, ed. 2011. *Bill Reid and the Haida Canoe*. Madeira Park, BC: Harbour Publishing.

–. 2016. *Bill Reid Collected*. Vancouver: Douglas and McIntyre.

Relyea, Kie. 2009. "The Seed Is There." *Whatcom Magazine*, April, 22–27.

Renker, Ann M., and Erna Gunther. 1990. "Makah." In *Northwest Coast*, edited by Wayne Suttles, 422–30. Vol. 7 of *Handbook of North American Indians*. Washington, DC: Smithsonian Institution.

Ringel, Gail. 1979. "The Kwakiutl Potlatch: History, Economics and Symbols." *Ethnohistory* 26, no. 4: 142–45.

Roberts, Kenneth, and Philip Shackleton. 1983. *The Canoe: A History of the Craft from Panama to the Arctic*. Camden, MA: International Marine Publishing.

Ryle, Terence. 2017. "Tribal Material Is Seen as Modern Art." *Antiques Trade Gazette*, no. 2285 (1 April): 16–17.

Schaffer, Simon. 2004. "Fish and Ships: Models in the Age of Reason." In *Models: The Third Dimension of Science*, edited by Soraya de Chadarevian and Nick Hopwood, 71–108. Stanford, CA: Stanford University Press.

Seguin, Margaret. 1986. "Understanding Tsimshian 'Potlatch.'" In *Native Peoples: The Canadian Experience*, edited by R. Bruce Morrison and C. Roderick Wilson, 473–500. Toronto: McClelland and Stewart.

Severi, Carlo. 2015. *The Chimera Principle: An Anthropology of Memory and Imagination*, translated by Janet Lloyd. Chicago: University of Chicago Press.

Sewid-Smith, Daisy (My-yah-nelth). 1979. *Prosecution or Persecution*. Cape Mudge, BC: Nu-Yum-Balees Society.

Shadbolt, Doris. 2004. "The Will to Be Haida." In *Bill Reid and Beyond: Expanding on Modern Native Art,* edited by Karen Duffek and Charlotte Townsend-Gault, 26–36. Vancouver: Douglas and McIntyre.

Sheehan, Carol. 1980. *Pipes That Won't Smoke; Coal That Won't Burn: Haida Sculpture in Argillite.* Glenbow, AB: Glenbow Museum.

Sillar, Bill. 1994. "Playing with God: Cultural Perceptions of Children, Play and Miniatures in the Andes." *Archaeological Review from Cambridge* 13, no. 2: 47–64.

Smith, Marian W. 1950. "The Nooksack, the Chilliwack and the Middle Fraser." *Pacific Northwest Quarterly* 40, no. 4: 330–41.

Soafer Derevenski, Joanna. 1994. "Where Are the Children? Accessing Children in the Past." *Archaeological Review from Cambridge* 13, no. 2: 7–20.

—. 2000. "Material Culture Shock: Confronting Expectations in the Material Culture of Children." In *Children and Material Culture,* edited by Joanna Soafer Derevenski, 3–16. London: Routledge.

Spradley, James, P. 1969. *Guests Never Leave Hungry: The Autobiography of James Sewid, a Kwakiutl Indian.* New Haven, CT: Yale University Press.

Steedman, Scott, and Nika Collison. 2011. *That Which Makes Us Haida – The Haida Language.* Skidegate, BC: Haida Gwaii Museum Press.

Stewart, Susan. 1984. *On Longing: Narratives of the Miniature, the Gigantic, the Souvenir, the Collection.* Baltimore: Johns Hopkins University Press.

Storrie, Robert. 2014. "Ambiguity in Northwest Coast Design." In *From the Forest to the Sea: Emily Carr in British Columbia,* edited by Sarah Milroy and Ian Dejardin, 103–5. Toronto/London/Fredericton, NB: Art Gallery of Ontario/Dulwich Picture Gallery/Goose Lane Editions.

Sullivan, Robert. 2001. *A Whale Hunt.* London: Headline Book Publishing.

Summers, David. 2004. "What Is a Renaissance?" In *Bill Reid and Beyond: Expanding on Modern Native Art,* edited by Karen Duffek and Charlotte Townsend-Gault, 133–54. Vancouver: Douglas and McIntyre.

Suttles, Wayne, ed. 1990. *Northwest Coast.* Vol. 7 of *Handbook of North American Indians,* edited by William C. Sturtevant. Washington, DC: Smithsonian Institution.

Sutton-Smith, Brian. 1986. *Toys as Culture.* New York: Gardner Press.

Taussig, Michael. 1993. *Mimesis and Alterity: A Particular Theory of the Senses.* New York: Routledge.

Taylor, Herbert C., Jr. 1974. "Anthropological Investigation of the Makah Indians." In *Coast Salish and Western Washington Indians,* vol. 3, 27–90. New York: Garland Publishing.

Thompson, Lynn. 2007. "Tulalips Shape Cultural Revival." *Seattle Times,* 2 May 2007.

Townsend-Gault, Charlotte. 2004. "Circulating Aboriginality." *Journal of Material Culture* 9, no. 2 (July): 183–202.

—. 2011. "Still a Forest, Still Symbols." In *Carvings and Commerce: Model Totem Poles 1880–2010,* edited by Michael D. Hall and Pat Glascock, 39–43. Seattle: University of Washington Press.

TRC (Truth and Reconciliation Commission). 2015a. *Canada's Residential Schools: The Final Report of the Truth and Reconciliation Commission of Canada.* Vol. 1, *The History,* Part 1, *Origins to 1939.* Montreal and Kingston: Published for the Truth and Reconciliation Commission of Canada by McGill-Queen's University Press.

—. 2015b. *Canada's Residential Schools: The Final Report of the Truth and Reconciliation Commission of Canada.* Vol. 1, *The History,* Part 2, *1939–2000.* Montreal and Kingston: Published for the Truth and Reconciliation Commission of Canada by McGill-Queen's University Press.

—. 2015c. *The Survivors Speak: A Report of the Truth and Reconciliation Commission of Canada*. [Winnipeg]: Truth and Reconciliation Commission of Canada.

—. 2015d. *Canada's Residential Schools: The Final Report of the Truth and Reconciliation Commission of Canada*. Vol. 5, *The Legacy*. Montreal and Kingston: Published for the Truth and Reconciliation Commission of Canada by McGill-Queen's University Press.

Turner, Edith. 1994. "A Visible Spirit Form in Zambia." In *Being Changes by Cross-Cultural Encounters: The Anthropology of Extraordinary Experience*, edited by D.E. Young and J. Goulet, 71–96. Ottawa: Broadview Press.

Tweedie, Ann M. 2003. *Drawing Back Culture: The Makah Struggle for Repatriation*. Seattle: University of Washington Press.

Van den Brink, J.H. 1974. *The Haida Indians: Cultural Change Mainly between 1876–1970*. Leiden, Netherlands: Brill.

Vastokas, Joan M. 1977. "Bill Reid and the Native Renaissance." In *Stones, Bones and Skin: Ritual and Shamanic Art*, edited by Anne Trueblood Brodzky, Rose Danesewich, and Nick Johnson, 158–68. Toronto: artscanada.

Wade, Edwin L., ed. 1986. *The Arts of the North American Indian: Native Traditions in Evolution*. New York: Hudson Hills Press.

Wagner, Henry R. (1933) 2002. *Spanish Explorations in the Strait of Juan de Fuca*. Mansfield, CT: Martino Publishing.

Wardwell, Allen. 1996. *Tangible Visions: Northwest Coast Indian Shamanism and Its Art*. New York: Monacelli Press.

Warrior, Claire. 1999. "Small Meetings across Cultural Boundaries: Model Totem Poles and the Imagination of Cultures on the Northwest Coast of America." *Journal of Museum Ethnography*, no. 11: 105–20.

Waterman, T.T., and Geraldine Coffin. 1920. *Types of Canoes on Puget Sound*. New York: Museum of the American Indian/Heye Foundation.

Wessen, Gary. 1990. "Prehistory of the Ocean Coast of Washington." In *Northwest Coast*, edited by Wayne Suttles, 240–60. Vol. 7 of *Handbook of North American Indians*. Washington, DC: Smithsonian Institution.

White, Frederick H. 2006. "Was Spain Really First? Rereading Juan Pérez's 1774 Expedition to Haida Gwaii." *Canadian Journal of Native Studies* 26, no. 1: 1–24.

Williams, Lucy Fowler. 2015. "Louis Shotridge: Preserver of Tlingit History and Culture." In *Sharing Our Knowledge: The Tlingit and Their Coastal Neighbours*, edited by Sergei Kan, 63–78. Lincoln: University of Nebraska Press.

Wilson, Barb. 2009. "Sometimes, It's All Right There." *Haida Laas: Journal of the Haida Nation*, March, 6.

Wilson, Raymond (Rocky). 2007. "To Honour Our Ancestors, We Become Visible Again." In *Be of Good Mind: Essays on the Coast Salish*, edited by Bruce Granville Miller, 131–37. Vancouver: UBC Press.

Windsor, W. Luke. 2004. "An Ecological Approach to Semiotics." *Journal for the Theory of Social Behaviour* 34, no. 2: 179–98.

Wolcott, H.F. 1967. *A Kwakiutl Village and School*. New York: Holt, Rinehart and Winston.

Worl, Rosita. 2008. *Celebration: Tlingit, Haida, Tsimshian Dancing on the Land*. Juneau: Sealaska Heritage Institute.

Wright, Robin K. 2015. "Skidegate Haida House Models." In *Sharing Our Knowledge: The Tlingit and Their Coastal Neighbours*, edited by Sergei Kan, 381–93. Lincoln: University of Nebraska Press.

Wright, Robin K., and Daina Augaitis, with Haida advisors Robert Davidson and James Hart. 2013. *Charles Edenshaw*. London: Black Dog Publishing.

Index

Note: "(f)" after a page number indicates a figure.

7idansuu. *See* Edenshaw, Charles

affordances, 16, 169–72, 186
Alert Bay, 3, 67–88, 160
Alfred, Wayne, 76–78, 80, 87, 145, 155, 161, 177
American Museum of Natural History (New York), 10, 48, 67
Amrute, Sareeta, 124
amulets, 152–54
argillite, 51, 56, 112, 145–46
Arima, Eugene, 131
art
 aesthetics and practicality, 8, 11
 marketing, 91–94
 protest, 61
 social relations, 9
 survival, 68, 83
art market, 6, 12, 26, 28, 79
assimilation, 4
autoethnography, 47

basketry, 33
Beaver Harbour, 43
Bellingham, 97
Boas, Franz, 11, 53, 67, 111, 117, 147, 174
Boldt Decision, 96
Boom Town, 91

Borlase, William Copeland, 47
British Museum (London), 47, 55, 57, 143
Brooklyn Museum, 158
Brown, Steven, 43
Bruce, Steven, Sr., 80–81, 114, 139, 160–63, 178, 184
Buchanan, Charles, 95
Burke Museum of Natural History (Seattle), 24–25

canoe racing, 105, 134
canoes, 10
 construction, 13, 140–43
 decoration, 23–24, 32, 41, 64
 first contact, 41
 importance, 10, 31–32
 modern resurgence, 32, 105–6, 109
 See also Westcoast canoes
carvers, 13, 139–40, 164–66, 170–71
 decision making, 14
 as educators, 35, 38–39
 learning process, 34–35, 159–64
cedar, 13, 106, 140–47
ceremony, 18, 21, 147–60, 189
Clarke, David, 127
Clifford, James, 7
clubs, 8, 111–12
Codere, Helen, 68, 70, 81

Cole, Douglas, 7
Colfax, Greg, 21, 25–26, 30, 153, 165
collecting, 6
Collison, Nika, 41, 61, 65
colonialism
 effects of, 20, 23, 44–46, 53, 169
 material resistance to, 14, 29, 37, 47, 49–50, 168–69
Colson, Elizabeth, 29
contact zone, 6–7
Coté, Charlotte, 19
Cranmer, Dan, 70, 82, 164
Cranmer Webster, Gloria, 5, 7–8, 120, 173
Crosby, Marcia, 61
cultural reclamation, 4, 14

Dark Time (Kwakwaka'wakw term), 71, 87
Davidson, Robert, 7, 60, 62
Daxiigang. *See* Edenshaw, Charles
Deans, James, 53–55
Denny, Mary Lou, 20
diorama, 25–26, 75–78, 156–59
Duff, Wilson, 79
Duncan, Robert, 56, 84
Durham, Bill, 31, 154
Duwamish, 90

Ebberts, 49, 56
Edenshaw, Charles, 50–52, 58, 60, 63
Edenshaw, Gwaii, 42, 58, 62–63, 64, 146, 161–63, 177, 181, 187
education, 18, 24, 30–31
emphasis (as term), 123–24, 146
epidemics, 19, 40, 44–45, 70
Errington, Shelly, 12
ethnodrama, 83
Evans, Christopher, 8, 118, 142
Everett, 90
exhibitions, 24, 37, 52–55, 57, 59, 158, 187

feasting, 22. *See also* potlatching
fidelity, 116–17, 133
Field Museum (Chicago), 54, 158
fishing, 7, 96
floating, 35–36
Florida State Museum, 48
forests, 3, 141–42, 187–88
formline design, 46–47

Gell, Alfred, 9, 31, 38, 61, 114–15, 122–23, 160, 186
Gobin, Joe, 93, 99, 101, 103–10, 108(f), 114, 139, 175, 178, 188
Gobin, Mike, 93, 125
Guujaaw, 43, 149

Haida, 8–9, 13–14, 17, 40–66, 79, 112, 145–46, 158
 colonialism, 44–46
 epidemics, 44
 supernatural canoes, 43
Haida Gwaii, 3, 40–44, 47, 51–66
Haina, 59
Haines (mission school), 59
Halliday, William M., 68–72, 184
Hamat'sa ceremony, 81–87, 171
Hawker, Ronald, 60, 74
head canoe, 42–43, 48–50, 134
Heiltsuk, 52
Heye, George, 27, 174
Hibulb Cultural Center (Tulalip), 99, 102, 107
Hillaire, Joseph, 97
Hogwarts Castle, 123
Holm, Bill, 43, 87, 131, 133, 180
Hope, Bob, 75
houses, 52–55, 130
Hunt, Corinne, 51
Hunt, Tony, 107

Indian Act, 68
Indian Reorganization Act, 28, 90, 95
Indigenous communities, 11–12
Ingold, Tim, 117
Insley, Jane, 156
interviews
 rationale, 7–8
Isaac, Trevor, 73, 78, 82, 155, 164

James, Charlie, 72–74, 79, 81, 83, 170, 180
Jensen, Ronald, 48
Jonaitis, Aldona, 154
Jones, Jerry, 105–6

Kane, Paul, 49
Keane, Webb, 119
King, Jonathan, 46
:klatle-bhi (Cloth-Bay), 147, 161–62, 177
Klukwan, 59

Knappett, Carl, 116–17, 120, 124–25
Kwakwa̱ka'wakw, 6, 13–14, 43–44, 67–88, 154

Lemmonier, Pierre, 114
Lévi-Strauss, Claude, 5, 8, 111–15, 118, 173, 182
logging, 3, 141–42
Loo Taas, 62
Lummi, 97
Lushootseed, 89–90

Mack, John, 116
Madison, James, 93, 99, 102–3, 141–42, 149, 160, 163–64, 177
Madison, Steven (Sa?ba?ahd), 93, 102, 163
Makah, 13–14, 15–39, 79, 152, 157, 171, 174, 176
 history of, 19–29
Makah Culture and Research Center, 16, 28, 38
Malaspina, Alessandro, 42, 175
maquettes, 101
Martin, Mungo, 72–79, 81, 83, 115, 157, 171, 173, 175, 179, 187
Marysville, 90
Masset, 45, 145
materiality, 140–47
McCarty, Alex, 32–36, 112, 127, 130, 139, 157, 162, 181, 187–88
McCarty, Spencer, 18, 31, 35–36, 126, 139, 142, 148, 152, 165–66
McIlwraith, T.F., 154
McLeod, Sarah, 97
Meares, John, 19
Metlakatla, 44
mimesis, 61, 76, 121–24, 171–73
miniature canoes, 9, 16–17, 23–24, 32–36, 131–32
miniature dissonance, 10, 112
miniature houses, 52–53, 132–33, 137
miniatures
 as ceremonial objects, 18, 42, 54–55, 147–50, 167
 as communication strategy, 4, 11, 33–34, 37–38, 49–50, 58, 65–66, 107–9, 169–70
 as educational tools, 24, 27, 30–31, 34, 37, 85–86, 159–64

 as identity, 25, 27–28, 33, 37–38, 49–50, 52–55, 57–58, 61–62, 65–66, 87–88, 107–9
 making of, 30–31, 79–80
 materiality, 140–47
 as practice, 33, 38
 as souvenirs, 10, 74–75
 theory of, 111–29, 166–68, 169–89
 as toys, 10, 18, 85–88, 126
Mitchell, W.J.T., 117
model (term), 127–28, 177. *See also* miniatures
Mona Lisa, 123
Munka, 134, 150
Musée du quai Branly (Paris), 138
Museum of Anthropology (Vancouver), 62, 75, 143, 151
Museum Volkenkunde (Leiden), 24
museums
 fetishization of objects, 5
 misunderstanding objects, 112
 Native American engagement with, 7, 9, 35–36, 59
 object acquisition, 6
 rediscovery of objects, 32, 35, 58, 62
 restrictions, 36
 satire in, 57

National Museum of Natural History (Washington, DC), 24–25
National Museum of the American Indian (Washington, DC), 26–27, 157
Neah Bay, 15–16, 20, 32, 130
Neel, Ellen, 73–75, 79, 81, 83, 173, 175, 179–80
Niblack, Alfred, 10
non-Indigenous miniatures, 138
nonsensical dimensions, 112–13
Nooksack, 98
Nowell, Charley, 162
Nuu-chah-nulth, 16, 19–20, 24, 29, 31
Nuxalk, 44, 154

Olympic Peninsula, 15
oral histories, 41
Ossipee, USS, 48
Ozette, 3, 15–18, 21, 28, 37–39, 152, 170
 miniatures of, 16–17

Parker, Aaron, 36

Penn Museum (Philadelphia), 59, 179
Pérez, Juan, 40–41
Petersen, Gary, 79–80, 142–43, 163, 165, 177
Peterson-Renault, Melissa, 29, 165
Phillips, Ruth, 12, 115–16, 126
Pitt Rivers Museum (Oxford), 8
Point, Steven, 107
Pomian, Krzysztof, 116, 180
potlaching, 45–46, 67, 154–56
Pratt, Mary Louise, 6–7
proportionality, 133
prototypes, 61, 121–23, 140, 149, 171–73, 182
Puget Sound, 89–90

Quatsino, 67
Quil Ceda Creek Casino, 91–92
Quileute, 105

Raibmon, Paige, 12, 78, 185
rattles, 5
Raven's Cry, 63
Raymond, 184, 185(f)
Reid, Bill, 10, 59–63, 106, 163, 173, 179, 181, 184
Reid, Joshua, 28
Reid, Martine, 127–28
resemblance. *See* mimesis
reservations, 19–20
residential schools, 20, 71–72, 88, 95, 97
riverine canoes, 151
Roberts, Kenneth, 10
Royal British Columbia Museum (Victoria), 75, 138, 151, 158
Royal Ontario Museum (Toronto), 71

Salish Sea, 15, 106–7
Samish, 90
Sandeman, Fleetwood, 47, 179, 187
Sartori, Louis, 48–49, 119
satire, 56
scaling, 23, 33, 38, 124–26, 132–34
Scow, Gordon, 81, 84–87, 138, 154, 171, 173, 175, 177–78, 187
seal hunting, 20
Seattle, 89–90, 151
Seattle Aquarium, 184
semiophores, 116, 180
semiotics, 118–21, 158, 176

Severi, Carlo, 115
Seward, William, 49, 56
Sewid, James, 82–85
Sewid-Smith, Daisy (My-yah-nelth), 71
Shackleton, Phillip, 10
Shadbolt, Doris, 50
shaking objects, 5, 7, 9, 120, 173, 187
Sheehan, Carol, 145
Shelton, William, 89, 95–98, 108
Shelton Dover, Hariette, 89, 95, 97
Shotridge, Louis, 58–59, 179–80
shovelnose canoes, 150–51
Silent Years (Haida term), 59–60
Sillar, Bill, 126
Simon Fraser University, 143
simplification, 126–29
Sistine Chapel, 123–24
Sitka, 40, 48–49, 119
Skagit, 90
skeuomorphism, 36, 46, 125
Skidegate, 45, 52–53, 140, 145, 179
Snohomish, 90
Snohomish River, 90
Snoqualmie, 90
Solomon, Felix, 148, 159–60, 160(f)
souvenirs, 26, 56–57
 dismissal of, 12–13
 See also tourist art
spoon canoes, 151
St. Michael's Indian Residential School, 71–72, 88
Stewart, Susan, 115, 162
Stillaguamish, 90
Suiattle, 90
Swan, Helma, 30, 126
Swan, James G., 24–26, 28
Swanaset, George, Sr., 98
synecdoche, 25, 176, 186

Tatoosh Island, 20
tattooing, 51
Taussig, Michael, 121–24
This is Our Life project, 8–9
Thompson, Art, 29
Tlingit, 7, 8, 40, 48, 59, 157, 174
Tluu XaaydaGaay, 43
Tongass, 56
totem pole, 56, 74–75, 96–101, 130, 159–60
tourist art, 12–13, 27, 28–29, 112. *See also* souvenirs

Townsend-Gault, Charlotte, 56, 83–84, 140
Tozier, D.F., 27
Treaty of Point Elliott, 89–90
Tsimshian, 40, 44
Tulalip, 3, 13–14, 20, 89–110, 138
Tulalip Resort Casino, 91
Tulalip Tribes Art Manufacturing Centre, 91–93, 99, 109–10

U'mista Cultural Centre, 75–78, 85

Vancouver Island, 15, 67
Vastokas, Joan, 60
Victoria, 44, 56

Village Island, 70

Wei Wai Kum, 56, 84, 97
Westcoast canoes, 16–17, 23, 132, 150
whaling, 20–25, 30, 152
 modern whaling, 24, 28, 38
Wilson, Rocky, 95
World's Largest Trophy Cup, 122(f)

Yahgulanaas, Michael Nicoll, 57
Yakutat Bay, 42, 150
Ye Olde Curiosity Shop, 26, 45, 184
Young Doctor, 26–27, 28, 34–35, 116, 138, 171, 173, 175, 187